MW01483806

Supernatural, Humanity, and the Soul

Supernatural, Humanity, and the Soul

On the Highway to Hell and Back

Edited by
Susan A. George and Regina M. Hansen

palgrave
macmillan

SUPERNATURAL, HUMANITY, AND THE SOUL
Copyright © Susan A. George and Regina M. Hansen, 2014.

First published in 2014 by
PALGRAVE MACMILLAN®
in the United States—a division of St. Martin's Press LLC,
175 Fifth Avenue, New York, NY 10010.

Where this book is distributed in the UK, Europe and the rest of the world,
this is by Palgrave Macmillan, a division of Macmillan Publishers Limited,
registered in England, company number 785998, of Houndmills,
Basingstoke, Hampshire RG21 6XS.

Palgrave Macmillan is the global academic imprint of the above companies
and has companies and representatives throughout the world.

Palgrave® and Macmillan® are registered trademarks in the United States,
the United Kingdom, Europe and other countries.

ISBN: 978–1–137–41255–3

Library of Congress Cataloging-in-Publication Data

 Supernatural, humanity, and the soul : on the highway to hell and
back / edited by Susan A. George and Regina M. Hansen.
 pages cm
 Includes bibliographical references and index.
 ISBN 978–1–137–41255–3 (alk. paper)
 1. Supernatural (Television program : 2005–) 2. Religion on television.
 I. George, Susan A., 1959– editor. II. Hansen, Regina editor.

PN1992.77.S84S875 2014
791.45′72—dc23 2014009910

A catalogue record of the book is available from the British Library.

Design by Newgen Knowledge Works (P) Ltd., Chennai, India.

First edition: September 2014

10 9 8 7 6 5 4 3 2 1

With my love and gratitude, I dedicate this book to my grandparents, Andre and Ludovina Bettencourt, for teaching me to value wisdom and not just knowledge, to my parents, Raymond and Delores George, and my partner in all things, Ken Stiles.

—Susan A. George

For my great-grandmother Emma Pizzella, who knew about angels, and for my beloved husband Brian Kemmett.

—Regina Hansen

Contents

Part III Men, Women, and *Supernatural*

Figures

Acknowledgments

This book was born in part from our conversations and panels at the International Conference for the Fantastic in the Arts. Conference members have contributed to this book in many ways, either directly with chapters or by reading drafts and giving support and advice. Deep appreciation goes to my coeditor Susan George. My gratitude, as always, to the support and friendship of my colleagues at Boston University's College of General Studies and the Center for Interdisciplinary Teaching and Learning. Thanks to the staffs of the Somerville Public Library and Bloc 11 Cafe in Somerville, Massachusetts, where much of the work on this volume took place. I am grateful to Avi Gold for his help with translations of Hebrew. Love and thanks to my family: my mother for watching my children and driving them places, my son Dominic Kemmett, for his help with the images for the volume, my daughters Angelina and Veronica Kemmett, for sharing me with the Winchesters and my husband Brian Kemmett, for everything.

REGINA HANSEN

This book came about from many poolside discussions at the International Conference of the Fantastic in the Arts. After years of saying, "we should really write a book on *Supernatural* before it gets cancelled," we decided to do it and now here it finally is. I would like to thank my coeditor, Regina Hansen, who has been a constant source of humor, support, and ideas as well as the contributors who were patient and dedicated to this project that took longer to go to press than any of us imagined. Since this is my first time editing a book, I had many questions and several people quickly gave me advice including Kent A. Ono, Sarah Projansky, and J. P. Telotte—thanks. A special thanks (and hugs) to Mary Pharr for answering my editing questions, providing constant encouragement, and reading several versions of my essay. I would also like to thank Michael Klein for his

support, Skype conversations, and comments on my various drafts. Thanks to those at the Popular Culture Association South Conference for their comments on an early version of my essay and to Shirley Kalhert for helping me think through and refine my essay and for offering advice on editing (and for the coffee and pastries, of course!). Thank you to Dominic Kemmett for helping with the images in this book. I want to thank the folks at Palgrave Macmillan, especially Robyn Curtis and Erica Buchman, for all their help and support over the last several years on this project and the one before it. Finally, as always, to my family and friends—thanks for your constant love and support.

SUSAN A. GEORGE

Introduction: The Highway to Hell and Back

Regina M. Hansen and Susan A. George

Over nine seasons, the television series *Supernatural* has inspired a large and still growing fandom—with conventions, fanfic websites and blogs, comic books, an animated series, and a series of novels. At the same time, like similarly fan-centered or cult shows, such as those of the *Star Trek* franchise, *The X-Files* (1993–2002), and *Buffy the Vampire Slayer* (1997–2003), throughout its run *Supernatural* has delved into social, philosophical, literary, and theological themes—as well as issues related to gender, family, capitalism, and postmodernism—that not only contextualize and add depth to the show's ongoing plots, but also reflect our era's intellectual concerns and may, in the end, be part of the reason for the program's popularity.

Supernatural, *Humanity, and the Soul: On the Highway to Hell and Back* analyzes the ways in which the series represents humanity, the human soul and will. The Winchester brothers struggle to retain their own humanity as they fight for humanity as a species. The brothers, Dean and Sam Winchester (Jared Padalecki and Jensen Ackles), represent the human condition even as they experience demonic and angelic powers that challenge them personally and as members of the human race. Much as the reimagined *Battlestar Galactica* (2004–2009) did, *Supernatural* plays with the line between human and monstrous Other, between justice and vigilantism, reflecting post-9/11 America's simultaneous acceptance of and unease with issues such as torture and preemptive violence. At the same time, this assertion of and for humanity—as well as the series' interrogation of what

Figure 1.1 Sam and Dean Winchester (Jared Padalecki and Jensen Ackels) in the Impala on the road hunting evil things.

humanity entails—takes place amid micro- and macronarratives: at the family level, the societal level, and the metaphysical level.

Supernatural's stories and central concerns have effectively tapped into our human tendency to create narratives about our lives, to live our lives as narratives, and to subordinate ourselves to the cultural narratives prescribed for us. In the show, the Winchesters serve as our representatives in their struggle to maintain agency within a series of overlapping story lines in which the conflicts and denouement are controlled by others. In fighting for (and as) humans, the brothers must contend with constraining external narratives. First, there is the family narrative: the effects of their mother's death, their identities as John Winchester's sons, and the carrying on of the family business, or tradition of hunting. While "the boys" strive to maintain their humanity within these narratives—which are often represented as their destiny—they are also denied many elements of human free will and happiness. More specifically, they are denied—and also deny themselves—the loving relationships that could lead them to start families of their own and rewrite their family story. Until recently, they had been denied a typical home, both in the physical sense (they were always moving) and in the sense of comfort and safety.

The Winchesters also exist and do their work amid social narratives that often conflict with the tasks of a hunter, as well as with Sam and Dean's attempts to remain human as they fight to protect

humanity. These include the stories being lived by everyday humans, who usually do not know that they are in danger from supernatural forces (or deny it as long as they can), as well as the narratives put in place by civil authorities (police, politicians, businessmen). Often, the Winchesters end up impersonating these authorities and undermining them by giving themselves the names of rock stars, the traditional icons of rebellion. Also, as KT Torrey writes in this collection, within the world of the show, the Winchesters must directly contend with the idea of themselves as "characters in someone else's story"—as the heroes of a series of potentially prophetic novels, as television characters played by actors named Jared Padelecki and Jensen Ackles as well as in the fan fiction written by recurring character Becky Rosen (Emily Perkins).

The Winchesters' struggles also take place within narratives that include supernatural or metaphysical elements. Early on (and sometimes even in later episodes), this meant fighting creatures from urban myth and folktales (stories that already had "endings" the brothers tried to avert) as well as literary fairy tales, stories of gods and tricksters from various cultures, and even stories from "real world" authors like H. P. Lovecraft. Sam and Dean, at various times, also have to contend with their fates as "chosen ones" or instruments of various actors in these narratives—in particular Lucifer and the Archangel Michael, in the apocalyptic story line from seasons four and five. Since the closing of that narrative arc, which ended in season five when *Supernatural* creator Eric Kripke stepped down as showrunner, the Winchesters have been caught up in ever-expanding, if less logical, story lines including the angel Castiel's quest to control Heaven, the Leviathans' plans for world domination, and Metatron's plot to rid Heaven of warring angels. In each case, the Winchesters are denied narrative agency. They either lack the knowledge and power to change the story or, in other cases, are deceived and unaware of the story being written for and about them.

In its portrayal of the Winchesters' struggles for agency, *Supernatural* simultaneously embraces and resists the postmodern impulse to critique and deconstruct hierarchies of thought and cultural value. Sam and Dean find small ways to break free of their subordination to narrative, which is usually framed as destiny. These ways include using humor through satire and self-effacing jokes and by asserting masculinity, through their embrace—especially Dean's embrace—of the immediate rewards of popular and material culture (classic rock music, the Impala, casual sex, hamburgers and pie), and also

through constantly reaffirming their relationship as brothers, a relationship that their antagonists seek to undermine. At the same time, as it recounts the Winchesters' and other characters' entrapment within layered narratives, the show itself plays with and deconstructs social and storytelling forms in surprising ways. It challenges scripture and foundational religious writings through the portrayal of sarcastic "dick" angels and its embrace of free will over scriptural determinism. This can be seen in the outcome of the aforementioned Apocalypse plot as well as the ways in which the episodes concerning angels have since broken free from the religious and literary texts that first inspired them. Whereas seasons four and five clearly and explicitly resonated with the Book of Revelation and Milton's *Paradise Lost*, in seasons since then, the angels have in effect been writing their own stories. More generally, through its story lines and characters, *Supernatural* questions the binary in which popular culture is subordinated to high culture, and attempts, in philosopher Jacques Derrida's words, to "deconstruct" the "structure of opposition" or "hierarchy" in which one idea is always privileged over another (42). The show brings into the popular culture zeitgeist some of the world's oldest stories, from the Bible and theology to folklore and mythology, as well as echoes of literary fairy tales, and puts them all on an equal footing with literary genres from mystery to horror to paranormal romance, film noir, situation comedy, reality television and, of course, the road film. All these genres can and are used to generate fear, but are just as often played for laughs, sometimes in the same episode. In overturning genre conventions, not only those of the horror genre to which the show ostensibly belongs, but also those of the genres it borrows from, *Supernatural* ends up engaging in all aspects of culture to address a number of philosophical questions, questions of free will and right action, of what makes us human, and to what extent our lives are governed by the stories others tell. This deconstruction of genre also helps to critique traditional social structures, including religious hierarchy as well as familial and class hierarchies. Even where *Supernatural* holds onto tradition, in its embrace of a potentially regressive hard masculinity, the show's use of satire—its winking at gender stereotypes—opens the door for a masculinity that takes into account discussions of how the narrow definition hurts both men and women.

Perhaps because of its long run and the change in showrunners, and because making a television series is always a collaborative effort, *Supernatural* has played with its own narrative structure as well,

allowing it to become more complex over the years. Early episodes of the series seemed to follow the monster-of-the-week format and looked to urban legends and occasionally folklore for antagonists. The first elements of a mythology had to do with the death of the Winchesters' mother, followed by the gradual introduction of other hunters, and, later, demons and recurring monsters like the reapers, and the powerful seasons four and five apocalyptic narrative that continues to resonate with viewers and critics. Yet, the Winchesters' struggle for agency continues because every time they win one battle for humanity (and for themselves), another challenge appears. With the conclusion of the Apocalypse story line, the show addressed Sam's return from Hell (an event from which this book takes its subtitle) and the loss of his soul. Later seasons have evoked the Leviathans, and most recently Metatron, the angel known as the voice of God in Jewish tradition. In each case, the series moves further away from its grounding in its scriptural and literary source material. Yet while some fans and critics long for the narrative consistency of earlier seasons, in making brand new unrecognizable stories out of traditional narratives, rebuilding tradition in a new image, *Supernatural* is only being faithful to its postmodernist impulse.

As *Supernatural* incorporates and builds upon other narratives, so this book builds upon the work of others in the ever-expanding field of scholarship on the series, particularly *In the Hunt:Unauthorized Essays on* Supernatural and Stacey Abbott and David Lavery's collection, *TV Goes to Hell: An Unofficial Road Map of* Supernatural, which covers the first five seasons of the show, concluding with Sam's sacrifice to avert the Apocalypse. This book continues the discussion of gender/women (or lack thereof), the importance of the music, the Impala, and lore, but also adds a more extensive focus on the theological and philosophical underpinnings of the series. This collection takes *Supernatural* seriously as a popular culture artifact in the same way that the series itself takes seriously (but also has fun with) its borrowings from throughout the culture.

Although some chapters focus on those early seasons, the chapters in this collection also engage with what has happened on the show in the years since Kripke left as showrunner, allowing the series to try out a number of story lines that did not necessarily flow from the five-season plan he initially imagined. Seasons six through nine have continued the use of religious themes through the ongoing interaction between angels and demons, as well as the conflicts among fallen versus unfallen angels. These seasons have also introduced new concepts

from religion including the Catholic concept of Purgatory, although used in a way very different from how it is conceptualized in theology (another example of how *Supernatural* plays with and deconstructs traditional sources to create its own narratives). The introduction of the biblical monsters the Leviathans as a foil for capitalism also shows the ways in which *Supernatural* continues the discourse between the present moment and literary and cultural tradition. The series also keeps questioning traditional values by giving us angels who are truly evil and demons who may be good—or if not good than at least understandable. These characterizations challenge the idea of what good and evil are and whether the terms continue to have meaning in the postmodern milieu. In many ways, since the end of season five, the show has been in a cycle of starting over, from Dean starting over without Sam, to Sam trying to start over with the veterinarian Amelia (Liane Balaban) and the dog Sam hits with his car, to the brothers starting over without Bobby Singer (Jim Beaver) to the angels starting over, first after losing the surety of the apocalyptic narrative and, as of season nine, having to rebuild and reassert their identities after being ejected from Heaven.

At the time of submitting this manuscript, *Supernatural* has gotten an early renewal from the CW for a tenth season. Even though some fans and critics have been less than awestruck with the seasons since Kripke's departure, the program has continued to hold a high market share for the CW. As one website notes, *Supernatural* has

> doubled the network's Tuesday night ratings year-to-year in adults 18–34…grown +150% in adults…and gained +88% in total viewers (3.2 million vs. 1.7 million) versus last season. In its ninth season, *Supernatural* has seen double-digit increases year-to-year in total viewers and all key demos, and recently had its most watched episodes since 2010. ("*Supernatural* Officially Renewed")

Although Kripke's five-season story line ended four years ago, *Supernatural* is still generating new fans, scholarship, fanfic, blogs, and interest in the news media, including a recent spot on National Public Radio (Ulaby). Those first five powerful seasons of *Supernatural* laid the groundwork, creating a long-term narrative and characters strong enough to be deconstructed and reconstructed many times, to be played with, satirized, and layered with meaning and meta-meaning just as the show does with its sources.

The fourteen chapters in this collection consider these narratives through close reading of the series episodes but also by grounding their analysis of *Supernatural* in philosophical, social, and theological discourses. Some of the chapters in this anthology employ the classic works of philosophy and theology reflected in the series' themes, including The Bible, the works of Thomas Aquinas, Plato, Augustine of Hippo, John Milton, and so on. Others use modern works of social, literary, and film criticism, such as Maria Tatar and Marina Warner's work on fairy tales, Tabitha Freeman and Stanley Greenspan on family dynamics, and various psychological approaches. Still other chapters locate *Supernatural* within the current popular cultural fascination/renaissance of the fantastic—including the shows already mentioned as well as phenomena such as the *Twilight* series. The series' roots in folklore and scripture are also examined, from seasons four and five's apocalyptic arc based in (but also challenging) Judeo-Christian scripture to more recent evocations of religious concepts such as Purgatory and biblical figures such as the Leviathans.

The authors in this collection are all admirers of the series although we are of varying opinions about its postmodernist project. The chapters in section one "Religion, Theology and Philosophy through a *Supernatural* Lens," discuss how the show engages with age-old texts in Western culture from the Old Testament and the works of Plato through the medieval Christian theologians. Regina Hansen's "Deconstructing the Apocalypse? *Supernatural*'s Appropriation of Angelic Hierarchies" posits the representation of angels in the apocalyptic narrative of seasons four and five as a postmodernist attempt to overturn the concept of hierarchy, both the subordination of humans to God, and sons to fathers, and the subordination of human agency to narrative. The chapter consults the Bible as well as Jewish and early and medieval Christian authors as a balance against *Supernatural*'s particular understanding of angels and, through them, religion. Elizabeth's Wolfe's "The Greatest of These: The Theological Virtues and the Problem of an Absent God in *Supernatural*" attempts a traditional "moral reading" of *Supernatural* as a text in which the characters of Sam, Bobby Singer, and Dean are viewed as admittedly not perfect representatives of the theological virtues of faith, hope, and love, respectively. Patricia Grosse's "Suffering Nuclear Reactors: Depictions of the Soul from Plato to *Supernatural*" looks at *Supernatural*'s attempts to answer one of the great philosophical questions, what it means to be human, while also exploring the

character of soulless Sam from season six through the lens of Platonic and Augustinian concepts of the soul. In keeping with *Supernatural*'s interrogation of religious narratives, KT Torrey's "We're Just...Food and Perverse Entertainment: *Supernatural*'s New Gods and the Narrative Objectification of Sam and Dean" focuses on Castiel (Misha Collins), the brothers' greatest ally in stopping the Acopalypse, and champion of free will, taking away their agency and all the brothers have gained as he constructs his own story.

The second section is "'Killing Evil Things' Or Not—*Supernatural*'s Complex Considerations of Monstrosity." Sharon King's "All Dogs Come from Hell: *Supernatural*'s Canine Connection" places the show's representations of man's best friend within the context of folklore about dogs and tries to answer the question of "what constitutes the monstrous" in the series. In "'This Isn't Wall Street, This Is Hell!': Corporate America as the Biggest *Supernatural* Bad of All," Erin Giannini examines the predatory nature of American business culture through the depiction of Dick Roman Enterprises and the Leviathans. The association of women with the monstrous rounds out the section. *Supernatural*'s complex relationship with its mostly female fans, and the potential monstrosity of the latter, is discussed in Cait Coker and Candace Benefiel's "The Hunter Hunted: The Portrayal of the Fan as Predator in *Supernatural*." The chapter attempts to locate *Supernatural*'s fandom within its narrative and to show the series' attempts to take back control of its narrative from the fans, in some ways in contradiction of the show's postmodern urge to question authority (any authority but its own). In "'A Shot On The Devil': Women Hunters and the Identification of Evil in Supernatural" Ralph Beliveau and Laura Bolf-Beliveau explore the association of female hunters with evil in the context of Nel Noddings work, *Women and Evil*. "All that Glitters: The Winchester Boys and Fairy Tales" by Rebecca-Ann Do Rozario discusses the challenges involved when "the lore associated with an episode rests upon a performance of the feminine" as it does when the monsters come from fairy tales, stereotypically gendered female both in the *Supernatural* universe and in the larger culture context.

If monsters are feminine, we need to talk about the ways in which *Supernatural* fails and sometimes succeeds in deconstructing traditional masculinity, both embracing and critiquing it. In the final section of the anthology, "Men, Women, and *Supernatural*," Susan A. George's "A Man and His 1967 Impala: *Supernatural*, U.S. Car Culture, and the Masculinity of Dean Winchester" discusses how

Supernatural evokes 1970s and 1980s hard masculinity through the symbolism of the car while at the same time suggesting the potential for an alternate version of the masculine. Rhonda Nicol, in her chapter, "'How Is That Not Rape-y?': Dean as the Anti-Bella and Feminism without Women in *Supernatural*," locates masculinity within a critique of female fandom through an examination of the objectification of Dean and the ways in which he is feminized by the series' vampire narrative. She also examines *Supernatural*'s critique of the vogue of the romantic hero vampire. The next two chapters deal with the issue of absent fathers and the reconstruction of the family within the show. In "God, the Devil, and John Winchester: Failed Patriarchal Families in *Supernatural*," Charlotte E. Howell sees a critique of patriarchy, both familial and religious, in the portrayal of both an absent God and Sam and Dean's absent father, John (Jeffrey Dean Morgan). Lugene Rosen's " Who's Your Daddy?: Father Trumps Fate in *Supernatural*" looks at the development of Dean Winchester's character, particularly through the lens of psychological studies of fatherless boys. Finally, "Metal and Rust: Postindustrial White Masculinity and *Supernatural*'s Classic Rock Canon" by Gregory J. Robinson closes the book with an analyses of Dean's embrace of classic rock music as both an act of rebellion against postmodern values and an affirmation of a nostalgic notion of working class white masculinity.

Since *Supernatural* went on the air nine years ago, there has been an explosion of horror television shows, many based on myth, legend, and fairy tales. *Once Upon a Time* (2011–) locates its story at least partially within a fairy tale world, NBC's *Grimm* (2011–) follows a format that is closer to *Supernatural*'s early monster of the week episodes, while sustaining an overarching mythology and a dependence on family lore and traditions. *Sleepy Hollow* (2013–) continues *Supernatural*'s focus on religious subjects, demons, Purgatory, and the Apocalypse as it adds elements of the police procedural and family melodrama. These new series are in part a testament to the success *Supernatural* has had within the culture and to our interest in finding new ways to evoke ancient narratives as we deal with current anxieties and concerns circulating in U.S. culture. Horror speaks to twenty-first century Americans in interesting and diverse ways. This anthology works to understand the human condition and learn more about this particular moment in history through an examination of the themes and concerns apparent in the *Supernatural* universe.

Works Cited

Derrida, Jacques. "Interview with Jean-Louis Houdebine and Guy Scarpetta." *Positions*. Trans. Alan Bass. Chicago: U of Chicago P, 1981. Print. Paris: Les Editions de Minuit, 1972. Print.

"*Supernatural* Officially Renewed for 10th Season." *Winchester Bros 2005–2012*. MediaBlvd. 13 Feb. 2014. n. pag. Web. 13 Feb. 2014.

Ulaby, Neda. "The Few, The Fervent: Fans of 'Supernatural' Redefine TV Success." 15 Jan, 2014. *NPR* Transcript. wbur.org. n. pag. 2 Mar. 2014. Web.

I

Religion, Theology, and Philosophy through a *Supernatural* Lens

Deconstructing the Apocalypse? *Supernatural's* Postmodern Appropriation of Angelic Hierarchies

Regina M. Hansen

Biblical angels are understood variously by early and medieval writers, both Jewish and Christian. Many, though not all, believe angels to be real beings but, real or not, these theological commentators think the metaphysical contemplation of angels can help humans to grow in both self-understanding and in the perception of and closeness to God. The modern-day theologian Steven Chase explains that past interpreters of scripture "understood angelic beings to be fluid and subtle. The angelic essence, their names, their ministries and their functions were varied and complex" (8). Although Chase is referring to early Christian commentators like Pseudo-Dionysius and medieval scholastic writers such as Bonaventure of Bagnoregio, this complex perspective is also evident in Jewish biblical or theological commentary, including the Midrash and Talmud. To all these writers, the angels of the Bible represent a multiplicity of virtues. They also interact with humanity in many ways—as guardians, guides, healers, mediators, messengers, judges, proclaimers of truth, and warriors. In seasons four and five of the television series *Supernatural*, the representation of angels is much less diverse.

In *Supernatural*, the angelic hierarchy is represented as both a familial and military hierarchy, and (within that) a set of binary hierarchies: God/angel, angel/human, father/son. These are examples of what Jacques Derrida would call an "opposition" or "a violent hierarchy" in which "one of the two terms governs the other...or

has the upper hand" (41). According to Derrida, "the conflictual, subordinating structure of opposition" must be "overtur[ned]" and eventually dismantled or "deconstruct[ted]" in order to make way for "a new 'concept'" (42), a new way of being and acting in the world. In focusing on angels as warriors and brothers, seasons four and five's apocalyptic narrative provides one interpretation of what angels represent in religion. In the narrative, angels embody obedience, or willing subordination to authority (paternal and military), as well as the subordination of free will to the workings of a predetermined narrative, destiny as revealed to prophets and written down in a sacred text. The show's critique of the angelic hierarchies is an essentially postmodern overturning of the foundational narratives of Christianity—their ostensible insistence on patriarchal and scriptural authority, the supremacy of the human father and God the father—in favor of what creator and past showrunner Eric Kripke has called an "intensely humanistic" and presumably more self-determined and egalitarian worldview (Ryan). Describing his plan for season five, which he has publicly stated is the completion of his multiyear narrative plan for the show, Kripke says, "for me, the story is about, 'Can the strength of family overcome destiny and fate, and can family save the world?'…the only thing that matters is family and personal connection, and that's the only thing that gives life meaning. Religion and gods and beliefs—for me, it all comes down to your brother" (Ryan). *Supernatural*'s apocalyptic narrative succeeds in elevating human relationships over obedience—elevating the Winchesters over the angels. It is less effective in its critique of religion as the subordination of free will to scriptural authority, or more broadly the authority of narrative over free will.

In seasons four and five, the narrative concerns the War in Heaven, a Christian concept, briefly mentioned in the New Testament Book of Revelation and fleshed out by biblical commentators and scholars in the early Christian and medieval periods, as well as in John Milton's *Paradise Lost*. *Supernatural* sets up parallels between the Winchester brothers and the angelic "brotherhood," especially through the archangel Michael and the fallen angel Lucifer, Milton's name for Satan[1] used in some translations of Isaiah 14:12 : "How art thou fallen from heaven, O Lucifer, son of the morning! how art thou cut down to the ground, which didst weaken the nations!" (*KJV*).[2] In the Bible, the events of the Fall of Satan and the Apocalypse are not presented in a linear or necessarily literal fashion but reconstructed by early

commentators (and later by Milton) from a number of biblical passages. Ezekiel 28:12, Jude 1:6, 2 Peter 2:4, and Revelation 12:9[3] are also understood by Christian commentators as references to Satan's rebellion against God and the angels' subsequent ejection from Heaven at the hands of the Archangel Michael. Revelation 20 then envisions another battle, an apocalyptic one, in which Michael and the good angels fight Satan in order to bring about the Second Coming of Christ. *Supernatural*'s fourth and fifth seasons' narrative arc posits that the literal Apocalypse is now upon us. Sam (Jared Padalecki) and Dean (Jensen Ackles) have been groomed since birth to be the vessels of brothers Lucifer (Mark Pellegrino) and Michael (Matthew Cohen 5:13, Jake Abel 5:22) for the final battle.

As scholars such as Erin Giannini, Lisa Kienzle, and Jutta Willmer have noted,[4] the paralleling of the two sets of brothers is central to *Supernatural*'s apocalyptic narrative. The series continually asserts family ties among the "loyal" angels like Castiel (Misha Collins), Michael, and others but also between them and the fallen angel Lucifer. There is no subtle metaphor here. The angels, including Lucifer, refer to each other as "brother" (and very occasionally sister) and talk of God as "Dad" or "Daddy" and there are constant references to in-family conflict. In season five's "Changing Channels" (5.8), the angel Gabriel (Richard Speight Jr.) is portrayed as having fled Heaven to get away from the family fighting: "I love my father, my brothers, love them, but watching them turn on each other, tear at each others' throats. I couldn't bear it. OK? So I left. And now it's happening all over again." Gabriel's outburst references the original War in Heaven and suggests that unresolved family resentments have led to the Apocalypse. He also makes one of the many overt references to the parallels between the brothers Winchester and the fraternal relationship between Michael and Lucifer: "This isn't about a war. It's about two brothers that loved each other and betrayed each other. You'd think you'd be able to relate" ("Changing Channels"). Most characters describe the coming battle between Michael and Lucifer as the ultimate extension of sibling rivalry, both among the angels and between the angels and God's human children. Later, in "Hammer of the Gods" (5:19), Gabriel confronts Lucifer: "Dad brought the new baby home and you couldn't handle it. So all this is just a great big temper tantrum." Such criticism hints at the show's perspective with regard to the angels' investment in the family hierarchy.

Figure 2.1 The Winchesters capture Gabriel, who does not want to take sides between his brother angels.

Other angels, those who wish to raise and follow Lucifer in the apocalyptic war, are portrayed as suspicious of humans, who represent a disruption of the accepted hierarchy of authority. In the season four episode "On the Head of a Pin," Castiel insists on obedience to God, the father, but rebellious angel Uriel (Robert Wisdom) replies: "Our father? He stopped being that, if he ever was, the moment he created them. Humanity, his favorites" (4.16). Lucifer (in the form of Sam) gives his own account of God's perceived favoritism toward humans in "The End": "And then he asked all of us to bow down before you, to love you more than Him. I said, 'Father, I can't.' I said 'these human beings are flawed, murderous,' and for that God had Michael cast me into hell" (5:4). Many modern theologians share *Supernatural*'s focus on biblical angels as feuding family. The idea of Lucifer as the jealous older brother to humans is suggested in early commentary on the Bible. In the Hebrew Bible (or Old Testament) as well as in the Talmud and Midrash, Satan is portrayed as being part of the heavenly court, one among the *bene elohim*, a term which is sometimes translated as "sons of God." Although, a more accepted translation might be "sons of the powerful,"[5] the term "sons of God" has modern cultural resonance. Biblical historian Elaine Pagels uses this translation in her book *The Origin of Satan*. She writes, "Christian and Jewish accounts of angels and fallen angels...were less concerned with the natural world as a whole than with the particular world of human

relationships" (xvi). Theologian Susan Garrett reminds us that many stories in the Bible involve the firstborn who resents losing his rightful place to a younger child. In Genesis 4, for instance, Cain kills Abel because God prefers the younger brother's sacrifice while, in Genesis 37: 22–23, Joseph is thrown into a cistern by his jealous older brothers. In this way, according to Garrett and Pagels, Lucifer is just one of many older sons rebelling against "the inversion of the natural order of things" in which "the firstborn (or first created, as the case may be) by rights would inherit the greater share of the parents' blessings" (Garrett 87). This idea is made explicit in a non-biblical or pseudoepigraphical Jewish text called "The Life of Adam of Eve," quoted by both Garrett and Pagels. The text would have been known to Jews and early Christians. In it Satan says to God, "Why do you press me? I will not worship one who is younger than me. I am older than he is; he ought to worship me" (qtd. in Pagels 49). With this in mind, Pagels suggests, "the problem of evil begins in sibling rivalry" (49). Pagels's and Garrett's points of view aptly apply to the narrative themes of *Supernatural*'s seasons four and five, and to Kripke's aforementioned vision for the show—one that focuses on the centrality of family.

The scriptural and pseudoepigraphical references to Satan's rebellion also prefigure the ways in which *Supernatural* critiques filial obedience and the god/angel and father/son hierarchies. Rebel angel Lucifer is acting to preserve what he sees as his proper place in the eternal order while the loyal angels insist on compliance to what they believe to be God's will. In each case, the angels explicitly uphold Derridean binaries: son as subordinate to father, older son to younger son, angel to God, and human to angel. Furthermore the angels in *Supernatural* are not only portrayed as brothers but as fellow soldiers, "brothers in arms," in a military hierarchy with God as both father and commander. In "Are You there God? It's Me Dean Winchester" (4.2), the angel Castiel not only has to get Dean used to the idea that angels are real but immediately disabuses him of any notion that angels are nice:

> DEAN: I thought angels were supposed to be guardians. White fluffy wings. You know Michael Landon. Not dicks.
> CASTIEL: Read the Bible. Angels are warriors of God. I'm a soldier.

The idea of angels as both sons (sometimes daughters) and soldiers foregrounds *Supernatural*'s critique of blind obedience to authority, as well as the concept of a heavenly hierarchy of power. As Castiel

tells Dean, if the order "comes from Heaven, that makes it just" ("It's the Great Pumpkin, Sam Winchester" 4.7). Still, on several occasions Sam and Dean openly question not only the loyal angels' obedience to God, but also their insistence on the Winchesters' obedience.

In "It's the Great Pumpkin, Sam Winchester," the angel Uriel arrives with Castiel to destroy a small town where a witch has completed a series of blood sacrifices. Her plan is to raise a demon called Samhain, an act that, in the *Supernatural* universe, will bring the Apocalypse one step closer. Uriel is a "specialist" who has "purified" other cities, perhaps making allusion to the destruction of Sodom and Gomorrah in Genesis 19. When Dean objects, Castiel's response connects both filial and military obedience: "When your father gave you an order, didn't you obey?" Dean will later agree to become Michael's vessel, answering Castiel's admonition "to follow God's will and his word as swiftly and obediently as you did your own father's" ("The End" 4.18). This makes sense for the show's narrative aims: As warriors and brothers, angels serve as supernatural foils for the evolving fraternal relationship between the hunter warriors Sam and Dean and in reference to their absent father, John. At the same time, just as the absence of John Winchester (Jeffrey Dean Morgan) adversely affects Sam and Dean, the absence of God the father unsettles the angelic hierarchy. God's nonappearance calls his authority into question even as the angels continue to subject themselves to what they imagine to be His will. After all, the angels claim to be taking orders from an absent power; the top of the God/angel hierarchy is an absence. By removing God from the God/angel binary, *Supernatural* interrogates traditional structures of authority and the very need for obedience and subordination.

The loyal angels' contradictory and irrational obedience to an absent God is explained by the fallen angel Anna Milton (Julie McNiven). Anna is under a "death sentence" for ripping out her grace and becoming human. When Dean asks how she knows there is a God, Anna's answer offers an explicit critique of religious faith as the show portrays it, as a form of oppression or subjugation that people are (or feel) forced to engage in: "We have to take it on faith which we're killed if we don't have"("Heaven and Hell" 4.10). Anna laments her years spent "watching, silent, invisible, out on the road, sick for home, waiting for orders from an unknoweable father I can't begin to understand." Dean's insistence that he "can relate" suggests that the Winchesters' family relationships not only mirror the show's apocalyptic narrative but also its postmodern critique of the heavenly hierarchy

and subservience to God. Even the name Anna Milton, a reference to the poet whose sympathy with the character of Lucifer has long been noted,[6] implies a questioning of authority. Anna is portrayed as heroic both because she prefers human emotion and because she does not trust that her fellow angels know God's will. She says to Castiel: "The father you love. Do you think he wants this? Do you think he'd ask this of you?…These orders are wrong and you know it" ("On the Head of a Pin"). Though not always an ally of the Winchesters, Anna is willing to ignore both the structure of Heaven and hierarchy for its own sake—insisting on individual moral agency over obedience. The narrative's implied approval of Anna as well as the actions of the Winchesters and Castiel—who end up calling themselves Team Free Will[7]—begins the process of deconstructing religious faith as a form of authority. Still, as suggested earlier in this chapter, this process is incomplete because it is based on a narrow understanding of the theology regarding angels. *Supernatural*'s critique leaves out other biblical portrayals. While Castiel insists that Dean "read the Bible" to learn the truth about warrior angels, biblically they are most often depicted as messengers (in fact, the Greek *aggelos* and the Hebrew *malakh* both mean messenger). Furthermore, although Castiel specifically rebuts the idea, angels are also portrayed in the Bible as guardians. Daniel 12:1 refers to Michael as he who "standeth for" (*KJV*) or is "guardian" (NABRE) of the people of Israel while Psalm 91:11 reads, "For he shall give his angels charge over thee, to keep thee in all thy ways"[8] (*KJV*). The idea of angels as guardians also appears in the Talmud: "Though they themselves saw nothing, their guardian angel did see it" (Babylonian Talmud, Sanhedrin 94a). To the early and medieval Jewish and Christian commentators, angels could be understood as many things at once, and as both real and metaphorical beings. As Steven Chase writes, "angels are thus symbols of contemplation conformed to our understanding and at the same time are themselves beings who contemplate the hidden divine nature" (45). Bonaventure of Bagnoregio believed in the "sublime vision of the Seraph" (*Life of St. Francis* 313), the angel that was said to have appeared to Francis of Assisi, but also saw that vision as an intellectual and contemplative tool (*The Souls Journey into God* 54–55). For Bonaventure and other writers such as Gregory the Great and Bernard of Clairvaux, the contemplation of the ways of angels was seen as a means to examine one's life, one's conscience. Dwelling on the virtues represented by each individual angel or angelic choir[9] was supposed to bring people to an understanding of God's will. Gregory writes, "But what does it profit

us to touch upon these angelic spirits, if we are not zealous to derive some profit by our contemplation of them?" (101). At the same time, the twelfth-century Jewish philosopher Moses Maimonides described biblical references to angels as referring to "a prophetic vision or a dream" (146) and intellectualized biblical stories about them as ways to understand God.

Supernatural's omission of this theological and scriptural variety in its depictions of angels might be just another way to overturn the authority of foundational texts in favor of the show's own narrative vision. After all, the concept of hierarchy, embraced by many early writings, has negative connotations even beyond the Derridean standpoint. Chase notes as much: "hierarchy as a social or political structure has been used to subjugate, control, and oppress" (20). Still *Supernatural*'s portrayal of the hierarchic structure of Heaven misunderstands the complexities of the theological sources, which go beyond a direct mirroring of sociopolitical structures. Depictions of angelic hierarchies from the early Christian era through the medieval period vary considerably but do not include *Supernatural*'s military hierarchy of the angels with its system of "garrisons;" or the structure of the show's family unit; nor do they look like the hierarchal configuration of many churches, created in part to legitimize earthly power by making it appear ordained by Heaven.

Rather than the structure the series imagines, from the point of view of early and medieval Christian writers, the angelic hierarchy looks more as described by Pseudo-Dionysius, who first named and classified angels into choirs: "a sacred order, a state of understanding and an activity approximating as closely as possible the divine," the goal of which is "to enable beings to be as like as possible to God and to be at one with him" (153). Chase invites us to see the "celestial hierarchy" as a "circle containing within it concentric circles at the very center of which is God" (21), noting that this imagery was common in "visual depictions of the angelic hierarchy in the medieval period" (21). Even when the hierarchy is perceived as a top-down structure as in the ladder of "ascending and descending" angels in the biblical vision of Jacob (*KJV*, Genesis 28:12), theologian David Albert Jones reminds us that the ladder "is not a fixed hierarchy but in constant movement" (81). The image conforms to this statement of Bernard of Clairvaux: "But when [the angels] descend, they bring compassion to us, that they may guide us in all our ways. These spirits are ministers sent to attend to us. Clearly they are our servants, not our masters" (113). This last idea, as well as the variety of visions of the heavenly

hierarchy, undermines *Supernatural*'s use of the angelic hierarchy as an example of the subordination of the human will.

As can be seen above, these biblical commentators conceptualized angels and their interrelationships in a way that was not fundamentalist, nor strictly scripture based, creating their own mystical systems from the stories and references to angels in the Bible. *Supernatural* attempts to overturn structures of authority through its representation of the oppressive familial and military angelic hierarchy, but those attempts are at least somewhat undermined by a misunderstanding of angelic theology—even if that misunderstanding is on purpose. This is especially evident when *Supernatural* critiques the authority invested in scripture as the revealed word of God. The series presents the angels as sort of Calvinist fundamentalists insisting both on predestination and on strict obedience, not only (as we have seen) to God as father and military commander but also to God's word as written.

The angels are portrayed as constantly insisting on the inevitability of the Apocalypse and the Winchesters' part in it. The angel Zachariah (Kurt Fuller) uses any violent means necessary, including torturing Sam and Dean ("Point of No Return" 5.18) to bring about the prophecy, declaring to Dean: "There must be a battle. Michael must defeat the serpent. It is written" ("Sympathy for the Devil" 5.1). As discussed earlier, the angel Gabriel also tries to force Sam and Dean to "play their roles" in the Apocalypse story ("Changing Channels" 5.8) and, like Castiel in these seasons, is portrayed as a hero/martyr when he abandons that course of action to side with human beings ("Hammer of the Gods"). At the same time, the rebel Anna goes so far as to attempt to murder Sam in order to avert the predestined Apocalypse, only to be killed by Michael ("The Song Remains the Same" 5.13).

Still, for a show seeking to undermine hierarchy and privilege free will over obedience and subordination to narrative determinism, *Supernatural* also makes selective use of fundamentalist narratives. For instance, in "The Song Remains the Same" Sam and Dean are supposedly destined to be the vessels of Michael and Lucifer because the Winchesters are from a "blood line stretching back to Cain and Abel." So, *Supernatural* gives us a world in which not only are angels real and behaving like at least some of their biblical counterparts but in which Cain and Abel are supposed to have been real too, as opposed to metaphorical representations of sibling rivalry. At the same time, what "is written," the written word that is being privileged—what

the angels are being fundamentalist about—is not always the Bible as we know it. While *Supernatural* claims to be giving us "real" Biblical angels (again, Castiel says, "Read the Bible"), it also maintains that it possesses written truth unavailable to your average Bible reader. In "Are You There God? It's Me Dean Winchester?" (4.2), the Winchester brothers' surrogate father Bobby Singer (Jim Beaver) tells the boys that the "widely distributed version" of the Book of Revelation "is strictly for tourists." In the tourist version of Revelation 6:1, Christ—called "the lamb" (*KJV*)—breaks the first seal to bring on the Apocalypse. On the other hand, in *Supernatural*'s nontourist version, Dean breaks the first seal. In "On the Head of a Pin," the demon Alastair (Christopher Heyerdahl) reveals that this happened when Dean was corrupted in Hell and started torturing others so his own torture would end. In the "The Monster at the End of This Book" (4:18), we also find out that the experiences of the Winchester brothers leading up to the Apocalypse are all written down in what Castiel says will be called "The Winchester Gospels," a series of novels written by Chuck Shurley (Rob Benedict). Chuck is thought to be divinely inspired at the very least and his novels are seen as prophecy. Commenting on one of the many times Dean tries to stop Chuck's predictions from coming true, Castiel says, "What the prophet has written can't be unwritten. As he has seen it so it shall come to pass." Through Chuck, *Supernatural* ends up substituting biblical and theological narrative authority with its own.

Although Castiel has insisted that Chuck is just a "mouthpiece" or "conduit" ("The Monster at the End of This Book"), there is some evidence that he is supposed to be God, as the actor Rob Benedict, who plays Chuck, suggested in a 2011 panel (thiniassk). Whether Chuck is God or God's prophet, his position within the *Supernatural* universe reestablishes a binary in which narrative is privileged over human will, even as the notion of free will is maintained. As season five comes to a close, Dean does not become Michael's vessel and, thanks to Sam's sacrifice, the supposedly fated apocalyptic battle between Michael and Lucifer is averted, all as written in a book by Chuck. So, while the angels are represented as wrong and their position in the hierarchy overturned, they are only wrong about which destiny was written, not that a written destiny exists. God may not have been giving the orders, either as Chuck or through Chuck, but God is ordering the world. The fates of both the Winchester brothers and the angels are still determined by someone else.

In seasons four and five, *Supernatural* is partly successful in deconstructing the heavenly hierarchy and the binary oppositions within it. In the show's depiction of Sam's choice of Dean over destiny, the rigid familial and military hierarchy of authority represented by the angels is replaced by a more egalitarian model, reflected in the humanist message that "it all comes down to your brother" (Ryan). In this way, the show goes beyond what Derrida calls "merely a suppression of all hierarchy…a simple change or reversal in the terms of any given hierarchy" to "a transformation of the hierarchical structure itself" (qtd. in Newman 118). On the other hand, the show's postmodernist critique of Judeo-Christian foundational narratives is less successful, since the very process by which these narratives are undermined sets up a new hierarchy. In it, human will is experienced as free will— Sam's choice of his brother—but remains subordinated to, if not eclipsed by, the force of narrative itself.

The brothers still have to play out a story, even if it is not the one the angels believed in. *Supernatural*'s interpretation of the angels of scripture itself selectively privileges narrative over free will, leading in some cases to a fundamentalist or literal representation of biblical themes and characters, and overlooking theological complexities. In the universe of *Supernatural*, angels, like vampires, wendigos, and fairies, are real; in fact, the show insists it knows what angels "really" are. Still, they are understood only in ways that will serve the show's particular narrative vision. The series' postmodern critique of religion through the representation of angelic hierarchy rests on a misunderstanding of the theology of angels that ends up replacing one form of authority with another, that of the narrative. In its fourth and fifth seasons, *Supernatural* begins the process of deconstruction, but does not complete it.

Notes

1. This chapter will use the name Satan when discussing the Bible and Lucifer in in reference to the character from *Supernatural*.
2. This chapter draws from two English translations of the Bible, the King James Version (KJV) and The New American Bible revised version (NABRE). When direct quotes are used, the version will be noted in text.
3. The Biblical Book of Revelation is also called The Apocalypse, particularly in Catholic versions of the Bible, but the more common term, Revelation, is used here.
4. See Giannini, and Willmer and Kienzle.

5. For rabbinical arguments against using the term "sons of god," see Bitton, 109.
6. The poet William Blake said that Milton "was a true poet and of the Devil's party without knowing it" (qtd. in Damon 275). This line is quoted throughout literary history, perhaps most recently by the novelist Philip Pullman: "Blake said Milton was a true poet and of the Devil's party without knowing it. I am of the Devil's party and know it" (de Bertadano).
7. The show somewhat minimizes the importance of free will, at least in Christian thought. See Thomas Aquinas. *Summa Theologica* 83:1.
8. Alternative translation: "For he commands his angels with regard to you, to guard you wherever you go" (NABRE).
9. Different commentators have different ways of classifying the angelic choirs and the virtues they represented. For instance, Gregory saw the Seraphim as representing "love" (100) while his precursor Pseudo-Dionysius saw them as showing, in Chase's words, "perennial circling around the divinity" (26).

Works Cited

Aquinas, Thomas (1225–1274). *Summa* Theologica, c. 1265–1274. Trans. Fathers of the English Dominican Province,1947. Coyote Canyon Press, 2010. Kindle file. Reprint.

"Are you there God? It's Me, Dean Winchester." *Supernatural*. Writ. Eric Kripke and Sera Gamble. Dir. Philip Sgriccia. CW, 25 Sept. 2008. *Netflix*. 2 Mar. 2014.

Babylonian Talmud: Sanhedrin. Trans. Jacob Schachter and H. Freedman. Ed. Rabbi Dr. I Epstein. *www.halakah.com*. English Babylonian Talmud. Web. 2 Mar. 2014.

Bernard of Clairvaux (1090–1153). *Sermons on Psalm 90, "He Who Dwells [in the Shelter of the Most High]."* Trans. Jean Leclercq and Henri-Marie Rochais. *Angelic Spirituality: Medieval Perspectives on the Ways of Angels*. Ed. Steven Chase. New York: Paulist Press, 2002.

Bitton, Yosef. *Awesome Creation: A Study of the First Three Verses of the Torah*. New York: Gefen, 2013. Print.

Bonaventure of Bagnoregio (1217–1274). *The Life of St Francis. Bonaventure: The Life of St Francis. The Tree of Knowledge. The Soul's Journey into God*. Trans. Ewert Cousins. New York: Paulist Press, 1978. Print. 177–328.

———. *The Soul's Journey into God. Bonaventure: The Life of St Francis. The Tree of Knowledge. The Soul's Journey into God*. Trans. Ewert Cousins. New York: Paulist Press, 1978. Print. 51–176.

"Changing Channels." *Supernatural*. Writ. Eric Kripke and Jeremy Carver. Dir. Robert Beeson. CW. 5 Nov. 2009. Netflix. 2 Mar. 2014.

Chase, Steven. "General Introduction." *Angelic Spirituality: Medieval Perspectives on the Ways of Angels*. Ed. Steven Chase. New York: Paulist Press, 2002. Print. 1–75.

Damon, S. Foster. *A Blake Dictionary: The Ideas and Symbols of William Blake*. Lebanon, NH: Dartmouth College Press, 2013. Print. Providence: Trustees of Brown University, 1965. Reprint.

De Bertodano, Helena. "I Am of the Devil's Party." *The Telegraph*. 29 Jan. 2002. Web. 1 Mar. 2014.

Derrida, Jacques. "Positions: Interview with Jean-Louis Houdebine and Guy Scarpetta." *Positions*. Trans. Alan Bass. Chicago: U of Chicago P, 1981. Print. Paris: Les Editions de Minuit, 1972.

"The End." *Supernatural*. Writ. Eric Kripke and Ben Edlund. Dir. Steve Boyum. CW. 1 Oct. 2009. *Netflix*. 2 Mar. 2014.

Garrett, Susan. *No Ordinary Angel: Celestial Spirits and Christian Claims about Jesus*. New Haven: Yale UP, 2008. Print.

Giannini, Erin. "'There's Nothing More Dangerous than Some A-Hole Who Thinks He's on a Holy Mission': Using and (Dis)-Abusing Religious and Economic Authority on *Supernatural*." *TV Goes to Hell: An Unofficial Road Map of Supernatural*. Eds. Stacey Abbott and David Lavery. Toronto: ECW Press 2011, 163–75. Kindle file.

Gregory the Great (b. 540) *Forty Homilies on the Gospels*. Tr. Steven Chase. *Angelic Spirituality: Medieval Perspectives on the Ways of Angels*. Ed. Steven Chase. New York: Paulist Press, 2002. Print.

"Hammer of the Gods." *Supernatural*. Writ. Eric Kripke and Andrew Dabb. Dir. Rick Bota. CW. 22 Apr. 2010. *Netflix*. 2 Mar. 2014.

"Heaven and Hell." *Supernatural*. Writ. Eric Kripke and Trevor Sands. Dir. J. Miller Tobin. CW. 20 Nov. 2008. *Netflix*. 2 Mar. 2014.

The Holy Bible. King James Version. (KJV). American Bible Society, 1980. Print.

"It's the Great Pumpkin, Sam Winchester." *Supernatural*. Writ. Eric Kripke and Julie Siege. Dir. Charles Beeson. CW. 30 Oct. 2008. *Netflix*. 2 Mar. 2014.

Jones, David Albert. *Angels: A Very Short Introduction*. New York: Oxford UP, 2011. Print.

Maimonides, Moses (1135–1204). *Guide for the Perplexed* (Abridged). Trans. Chaim Rabin. Ed. Julius Guttman. Indianapolis: Hackett, 1995. Print. East West Library. 1952. Reprint.

The New American Bible, Revised Edition (NABRE). United States Conference of Catholic Bishops, 2011. Print.

Newman, Saul. *From Bakunin to Lacan: Anti-authoritarianism and the Dislocation of Power*. Oxford: Lexington Books, 2001. Print.

"On the Head of a Pin." *Supernatural*. Writ. Eric Kripke and Ben Edlund. Dir. Mike Rohl. CW. 19 Mar. 2009. *Netflix*. 2 Mar. 2014.

Pagels, Elaine. *The Origin of Satan*. New York: Vintage Books, 1996. Print. New York: Random House, 1995. Reprint.

"Point of No Return." *Supernatural*. CW. Writ. Eric Kripke and Jeremy Carver. Dir. Philip Sgriccia. 15 Apr. 2010. *Netflix*. 2 Mar. 2014.

Pseudo-Dionysius, the Areopagite (c. 485–528). *The Celestial Hierarchy. Pseudo-Dyonisius, The Complete Works*. Trans. Luibheid Colm. Eds. Luibheid Colm and Paul Rorem. New York: Paulist Press, 1987. Print.

Ryan, Maureen. "'It's the Fun Apocalypse': Creator Eric Kripke talks 'Supernatural.'" Interview transcript. Blog post. *Chicago Tribune*. 26 Aug. 2009. Web. 1 Mar. 2014.

"The Song Remains the Same." *Supernatural*. Writ. Eric Kripke and Sera Gamble. Dir. Steve Boyum. CW. 4 Feb. 2010. *Netflix*. 2 Mar. 2014.

"Sympathy for the Devil." *Supernatural*. Writ. Eric Kripke. Dir. Robert Singer. CW. 10 Sept. 2009. *Netflix*. 2 Mar. 2014.

thinniask. "JIB 2011 ROB panel chuck is god.AVI." Online Video Clip. *YouTube*. 11 Apr. 2011. Web. 2 Mar. 2014.

Willmer, Jutta and Lisa Kienzle. " 'I Am an Angel of the Lord': An Inquiry into the Christian Nature of *Supernatural*'s Heavenly Delegates." *TV Goes to Hell: An Unofficial Road Map of Supernatural*. Eds. Stacey Abbott and David Lavery. Toronto: ECW Press 2011, 176–86. Kindle File.

3

The Greatest of These: The Theological Virtues and the Problem of an Absent God in *Supernatural*

Elisabeth G. Wolfe

When most people hear the word "allegory," they think of a text like *The Pilgrim's Progress*, with characters named according to the virtues or vices they represent, or *The Romance of the Rose*, which is clearly about something other than what the surface of the text suggests. Even texts that are not deliberate allegories can be read allegorically however, and this is true of *Supernatural*. The show is not an intentional allegory, but each of the three main characters seems strongest in one of the theological virtues—faith, hope, and love—which allows for a moral reading of the story. If Sam's (Jared Padalecki) chief virtue (with soul intact) is faith and Dean's (Jensen Ackles) is love, the chief virtue of their surrogate father Bobby Singer (Jim Beaver) is hope. Examining these virtues in classical Christian thought can explain a great deal about these characters, their relationships to one another through the first eight seasons, and the problems they face in a world where God is willfully absent.

The Allegory of the Poets

The preeminent case in point for this type of reading is found in ancient and medieval methods of reading and interpreting the Bible, a process called exegesis. Until the late Middle Ages, Jewish and Christian scholars' standard practice was to consider the text first

in the *literal* or *historical* sense—the words on the page, including literary devices—and then according to the *spiritual* sense, which presented meanings with applications beyond mere history. The most common spiritual senses examined by Christian exegetes were allegorical, regarding Christ and the Church; moral, regarding the way one should live; and anagogical, regarding last things, or death and the afterlife. Another scheme, influenced by Jewish scholars like Philo, considered the moral sense before a more general allegorical sense. None of these spiritual senses alter or ignore the literal meaning of the text; rather, they acknowledge and organize multiple layers of meaning that go beyond the surface (de Lubac 82–115).

Dante Alighieri argues in his *Convivio* that this form of reading, which he calls "the allegory of the theologians," need not be restricted to scripture. An analogous process, "the allegory of the poets," can also be applied to imaginative literature. There are obvious differences between the two methods; the literal level in the allegory of the poets is a fictional story, and the allegorical level need not be restricted to Christian themes (Dante 2.1). Not every text that can be read this way was written with a higher spiritual purpose in mind, nor does every text support a full fourfold reading. Yet texts that can sustain this kind of reading present valuable lessons to their audience and are worth reading for those lessons, even if their literal level seems less compatible with Christian teaching. One advantage of this model is its capacity for preserving multiple senses of the same text without confusion and without denying the legitimacy of any one reading.

A complication for a moral reading of *Supernatural* is that Christian thought holds the proper object of faith, hope, and love to be God. Thomas Aquinas states that these virtues are called theological "because their object is God ... [and] these virtues are not made known to us, save by Divine revelation, contained in Holy Writ" (*Summa* I-II.62.1). Similarly, in *City of God*, Augustine of Hippo states that "if there is no reference to God in the matter," traits that seem to be virtues are actually vices because they are tainted with pride (19.25). He defines true virtue as "the order of love" (15.22, 19.14), and he explains in *On Christian Doctrine* that rightly ordered love should first be directed toward God and then toward others and the self in due degree (1.27.28). This view exposes a major disconnect between the Christian view of our world and the world of *Supernatural*: in that universe, God is conspicuously, willfully absent. As a result, the show portrays the theological virtues at their strongest when oriented

toward others within the family unit, whether blood or chosen. As Chuck Shurley (Rob Benedict), pulp writer and prophet, notes in "Swan Song" (5.22), the Apocalypse "was a test—for Sam and Dean. And I think they did all right...They chose family." This context is fitting, Aquinas would argue, not only insofar as charity toward humans should be directed toward family first (*Summa* II-II.26.8), but also because scripture states that "if any provide not for his own [family]...he hath denied the faith, and is worse than an infidel" (1 Tim. 5:8 *King James Version* [*KJV*]).[1]

Since John Winchester's (Jeffrey Dean Morgan) death at the beginning of season two, Sam, Dean, and Bobby have not only formed the familial core of the show, but have also grown to represent each of the three theological virtues in unique and sometimes startling ways. Each character's main vices are also the vices opposed to his chief virtue. Those virtues are not limited in exercise to the family; Dean's *agape* love, for example, can be seen even in his act of mercy at the end of "Changing Channels" (5.8), when he frees rogue archangel Gabriel from a holy fire trap despite his anger over Gabriel's tricks (Aquinas, *Summa* II-II.30). Within the family, though, the virtues are exceptionally effective and make the characters who exemplify them uniquely powerful—yet because of God's absence, this situation may be more problematic than it might seem at first.

Figure 3.1 Saving people, hunting vices—the virtues' business.

Dean: Love

Inveterate ladies' man Dean might represent physical love (*eros*) to many fans or even *cupiditas* (cupidity or covetousness), which is a vice (Jeffrey 55–74). But in truth, much of Dean's life is defined by both *philia* or familial love, and *agape* or unconditional love (Latin *caritas*, or "charity"), the latter being the only form of love considered a virtue. Where family is concerned, Dean's *agape* will endure just about anything. Even his pain over John's faults falls by the wayside when John's father, Henry, scorns the Winchesters' upbringing in "As Time Goes By" (8.12). By then, Dean is able to acknowledge that John was not perfect while still defending him to Henry. Given his short temper, Dean may not seem patient in the modern sense, but his behavior in familial relationships might be described as *longsuffering*, the term the *King James* version of the Bible uses to translate the Greek verb *makrothymei* in 1 Corinthians 13:4.

Dean embodies the 1 Corinthians 13 definition of *agape* beyond familial contexts. He hates true evil, and Hell haunts him less because of what he went through than because of what he did there. Indeed, in "Slash Fiction" (7.6), his Leviathan double speaks disdainfully of Dean's desire for righteousness, mocking his relationships as "applications for sainthood" and complaining to Sam that being "so caught up in being *good*" weakens the brothers. On a more symbolic level, fourteenth-century mystic Walter Hilton notes that "Love slays sins generally, reforming the soul in a new experience of virtue" (145), a point illustrated by Dean's hunting evil in the form of monsters and demons.

Still, Dean's *agape* is clearest toward Sam and persists even when his *philia* for Sam is at its lowest points; as C. S. Lewis writes in *Mere Christianity*, showing *agape* toward another person has nothing to do with liking that person and everything to do with desiring good for him or her (115). Dean's anger over Sam's demon blood addiction in "When the Levee Breaks" (4.21) does not stop him from trying to save Sam. In "Lucifer Rising" (4.22), also in season four, Zachariah must twist the loving voicemail Dean leaves to goad Sam into killing Lilith. Though Heaven and Hell do their combined worst, Dean's love for Sam ultimately will not fail.

One reason Dean's love is so strong is that *agape* is an act of will that "transcends the rule of human reason" (Aquinas, *Summa* II-II.24.1). Dean's will is arguably the strongest of the three main characters, and his wisdom shows him truths about Sam that are

not immediately apparent to others, prompting his active refusal to give up on Sam even in situations such as those in "When the Levee Breaks." For others, too, Dean's love combines will and wisdom in deed and word, such as in his empathetic advice to a djinn-poisoned Charlie Bradbury to let her comatose mother die so that she can live herself ("Pac-Man Fever" 8.20). Though Dean will sometimes give in to what other characters want, Sam and Bobby more often bend to Dean's will. Indeed, Dean comes to fear that expecting others to follow his will makes him selfish and brings hardship to those he loves. In "Defending Your Life" (7.4), Sam cannot convince Dean that he should not feel guilty about others following him.

Aquinas defines and discusses three main external acts of *caritas* in the *Summa Theologica*. Beneficence, which he states "simply means doing good to someone" (II-II.31.1), is clear both in Dean's drive to take care of his family and in his emphasis on "saving people" before "hunting things." The second act is almsdeeds, which range from feeding the hungry to giving counsel and instruction (II-II. 32.2); Dean's mother-hen tendencies take specific form in just this way. The final act of charity, however, may be the most obvious for Dean: fraternal correction, "which applies a remedy to the sin considered as an evil of the sinner himself" (II-II. 33.1). As plainly as this act appears in Dean's relationship with Sam, it applies equally to anyone who receives Dean's *philia*, including the angel Castiel (Misha Collins) and even (surprisingly) Gabriel (Richard Speight Jr).[2] To be sure, Dean is not always right, nor does he always go about correcting others in the best way. His initial refusal to let a repentant Sam back into his life after the disasters of season four carries the potential to create the even more disastrous timeline, as he discovers in "The End" (4.18), with the Croatoan virus rampant and Lucifer, possessing Sam, on the brink of final victory. But Dean's reproofs are right more often than not, and in every case, Dean argues or pulls rank because he loves the wrongheaded individual.

The act of fraternal correction relies on wisdom, the spiritual gift associated with charity. Aquinas states that wisdom in this sense "enables us to judge aright of Divine things, or of other things according to Divine rules" (*Summa* II-II.45.4). Regarding the Apocalypse, for example, Dean corrects both Castiel and Gabriel by arguing that *they know* this plan is wrong but lack the courage to act rightly; both angels eventually accept that correction and do the right thing, even though it costs them their lives (5.19). These exchanges indicate that Dean possesses the kind of wisdom Aquinas connects with love. So

does Dean's acting as peacemaker, especially between John and Sam; Aquinas links peacemaking to wisdom because it involves the restoration of order (*Summa* II-II 45.5). The angels consider Dean the Righteous Man fated to start and end the Apocalypse, but many viewers find that idea counterintuitive. Insofar as Dean's wisdom enables him to live instinctively by what the medieval mystics called "the law of love," however, the label is actually correct.

Sam: Faith

As mentioned above, Aquinas argues that charity is an act of will governed by wisdom. Faith, on the other hand, is an act of intellect governed by reason and based on belief, defined as giving firm assent to truths that lack the certainty of scientific knowledge (*Summa* II-II.2.1, 4.2, 23.6). Fittingly, therefore, the Winchester most noted for his intellect, Stanford-educated Sam, is also the character most associated with faith. Dean, at most an agnostic in early seasons, is always surprised when Sam confesses to praying regularly and believing in angels; yet in his farewell letter in "Point of No Return" (5.18), Dean asks Sam to pray for him as he goes to meet Michael.

While Dean's standard mode seems to be action, Sam's are study, contemplation, and belief, and he frequently exercises the gifts of knowledge and understanding that complement Dean's wisdom (Aquinas, *Summa* II-II.8–9). Sam characterizes the Winchesters and Campbells as "the brains and the brawn" in "As Time Goes By" (8.12), and since Sam is more like John and Dean more like Mary, one could divide the brothers the same way. That dichotomy does a disservice to both Dean's intelligence and Sam's physical strength. The relation between faith and love provides a much better picture of the brothers' ability to work as a team. "Faith...worketh by love" (Gal. 5:6), considering that "the act of faith requires an act of the will, *and* an act of the intellect" (Aquinas, *Summa* II-II.4.5, emphasis added), so both Sam's brain and his brawn function best when his faith is cooperating with Dean's love. However, "faith without works is dead" (Jas. 2:26). The vocation of hunting can have allegorical connections to the work of the virtues, which Augustine argues is "to wage perpetual war with vices" (*City of God* 19.4), but whenever Sam is on his own, he typically displays a form of spiritual deadness in that he stops hunting. This connection is clearest in season eight, when Sam cannot justify his abandonment not only of Dean, Castiel,

and the hunting life but also of teenaged prophet Kevin Tran (Osric Chau) and demonic enemy-turned-ally Meg (Nicki Aycox and Rachel Miner), both of whom the demon Crowley (Mark Sheppard) had captured at the end of season seven.

Sam's faith in God allows him to grant the benefit of the doubt to monsters like "vegetarian" vampire Lenore and potential Antichrist Jesse Turner despite their nature and others' insistence that they cannot be trusted. Often—though not always—that faith proves to be justified. Perhaps the most crucial act of faith on Sam's part, however, is his decision to bring an openly suicidal Dean along when he and Castiel attempt to rescue Adam (Jake Abel) in "Point of No Return" (5.18). When Dean asks him why, he replies simply, "Because you're still my big brother." This statement rests on *philia* and *agape*, but though Dean loves Sam, he would not take the same risk in Sam's position. Sam's choice is framed explicitly as a leap of faith, and Dean confesses to Sam afterward that his last-second change of heart came about because "I just didn't want to let you down...if you're grown-up enough to find faith in me, the least I can do is return the favor." This response proves crucial in the events leading to "Swan Song."

A further aspect of faith Sam illustrates is its ability to redeem. In Ephesians 2:8 Paul states, "For by grace are ye saved through faith;" and 1 John 5:4 characterizes faith as "the victory that overcometh the world." Inasmuch as Sam represents faith, his choice to redeem himself and save the world by dragging Lucifer back into the Cage in "Swan Song" is fitting. Yet Sam is not able to succeed in overcoming Lucifer on his own in Detroit any more than faith can overcome sin without grace. Dean's refusal to give up on Sam in Stull Cemetery positions both brothers so that the sudden grace of sunlight glinting off the Impala's trim can spark Sam's memories of Dean's love, empowering him to defeat Lucifer and so illustrate the saving power of faith ("Swan Song"; Aquinas, *Summa* II-II.7.2).

Significantly, however, this monumental feat occurs only after five years of Sam struggling with demon blood, self-righteousness, and intellectual pride. Lewis notes that "No man knows how bad he is until he has tried very hard to be good" (126), and that form of knowledge is imperative for Sam's success. Moreover, both types of struggle relate to infidelity, a vice for which the Woman in White attacks Sam in the series pilot. When he insists that he has never been unfaithful, the spirit replies only, "You will be." Sam's fidelity to Jess is overshadowed by a type of infidelity defined generally as unbelief and specifically as apostasy, walking away from true faith (Aquinas,

Summa II-II.10, 12). In season four, Sam puts his faith in the demon Ruby (Genevieve Cortese) and in his own powers, fueled by his drinking of her blood in a perverse parody of the Eucharist. The show's narrative also frames Sam's flights from family as a type of apostasy. As Lucifer tells him in "Swan Song," "All those times you ran away, you weren't running from them. You were running towards me." Sam even confesses in season eight's "Sacrifice" (8.23) that his greatest sin has been letting Dean down. Whatever Sam's reason for saying yes in "The End," he could not succeed in defeating Lucifer on his own. Only the relationship between Sam's faith and Dean's love can open the door for the grace Sam needs to win, and that relationship is possible primarily because Sam has learned the hard way how to keep faith rightly.

Bobby: Hope

When Bobby accidentally makes skin contact with Chet the Leviathan in season seven's "Slash Fiction," allowing the monster to download his memories and shift into his form, Chet is surprised that after everything Bobby has endured, he still has hope, not only for victory but also of a potential for romance with Sheriff Jody Mills. Bobby retorts, "A man's reach should exceed his grasp." This line from Robert Browning's "Andrea del Sarto" fits with Aquinas's statement that "hope denotes a movement or a stretching forth of the appetite towards an arduous good" (*Summa* II-II.17.3). Bobby knows that any victory is hard-won and that forming a relationship with Jody might be beyond him, but these good things are still worth striving toward. Chet taunts Bobby with the futility of hope in the face of an enemy that cannot be killed—until Jody's accident with a borax solution provides Bobby with both the means of dispatching Chet and the knowledge that will help Sam and Dean defeat their own Leviathan doubles. Most of Bobby's hopes do fail when he is shot, but his hope for victory does not, thanks largely to these discoveries.

Augustine notes in *On Christian Doctrine* that hope provides strength and support for faith (1.15), and Bobby provides that function not only for Sam and Dean but for a number of other hunters. He and Sam also play off each other as researchers and intellectuals. Similarly, Aquinas states that hope shares the certainty of faith (*Summa* II-II.18.4), and Bobby's observation of Sam in "Two Minutes to Midnight" (5.21) brings him to share Sam's certainty that the plan to trap Lucifer will work. Aquinas argues, however, that

hope, like charity, is located in the will (*Summa* II-II. 18.1), so in
that regard, it makes sense that Dean is both the brother more like
Bobby overall and the brother Bobby considers his favorite. Even
Bobby's final one-on-one conversations with Sam and Dean in "How
to Win Friends and Influence Monsters" (7.9) illustrate the differ-
ing ways his hope supports each brother's chief virtue. Dean's major
problem in that episode is a lack of motivation to keep doing the
right thing, so Bobby's advice for him is action-oriented, pointing
out brusquely that Dean's current attitude is likely to get him killed
and insisting that he find a reason to keep going, "whether it's love
or spite or a ten-dollar bet." Sam's problem is a hampered ability to
distinguish reality from hallucination, so Bobby's tone with him is
far more philosophical; he tries to convince Sam to worry less about
Dean but notes that Sam has always been "deep" when Sam argues
that others' suffering is worse than his.

The vice directly opposed to hope is despair (Aquinas, *Summa*
II-II.20), and Bobby must battle despair stemming from his abu-
sive childhood. His father tells him in "Death's Door" (7.10) that he
breaks everything he touches, and when Bobby saves his mother's
life by killing his father, she tells him that God will punish him. This
experience warps the fear of fault that Aquinas states can be a gift
allied with hope into a fear of failure that prevents hope (*Summa*
II-II.19). Bobby is able to conquer that fear of failure only at the end
of his life by confronting the memories of abuse in hopes of aiding
his heart's sons against Dick Roman ("Death's Door"). In "Sympathy
for the Devil" (5.1), as Heaven and Hell try to ensure the Apocalypse,
they assault Bobby's ability to hope for a different solution by leaving
him crippled. In "The Devil You Know" (5.20), Crowley capitalizes
on Bobby's growing despair by convincing him to trade his soul for
Death's location, presented with the implied (false) hope that he will
renounce his claim after the Apocalypse is thwarted. Lacking a bet-
ter way to help the boys, Bobby takes the bait—but the true hope he
gains from their victory allows him to force Crowley to honor the
spirit of the agreement in "Weekend at Bobby's" (6.4). He continues
to share that hope with the boys to his dying breath.

The Balance of the Virtues

Both "Point of No Return" and "Swan Song" illustrate the necessity
of balance among the virtues. As noted above, Sam's faith in Dean

enables Dean to overcome his despair and refuse allegiance to the angelic hierarchy, and Dean's love for Sam enables Sam to overpower Lucifer and throw him back into the Cage. Bobby's hope intervenes in both cases, strengthening and being strengthened by the boys' virtues. He reminds Dean in "Point of No Return" that he has not committed suicide over his paralysis "because I promised *you* I wouldn't give up," and he does his best to help Sam prevent Dean from saying yes to Michael. In "Swan Song," Bobby's hope responds to Sam's faith by encouraging him to fight Lucifer with all his might; though he despairs when the initial plan fails, Dean's refusal to let Sam die alone rekindles Bobby's hope enough that he can help Castiel banish Michael. In both instances Bobby, Sam, and Dean could not exercise their virtues properly—or have stopped the Apocalypse—without the input of the other two.

G. K. Chesterton argues, however, that the individual virtues do not merely lose their power when they attempt to function alone; they become dangerous (35). This danger becomes apparent when either Sam or Dean is separated from the other by death. In each case, the brothers also separate from Bobby and stumble into the vices directly opposed to their chief virtues. Aquinas states, for example, that there can be no true virtue without charity (*Summa* II-II.23.7), and Bobby and Sam do fall into vice during the summer after Dean's death in "No Rest for the Wicked" (3.16). Bobby does crawl out of his alcoholic despair and go back to work before Dean returns in "Lazarus Rising" (3.16), but flashbacks in "I Know What You Did Last Summer" (4.9) reveal that Sam succumbs to the temptation to develop his demon-granted powers when Ruby presents herself as a surrogate object of his faith. He makes this choice even though he knows it is both wrong and against Dean's last wishes. This act of apostasy also throws all Sam's loves out of order. He justifies his actions in "Metamorphosis" (4.4) by claiming to want to avenge Dean's death and safely release people who are possessed by demons. By "On the Head of a Pin" (4.16), however, that pursuit has led him to value his own power and judgment over the greater good of Dean's love and wisdom. Likewise, since "charity is quite impossible without faith and hope" (Aquinas, *Summa* I-II.45.5), when Sam dies in season two's "All Hell Breaks Loose Part 1" (2.21), Dean rejects Bobby's wise counsel and refuses to act to stop the world from ending; lacking the faith to see why he should live after Sam's death, he sells his soul to bring Sam back. He thus succumbs not only to despair but also to sloth and folly, two of the vices Aquinas opposes to charity (*Summa* II-II.35, 46). Both of

these failures set in motion the very Apocalypse the brothers must join forces to halt.

The Problem of God's Absence

The true horror of *Supernatural* may lie in God's refusal of relationship. Douglas E. Cowan argues that the horror genre capitalizes on fear of change or breakdown within the sacred order (61–92). For all the gore *Supernatural* portrays, perhaps the most terrifying image—at least from a Christian perspective—is of a world largely abandoned by its creator, who rewards those who diligently seek Him only with a resounding "Back off" as the angel Joshua (Roger Aaron Brown) tells Dean in "Dark Side of the Moon" (5.16). The effectiveness of this form of horror becomes particularly apparent in a discussion of virtue. If God is neither loving nor compassionate and actively withholds himself from humans, the virtues lack a firm foundation or purpose and cannot function as they ought.

God's absence may explain a good number of Sam and Dean's worst problems and weaknesses. Even Dean admits that he has difficulty functioning when Sam is dead, and the prospect of Bobby's death in "Hello, Cruel World" (7.2) prompts Dean to threaten to "strap my *Beautiful Mind* brother into the car and drive it off the pier." His love has no other anchors by then, for all their other family and friends are dead. Dean even has difficulty loving himself because his hyperawareness of his own faults cannot be checked by the assurance that God will forgive him; Hilton notes that a soul that is confident of God's love and forgiveness "is no longer preoccupied with its own unworthiness or its past sins" (146). Similarly, once God and the angels disappoint Sam, the only anchor of his faith—and sanity—is Dean, but his hallucinations of Lucifer in season seven prey on his ability to believe that Dean is even real. Sam's season eight flashbacks reveal how poorly he managed his year of normalcy without Dean.

Bobby can function without the boys, but his hope remains mixed with fear. In a lecture on Hebrews 2, Aquinas distinguishes this kind of hope from what he calls "trust," the superior, firm, and fearless hope that expects future aid from God (*Commentary* 65). Bobby has difficulty trusting others enough to ask for help in "Weekend at Bobby's" and his hope becomes the vice of presumption when it prompts him to linger as a ghost after "Death's Door." Though he is able to pass on crucial information Sam and Dean need to defeat

Dick Roman, Bobby cannot prevent himself from becoming a vengeful spirit, which causes all three hunters considerable heartache until Bobby repents and instructs the boys to destroy the flask to which he is tied ("Survival of the Fittest" 7.23). Had he been able to trust God to provide that aid through other channels, he might well have gone with the Reaper.

God's absence may also help explain why certain virtues are weaker in each character than they might be otherwise. Dean has trouble maintaining both faith and hope on his own because he can find no reason to trust in God, and attempting to place that trust in anyone else inevitably leads to disappointment. Sam often states or implies that he must believe the best of others because his hope for himself relies on being able to reject or control the influence of his demonically tainted blood; given the apparent absence of Christ the Redeemer in the world of *Supernatural*, Sam has no reason to hope that he can be saved by anyone but himself (or maybe Dean).[3] Bobby has plenty of friends and a budding romance with Jody before his death, but it seems that the only people he will allow himself to love or believe in wholeheartedly are Sam and Dean. Even that love proves treacherous after his death; the instinct to protect "his" boys quickly turns him vengeful, which nearly causes him to kill Sam ("Survival of the Fittest").

Conclusion

Time will tell how Sam's faith in Dean and Dean's love for Sam will continue to function in season ten and beyond. Henry's last words may help them to strengthen what hope remains within themselves, and God may yet break silence and show them that their virtue has not been without merit. Yet their continued practice of virtue even in the face of God's absence within the series is a model for the practice virtue no matter the cost. Of these men, indeed, their world is not worthy.

Notes

1. All scripture quotations are taken from the *King James Version* (*KJV*).
2. Other translations of *philia* include both "friendship" and "brotherly love."
3. While "God" in *Supernatural* always refers to YHWH, the show's mythology is notoriously unclear as to whether God in that universe is the Christian Trinity.

Works Cited

"All Hell Breaks Loose Part Two." *Supernatural*. Writ. Eric Kripke and Michael T. Moore. Dir. Kim Manners. CW. 17 May 2007. Television.

Aquinas, Thomas. *Commentary on the Epistle to the Hebrews*. Trans. Chrysostom Baer. South Bend: St. Augustine's, 2006. Print.

———. *Summa Theologica*. Trans. Fathers of the English Dominican Province. 5 vols. 1911. Notre Dame: Christian Classics, 1981. Print.

"As Time Goes By." *Supernatural*. Writ. Adam Glass. Dir. Serge Ladouceur. CW. 30 Jan. 2013. Television.

Augustine of Hippo. *City of God*. Trans. Marcus Dods. *Augustine: City of God, Christian Doctrine*. Vol. 2 of *Nicene and Post-Nicene Fathers, First Series*. Ed. Philip Schaff. Buffalo, 1887. Print.

———. *On Christian Doctrine*. Trans. D. W. Robertson, Jr. Upper Saddle River: Prentice-Hall, 1958. Print.

"Changing Channels." *Supernatural*. Writ. Jeremy Carver. Dir. Charles Beeson. CW. 5 Nov. 2009. Television.

Chesterton, G. K. *Orthodoxy*. 1908. San Francisco: Ignatius, 1995. Print.

Cowan, Douglas E. *Sacred Terror: Religion and Horror on the Silver Screen*. Waco: Baylor UP, 2008. Print.

Dante Alighieri. *The Convivio*. Trans. Richard Lansing. 1998. *Digital Dante Project*. Columbia University, Web. 8 Sept. 2012.

"Dark Side of the Moon." *Supernatural*. Writ. Andrew Dabb and Daniel Loflin. Dir. Jeff Woolnough. CW. 1 Apr. 2010. Television.

De Lubac, Henri. *Medieval Exegesis, Volume 1: The Four Senses of Scripture*. Trans. Mark Sebanc. Grand Rapids: Eerdmans, 1998. Print.

"Death's Door." *Supernatural*. Writ. Sera Gamble. Dir. Robert Singer. CW. 2 Dec. 2011. Television.

"Devil You Know, The." *Supernatural*. Writ. Ben Edlund. Dir. Robert Singer. CW. 29 Apr. 2010. Television.

"The End." *Supernatural*. Writ. Ben Edlund. Dir. Steve Boyum. WC. 1 Oct. 2009. Television.

"Hello, Cruel World." *Supernatural*. Writ. Ben Edlund. Dir. Guy Norman Bee. CW. 30 Sept. 2011. Television.

Hilton, Walter. *Coming to Perfection (The Ladder of Perfection)*. Trans. David Lyle Jeffrey. *Toward a Perfect Love: The Spiritual Counsel of Walter Hilton*. 1985. Vancouver: Regent College, 2001. 37–180. Print.

Holy Bible, King James Version. Nashville: Thomas Nelson, 1977. Print.

"How to Win Friends and Influence Monsters." *Supernatural*. Writ. Ben Edlund. Dir. Guy Norman Bee. CW. 18 Nov. 2011. Television.

"I Know What You Did Last Summer." *Supernatural*. Writ. Sera Gamble. Dir. Charles Beeson. CW. 13 Nov. 2008. Television.

Jeffrey, David Lyle. "Charity and Cupidity in Biblical Tradition." *Houses of the Interpreter: Reading Scripture, Reading Culture*. Waco: Baylor UP, 2009. 55–74. Print.

"Lazarus Rising." *Supernatural*. Writ. Eric Kripke. Dir. Kim Manners. CW. 18 Sept. 2008. Television.

Lewis, C. S. *Mere Christianity*. 1943. New York: Simon and Schuster-Touchstone, 1996. Print.

"Lucifer Rising." *Supernatural*. Writ. and dir. Eric Kripke. CW. 14 May 2009. Television.

"Metamorphosis." *Supernatural*. Writ. Cathryn Humphris. Dir. Kim Manners. CW. 9 Oct. 2008. Television.

"No Rest for the Wicked." *Supernatural*. Writ. Eric Kripke. Dir. Kim Manners. CW. 15 May 2008. Television.

"On the Head of a Pin." *Supernatural*. Writ. Ben Edlund. Dir. Mike Rohl. CW. 19 Mar. 2009. Television.

"Pac-Man Fever." *Supernatural*. Writ. Robbie Thompson. Dir. Robert Singer. CW. 24 Apr. 2013. Television.

"Pilot." *Supernatural*. Writ. Eric Kripke. Dir. David Nutter. WB. 13 Sept. 2005. Television.

"Point of No Return." *Supernatural*. Writ. Jeremy Carver. Dir. Philip Sgriccia. CW. 15 Apr. 2010. Television.

"Sacrifice." *Supernatural*. Writ. Jeremy Carver. Dir. Philip Sgriccia. CW. 15 May 2013. Television.

"Slash Fiction." *Supernatural*. Writ. Robbie Thompson. Dir. John Showalter. CW. 28 Oct. 2011. Television.

"Survival of the Fittest." *Supernatural*. Writ. Sera Gamble. Dir. Robert Singer. CW. 18 May 2012. Television.

"Swan Song." *Supernatural*. Writ. Eric Gerwirtz and Eric Kripke. Dir. Steve Boyum. CW. 13 May 2010. Television.

"Sympathy for the Devil." *Supernatural*. Writ. Eric Kripke. Dir. Robert Singer. CW. 10 Sept. 2009. Television.

"Two Minutes to Midnight." *Supernatural*. Writ. Sera Gamble. Dir. Philip Sgriccia. CW. 6 May 2010. Television.

"Weekend at Bobby's." *Supernatural*. Writ. Andrew Dabb and Daniel Loflin. Dir. Jensen Ackles. CW. 15 Oct. 2010. Television.

"When the Levee Breaks." *Supernatural*. Writ. Sera Gamble. Dir. Robert Singer. CW. 7 May 2009. Television.

Suffering Nuclear Reactors: Depictions of the Soul from Plato to *Supernatural*

Patricia L. Grosse

As the season five finale of *Supernatural* draws to a close, Sam Winchester (Jared Padalecki) dives into an unbreakable cage within the bowels of Hell while psychically grasping the archangel Licifer (Mark Pellegrino) within his own body ("Swan Song" 5.22). In doing so, Sam saves the world from the Apocalypse but also damns himself to eternal torture. His brother, Dean (Jensen Ackles), can only watch on in impotent anguish, knowing Sam's future torment. The episode's denouement makes clear that, following Sam's wishes, Dean goes on to lead an ordinary life with his sometime lover Lisa (Cindy Sampson) and her son Ben (Nicholas Elia). Therefore, it is a shock to the viewer when the final shot shows Sam watching over Dean as he eats a meal with Lisa and Ben. Sam has escaped the cage, but how and at what cost?

The philosophical problem that is Sam Winchester haunts season six of *Supernatural*. This problem manifests itself within the season as an exploration of two questions: "What does it mean to be human?" and "What is the exact composition of the human soul?" As the season progresses, the metaphysical ramifications of the human soul are referenced more and more frequently, beginning as merely quick references in the first few episodes and ending with Sam fighting to reintegrate the parts of his soul. The season ends with Sam and Dean fighting to stop the angel Castiel (Misha Collins) and the demon Crowley (Mark Sheppard) from accessing the power of the millions of souls in Purgatory. A major arc of this season, however, is

one of the most pressing questions of the entire series. What, exactly, is wrong with Sam? Why is he making decisions that are so out of character? The Sam shown watching his brother from afar at the end of season five is not quite right, not quite himself. This is explored further in episodes such as "Live Free or Twihard" (6.5), in which Sam watches as Dean is attacked by vampires, and "Clap Your Hands if You Believe" (6.9), when Sam has sex with an enthusiastic alien-believer rather than attempting to find the missing Dean. In the season six episode "Family Matters" (6.7), we discover that while Sam's body made it back from the cage he was trapped in at the climax of "Swan Song" (5.22), his soul did not. The ramifications of that loss are developed throughout the season in such a way as to give a robust theory of the soul. Moreover, the sixth season of the show offers the opportunity to inquire into the τί ἐστι (*ti esti*), the question of "what it is [to be human]."

In the world of *Supernatural* there is no question of whether humans have souls—souls do exist, and the psyche very delicately bridges the gap between the soul and the body. In "Clap Your Hands If Your Believe" (6.9), when Sam and Dean discuss the purpose and value of the human soul, Dean can only relate it to "suffering". Sam responds, "So, you're saying having a soul equals suffering." Dean answers, "Yes, that's exactly what I'm saying." "Soulless" Sam fights against reuniting with his soul because he desires to avoid suffering, and upon being made whole later in the season ("Appointment in Samarra" 6.11) Sam does indeed suffer.

The modern concept of the soul has its roots in the works of fourth century BCE Athenian philosopher Plato and the fourth century CE Roman North African theologian Augustine of Hippo. Their writings claim that to have a soul is to be something more than an animal (as a cat is an animal) or a thing (as a desk is a thing). Moreover, these authors further consider the questions about the nature of humans—are we a composite of mind and body or body and soul? In this chapter, I give a philosophical analysis of the nature of souls as presented in season six of *Supernatural* by analyzing the implications of the soulless body and the bodiless soul through the lens of Platonic and Augustinian thought. This analysis leads to an account of the extent to which Sam is morally culpable for the terrible actions he committed while "soulless."

Supernatural's Mythology of Soul

Halfway through *Supernatural*'s sixth season, Death (Julian Richings) arrives to place Sam's tortured soul back into his body. Before doing so,

Death says to Dean, "The human soul is not a rubber ball. It's vulnerable, impermanent, but stronger than you know. And more valuable than you can imagine" ("Appointment in Samarra"). One of the overarching themes of this season is determining the value of a human soul and why angels and demons are so concerned with them. *Supernatural* has been concerned with the nature of the human soul since its first episode. In the pilot episode, the boys battle a Woman in White, which Sam defines as a ghost of a woman who committed suicide after murdering her children while "suffering from temporary insanity" ("Pilot"). Earthbound ghosts are a common foe of the Winchester brothers, appearing again and again in every season of the series. They are remnants of living humans who have unfinished business or who were greatly wronged in their lives. The ghosts the brothers face are nearly always angry, vengeful, and dangerous. Sam and Dean banish violent ghosts by destroying their remains or by attempting to resolve their unfinished business. For example, in "Hook Man" (1.7) the brothers burn the silver necklace made from the titular ghost's corporeal hook. In "Pilot" they defeat the Woman in White by "taking her home" where she is claimed by the children she murdered in life. The burning of the remains as a way to destroy ghosts implies something profound about the nature of the bond between the material and the immaterial in the show. If these spirits are "souls," then the existence of these souls on earth is tied to their former materiality.

In "Frontierland" (6.18) when the injured Castiel siphons off some of the energy of Bobby Singer's (Jim Beaver) soul in order to heal himself, he says, "Doing this is like putting your hand in a nuclear reactor. I have to do it very gingerly." On the few occasions when the show calls for a depiction of a human soul severed from its body, such as in "My Bloody Valentine" (5.14) and "Appointment in Samarra," the soul is represented by a palm-sized orb emitting a blinding white light. Souls are tangible in *Supernatural*. They are consumable and their power usable. The Horseman Famine consumes souls in "My Bloody Valentine"; the King of Hell, Crowley, controls them and uses their power in "The Man Who Would Be King" (6.20); and Heaven and Hell fight over the power of the untapped resource that is Purgatory's cargo of fanged, furry souls throughout season six. *Supernatural*'s many depictions of the soul connect to the theory of the soul as the power source that makes a human being an individual capable of action. Given this depiction of the soul, Sam's time as "soulless" Sam becomes all the more problematic. A look at the Platonic conceptualization of the soul might help us understand the problem of Sam Winchester as a dislocated, dismembered human being.

Platonic Soul: Origins and Divisions

There is an important philosophical distinction between a soulless body and a bodiless soul. To be embodied implies that a person consists of a soul with a body wrapped around it. This view of matter as accidental property of the soul is a remnant of the Aristotelian theory of matter and form; that is, matter does not exist without the soul. All material things have individual souls that give form to their matter. However, to be ensouled is another matter entirely. The very composition of the word implies that the body exists as matter and is then imbued with personality: en-soul-ment, flesh injected with life. The question, then, is whether Sam's difficulties in the sixth season are related to the problem of embodiment or the altogether different problem of ensoulment; how does flesh come to be vivified with a soul? In order to more fully develop the particular problem of ensoulment faced by "soulless" Sam in season six, it is first necessary to philosophically examine the natural course of embodiment.

Though Plato's *Phaedrus* is known as the Platonic dialogue devoted to the proof of the immortality of the soul, in the course of the dialogue Plato's Socrates quickly moves on from directly discussing immortality to the structure of the soul itself. Socrates claims to have difficulty clearly stating what "the soul" is and instead represents the ethereal nature of the soul with an allegory. In this allegory, Plato likens "the soul to the natural union of a team of winged horses and their chari-oteer" (246a, 524). According to Plato, all souls are made up of chari-oteers and horses, including those of the gods. Unlike divine souls, which have two good horses, human souls possess a mixture of good, divine elements and bad, untempered elements that incline toward the chaotic. From Plato's perspective, human souls have one horse that is beautiful and good and another that is ugly and bad. In this dialogue, Plato establishes that the soul is both immortal and tripartite before it ever gets near a body. For Plato, embodiment is a result of the loss of the soul's white, downy wings. While the soul's wings are still strong, it flies about with the gods and looks at the wonders of the universe— the Forms of beings themselves (e.g. Beauty, Goodness, etc.). Because of the struggle of its horses, it is not easy for the human soul to maintain its height. The wings are not a permanent part of the soul and they can become broken and weak when not nourished on the vision of properly divine things. When the soul loses its wings, it "wanders until it lights on something solid, where it settles and takes on an earthly body, which then, owing to the power of this soul, seems to

move itself" (246c, 524). Embodiment, for Plato, is a falling of the soul from the heights of reality to the depths of flesh.

In "The Man Who Knew Too Much," the final episode of season six, we learn that Sam's soul is tripartite—there is the "soulless" part that controls Sam's body, the part that remembers Hell, and the part without memories that must defeat the other two. The struggle between these three parts is suggestive of the chariot allegory given in Plato's *Phaedrus*. The part with no memories might be the white horse (generally desirous of good actions); the part that had reign of the body—and allowed Dean to become a vampire in "Live Free or Twihard"—is clearly the bad, dark horse, and the part that remembers Hell is the charioteer. However, the *Phaedrus* allegory seems to be incomplete because it makes the dark horse completely wild, and "soulless" Sam is not entirely wild, vicious, and uncontrollable. The chariot allegory severs one's mind and one's goodness from one's desire in a way that is unsatisfactory. Fortunately, in his *Republic*, his dialogue devoted to justice, Plato does attempt to mend this wound to the soul; this dialogue can be used to expand upon what happened to Sam that allowed him to be "soulless" and yet walking around, talking, fighting, having sex, eating, reasoning, and all other manner of human activities.

As in the *Phaedrus*, Plato cuts the soul in three in his *Republic*. Each of the soul's three parts receive a different classification: νοῦς (*nous*), intellect, reason; θυμός (*thumos*), passion, spiritedness, courage; and ἐπιθυμία (*epithumia*), appetite, desire. Socrates identifies the interaction of these three parts as follows: "we learn with one, become spirited with another of these parts within us, and desire the pleasures of nourishment and generation and all their kin with a third" (*Republic* 436a, 114). The *Republic*'s depiction of the soul does not directly map onto that of the *Phaedrus*, for Plato has different goals for each text. *Thumos* is not easily relegated to the dark horse, nor is *epithumia* to the white. However, reading these two accounts together gives a better idea of what is going on with Sam in season six.

In the *Republic*, the desiring part of the soul yearns for things of the body, the calculating part must be taught how to desire properly, and the spirited part, in need of guidance, can either be submissive to the calculating part or team up with the desiring part to wreak havoc on the individual's personal life. Basically, the soul is chaotic and in need of ordering. In "The Man Who Knew Too Much," we meet with these parts of Sam's soul. "Soulless" Sam represents spiritedness run amok because the other parts are not there to temper it. Or perhaps

it is the calculative soul run amok, or the appetitive soul; more likely, however, the complex intertwining that underpins the human soul has been undone in Sam. There is no balance and therefore he cannot empathize with others. It is helpful to go back to the idea of the *Phaedrus*'"dark horse" here. In Sam, his "dark horse" lacks all moderation. Season six, then, does not show what humans are capable of when soulless, but instead it provides a compelling demonstration of what happens when the dark horse possesses the body. With only the dark part of the soul in charge, Sam is more efficient, a better hunter, and a more voracious lover: much more like his brother Dean, as the show suggests. However, unlike Dean, "dark horse" Sam is deficient in understanding emotions. Though he attempts to be rational, he misses key concepts like compassion, allows bad things to happen to people he should protect, and commits heinous acts of violence. In effect, "dark horse" Sam is a sociopath with the memories of a good man.

The Problem of Sam

Sam is only "soulless" for eleven episodes of season six. His actual time while soulless, however, is about a year and a half, as a year has elapsed between the season five finale and the first episode of season six. In "Unforgiven" (6.13), we learn that "dark horse" Sam led innocents into danger to catch the monsters he hunted, even going so far as to kill a human woman to get his prey. Within the time span that the show covers, we see "dark horse" Sam endangering his brother, womanizing, and generally neglecting to consider the safety of others, all for the sake of his own goals. The series does not linger on the implications of Sam's actions while he was "soulless." Indeed, there are few points in season six where his time on earth while his "soul" is in Lucifer's cage is even mentioned. Season seven quickly focuses on Sam's deteriorating mental state rather than his soullessness. "Ensouled" Sam is broken, his psyche shattered and barely held together by Death's wall. It is the characterization of "soulless" Sam that most reflects the question of moral culpability in relation to the human soul as examined in the previous section.

The revelation that Sam is "soulless" strains the fraternal relationship at the heart of *Supernatural*. Dean has difficulty dealing with the situation, exclaiming "I mean, it's your gigantor body and maybe your brain, but it's not you. So just stop pretending. Do us both a favor" ("All Dogs Go to Heaven" 6.8). By now, the brothers are familiar

with demon possession, shapeshifting, ghouls who can mimic the dead, and even the odd witch or warlock that can body swap. For these reasons, when the boys are separated for any length of time, usually by death, they meet each other with violence, splashes of holy water, and blades of silver. Now Dean is faced with something new—someone who is and is not his brother. Dean takes the view that this "thing" is not Sam without much reflection, which is not surprising considering Dean's hard and fast ideas about what is real and what is not real (for example, his discomfort with the concept of personalized heavens in "Dark Side of the Moon" 5.16).

Regardless of the show's quick absolution of Sam for his sins when soulless, if the *Supernatural* universe has souls, and those souls are pure energy, then there simply cannot be bodies walking around without any kind of soul. One need not completely ascribe to a Platonic conception of the soul in order to come to this conclusion, but it helps. "Soulless" Sam cannot be truly soulless if he also has memories, logic, and the ability to breathe. The previous section was concerned with the problems of the soul that arise from natural embodiment, that is, how the soul interacts with the body, how it is composed, from whence it came; the concern now has a different focus—ensoulment. What does it mean for bodies to have souls, how are bodies moved by souls, and, finally, what happens when a soul is mutilated?

Sam's soul is violently rent asunder when Castiel rescues his body from the pit with some parts of his soul staying below and some parts coming back above. What, then, is the breakdown of that rendering? Augustine's account of the irrational part of the soul in *The Literal Meaning of Genesis* is helpful here. He claims that the irrational part of the soul is "a power of the soul by which images of all corporeal things are received and which itself is not similar in any way to any corporeal substance" (7.21.29, 22). For Augustine, all living, bodied humans and animals have an irrational soul that allows them to interact with the world. This irrational soul is not contemplative and cannot be fully controlled by one's will; it is a part of the soul that controls one's experience of sensations like vision and hunger. "Irrational," then, refers to the kind of soul that "soulless" Sam shares with animals and the rest of humanity, the part of the soul that allows for movement and interaction with stimuli. He must experience some pain and pleasure or he could hurt himself by accidentally stabbing himself and not feeling it.

"Soulless" Sam clearly has some kind of faculty of reason that is divorced from emotions like love, hate, or even fear. Even "soulless"

Sam's attempt to block his soul's readmittance into his body by murdering family friend Bobby Singer is not evidence of a true fear of dying. Rather, this violent act is merely indicative of "soulless" Sam's natural compunction to live rather than to die. "Soulless" Sam's conclusion that "having a soul equals suffering" in "Clap Your Hands If You Believe" indicates the kind of wound Sam's soul has suffered. He is missing the self-reflective part of his reason, the part of reason that both torments and differentiates humans is missing. In the *Republic*, Plato's character Socrates is able to explain the right relationship among the parts of the human soul by examining the concept of self-reproach, the feeling that arises when someone chooses a merely desirable action over a morally right action. Plato is correct here; anyone who claims to have never deeply regretted an action or a comment is either a liar or has a serious defect in her soul. In the *Republic*, Plato puts the calculating part of the soul at the reigns of the tripartite soul because it is the part that *should know better*. That is why he spends so much time discussing the training of the guardians of the city in the earlier books of that dialogue, for what need to be trained are the spirited and appetitive parts of one's soul.

In a way, the character of "soulless" Sam shows what happens when the spirited dark horse is left to run amok. The part of the soul that is powerful and vibrant and seeks glory is the part of Sam left at the reigns of his body, rather than a proper balance between charioteer, white horse, and dark horse. But is such a severance truly possible in the context of the show's theology? A part of Sam's consciousness was in Hell, his "soul," but what is the soul without the body? Ghosts become insane, demons are mutilated smoke monsters that were once human, and those few lucky souls who actually make it to Heaven, what do they have? A fantasy that is not real, images and interactions with loved ones that are merely gleaned from memory ("Dark Side of the Moon" 5.16). Dean's difficulty with the Apocalypse and the promises of Heaven stems from his distrust of things that are not "real." Dean must be a proponent of Plato's Forms, because he always calls for the actual thing itself rather than a facsimile. And so we cannot leave behind the horses and charioteer from the *Phaedrus* as they have something to offer, as well. That mysterious white horse—the part of the soul that knows the good, the good conscience that is always actively noble—is what is missing in "soulless" Sam. That is the part that makes him fully himself and human. It is as if the charioteer were cut in two, one half staying in the body with the overwhelming dark horse, and the other half staying with the white horse in Hell. Therefore, it is fitting that in the

Figure 4.1 In order to heal his psyche, Sam must "kill" the part of his soul that remembers his time while soulless and the part that remembers his time in Hell. These parts of his soul transfer back into him in a great vortex of white energy.

season six finale Sam must kill the parts of himself that have been driven from him so that he may become a whole person again. He must kill the part of him that was "soulless" Sam and remembers his soullessness, and also the good part of him that remembers being tortured in Hell for a year and a half Earth-time (and significantly longer in Hell-time). In killing these parts of himself, he incorporates them back into a whole psyche—all three parts of the soul make him human and whole again, if psychologically scarred. Dean is wrong when he concludes that "soulless" Sam is not Sam. He is Sam, but fractured, incomplete, and wrong.

In *On Free Choice of the Will*, Augustine grapples with the theological issue of evil in a world created by an all-powerful God. For Augustine, God must be just, cannot be blamed for sin, and cannot punish those who are not able to help themselves. Augustine approaches the problem by stating that the soul and the choices made by the will are not determined by outside forces, but by the soul. However, the nature of one's capacity to will was disfigured by the sin of the first humans—the eating of the fruit of the tree of the knowledge of good and evil (which Augustine claims to be a fitting punishment). Given the disfigurement of the human will Augustine makes the bold claim that one can never choose freely to sin. The pleasure one has from partaking in the deliciousness of bodily desires makes any choice for sinful actions (for example, for sex, money, rich foods,

etc.) less a choice and more a default setting. But how, then, can one be culpable for not climbing out of the pit of cupidity? The culpability lies in the fact that one is *capable* of making the free choice to be better (i.e. turn towards God). There is an echo of the *Republic*'s self-chastising calculative part of the soul here; something is wrong with our souls: "we often know, not merely that they *are* a certain way, but that they *ought to be* that way" (*On Free Choice of the Will*, 2.12, 54). That is, "we say that a soul is less capable than it ought to be, or less gentle, or less forceful, depending on our own character there are many instances when we are very well aware of a lacking in our moral fiber" (*On Free Choice of the Will*, 2.12, 55). Like Plato, Augustine thinks that we should "know better" but often we do not. Someone's soul is a certain way (unjust, licentious) and usually is capable of being better (just, temperate).

Given the above conclusion that "soulless" Sam is himself even when "soulless," is Sam deserving of punishment for his heinous crimes? Not in the Augustinian sense, because all moral culpability comes from the soul and the part of Sam's soul capable of choosing the good rather than being embroiled in bodily pleasures was severed from his active psyche at the time. Of course, all of this does not make Sam's conscience clear, as he has done many disreputable things in the past and surely continues to do so even while "ensouled." Sam is always broken in one way or another. Indeed, the series begins with Sam being forced out of his new "normal" life as a pre-law student by his older brother in order to locate their absentee father. Throughout the series, Sam repeatedly voices his desire to have had a normal upbringing as well as his anger at his father for raising him as a hunter. The series, then, revolves around a person who cannot decide who he is. Whenever Sam does embrace a specific part of himself (as hunter, as demon-powered, as pre-law), he does so at the expense of all other aspects of his personality. His willful ignorance causes him to repeatedly go to bed with demons and monsters (metaphorically and physically). Sam is not responsible for "soulless" Sam being unable to feel and reflect on his misdeeds, but he is certainly responsible for cutting himself to pieces in search of one perfect way of life.

Conclusion: "More of the Same"

The representation of the soul in *Supernatural* is indicative of the nuanced philosophical and theological inquiries made into the

nature of the soul and its moral culpability and relationship to the body. As discussed above, the show's analysis of the soul is suggestive of the works of Plato and Augustine: the correct balance of the parts of the soul is what makes a person capable of human emotions, including joy and suffering. To be human is to be the soul and body together as well as to be capable of willfully choosing to do good or evil. The character Sam Winchester provides an example of what it looks like when the soul is maimed and in need of reshaping. By showing the audience a character that goes through so many transformations, for good and ill, the series points toward an answer to the ancient question about τί ἐστι (*ti esti*) what it is [to be human]. *Supernatural*'s modern answer to this ancient question is that to be human is to make mistakes and to try one's best to overcome them. Being human is messy, especially in a world that is not always a hospitable home.

Works Cited

"All Dogs Go to Heaven." *Supernatural: The Complete Sixth Season*. Writ. Adam Glass. Dir. Phil Sgriccia. Warner Brothers, 2010. DVD.

"Appointment in Samarra." *Supernatural: The Complete Sixth Season*. Writ. Sera Gambel and Robert Singer. Dir. Mike Rohl. Warner Brothers, 2010. DVD.

Augustine of Hippo. *On Free Choice of the Will*. Trans. Thomas Williams. Indianapolis: Hackett Publishing Company, 1993. Print.

———. *The Literal Meaning of Genesis Vol. II. Books 7–12*. Trans. John Hammond Taylor. New York: Newman Press, 1982. Print.

"Clap Your Hands If You Believe." *Supernatural: The Complete Sixth Season*. Writ. Ben Edlund. Dir. John F. Showalter. Warner Brothers, 2010. DVD.

"Dark Side of the Moon." *Supernatural: The Complete Fifth Season*. Writ. Andrew Dabb and Daniel Loflin. Dir. Jeff Woolnough. Warner Brothers 2009. DVD.

"Family Matters." *Supernatural: The Complete Sixth Season*. Writ. Andrew Dabb and Daniel Loflin. Dir. Guy Bee. Warner Brothers, 2010. DVD.

"Frontierland." *Supernatural: The Complete Sixth Season*. Writ. Andrew Dabb and Daniel Loflin. Dir. Guy Bee. Warner Brothers, 2010. DVD.

"Hook Man." *Supernatural: The Complete First Season*. Writ.John Shiban. Dir. David Jackson. Warner Brothers, 2005. DVD.

"Live Free or Twihard." *Supernatural: The Complete Sixth Season*. Writ. Brett Matthews. Dir. Rod Hardy. Warner Brothers, 2010. DVD.

"Man Who Knew Too Much, The." *Supernatural: The Complete Sixth Season*. Writ. Eric Krepke. Dir. Robert Singer. Warner Brothers, 2010. DVD.

"Man Who Would Be King, The." *Supernatural: The Complete Sixth Season*. Writ. and Dir. Ben Edlund. Warner Brothers, 2010. DVD.

"My Bloody Valentine." *Supernatural: The Complete Fifth Season*. Writ. Ben Edlund. Dir. Mike Rohl. Warner Brothers, 2009. DVD.

"Pilot." *Supernatural: The Complete First Season*. Writ. Eric Kripke. Dir. David Nutter. Warner Brothers, 2005. DVD.

Plato. *Phaedrus. Complete Works*. Ed. John M. Cooper and D. S. Hutchinson. Indianapolis: Hackett Publishing Company, 1997. Print.

———. *The Republic of Plato*. Tran. Allan Bloom. New York: Basic Books, 1991. Print.

"Swan Song." *Supernatural: The Complete Fifth Season*. Writ. Eric Kripke. Dir. Steve Boyum. Warner Brothers, 2009. DVD.

"Unforgiven." *Supernatural: The Complete Sixth Season*. Writ. Andrew Dabb and Daniel Loflin. Dir. David Barrett. Warner Brothers, 2010. DVD.

"We're Just…Food and Perverse Entertainment": *Supernatural*'s New God and the Narrative Objectification of Sam and Dean

KT Torrey

Over the course of *Supernatural*'s first five seasons, Sam (Jared Padalecki) and Dean (Jensen Ackles) Winchester fight for the right to tell their own story, to maintain the integrity of their own narrative, despite the pressures of their past and the many forces moving to ensure their participation in a single, possible future. For the brothers, this desire to resist objectification, to avoid becoming mere characters in someone else's story—brought into even sharper relief after the events of "The Monster at the End of This Book" (4.18)—ultimately affords them the narrative agency they need to subvert the Apocalypse. However, this flash of authorial self-control is quickly disrupted by an unexpected source: the Winchesters' greatest ally, their savior, their friend—the angel Castiel (Misha Collins).

In season six, Castiel accomplishes what his archangel brothers could not: he subverts the brothers' hard-won narrative agency and transforms them into mere characters, narrative objects in the story of rebellion that Castiel composes on his own. As the events of "The Man Who Would Be King" (6.20) illustrate, Castiel is convinced that his actions following the Winchesters' arrest of the Apocalypse—beginning with Sam's resurrection at the end of "Swan Song" (5.22) and culminating in Castiel's decision to resist Raphael—are designed to protect the Winchesters' free will. Despite the fervency of his conviction, Castiel's

choices serve only to reinscribe the very ideologies against which the angel has attempted to define himself.

Implicit in Castiel's engagement with the chaotic cosmic realities of a non-apocalyptic world is a fundamental desire to negate what he perceives as the dominant set of beliefs—those of Raphael and other angels who want to restart Armageddon—by substituting the beliefs of the oppressed, of his own. Castiel's style of engagement with a world in which he has "ripped up the script" embodies what rhetorician John Muckelbauer calls the postmodern mode of "critique," a way of being that "seeks to change things" by overthrowing the position that has dominated and supplanting them with "concepts that have been historically derided" ("The Third Man"; Muckelbauer 7). As a creature of power, one is always already trapped within "the apparatus as a whole that...distributes individuals in this permanent and continuous field" and Castiel is deeply invested in his identity as a champion of freedom (Foucault, *Discipline* 177). That investment, coupled with his desire to negate his enemies' beliefs, blinds him to the ways his actions cleave Sam and Dean from their narrative agency, thus transforming them into characters in a tale that Castiel ultimately regards as his own. In this way, Castiel, the brothers' most fervent and loyal ally, reframes the Winchesters as objects, mere "food...and perverse entertainment" for their new God, rather than wielders of their own free will ("Of Grave Importance" 7.19).

For much of *Supernatural*'s first five seasons, the brothers' lack of narrative agency, their inability to "make the fiction" of their own lives, lies at the center of the series' arc (Corder 17). As Suzette Chan notes, this absence has been present in the boys' lives since their childhood. "From living under their father's command, to being infected with demon blood or resurrected by an angel," she observes, "it has become clear that neither Sam nor Dean has an exclusive claim on his own body—or his fate" (Chan, par. 1.2). Seasons four and five lay bare the extent to which the Winchesters' lives—along with those of their parents and grandparents—have fallen prey to the "unceasing manipulation...[of] angels and demons" (Gray, par. 6). In this way, the forces of Heaven and Hell detach Sam and Dean from a fundamental element of humanity: the ability to "invent...the narratives that are our lives" (Corder 17). For rhetorician Jim Corder, "each of us is a narrative," an embodiment of "all the choices we've made, accidentally or on purpose," choices which form "the evidence we have of ourselves and of our convictions" (18). Sam and Dean's bodies, by contrast, bear the scars of others' choices, including Castiel's

handprint, the absence of Sam's soul, and the psychological trauma inscribed by their mother's death—all of these key elements of the Winchesters' story are created without their consent. For much of their lives, then, the brothers are characters, mere objects, in narratives that are not their own.

However, the brothers manage to resist this final objectification in part because that same script also demands their agency. In order to fulfill their destiny as "angel condoms," Sam and Dean must freely give their consent to Lucifer and Michael, archangels who must occupy earthly vessels in order to engage in the final battle of the Apocalypse ("Sympathy for the Devil" 5.1). Without the brothers' invocation of agency, albeit temporarily, even Heaven's power is stayed, much to the annoyance of those who, like Castiel's supervisor Zachariah (Kurt Fuller), wish to see the fulfillment of God's original intent.

The increasingly creative nature of the angels' attempts to demonstrate their narrative mastery over the Winchesters reinforces the paradoxical nature of the situation. For example, in "It's a Terrible Life" (4.17), Zachariah wipes the boys' memories and transforms them into Dean Smith and Sam Wesson, two office-bound employees of Sandover Bridge and Iron. Although neither man remembers being a hunter nor that they are related, "Smith" and "Wesson" find themselves joining forces against the homicidal ghost of the company's founder. The experience convinces them both that they are living the wrong lives. When Dean finally confronts Zachariah, who is masquerading as his boss at Sandover, the angel reveals himself and unmasks the game: to convince Dean that his best hope for the future lies in fulfilling his destiny by consenting to be Michael's vessel. Initially, Zachariah's actions make it impossible for the brothers to exercise agency; without their memories, stripped of their identities, the Winchesters are temporarily rescripted as characters in a story of Zachariah's own choosing. However, even this extreme display of the potential of the angels' narrative mastery fails, and the incident serves only to solidify Sam and Dean's desire to secure their own agency once and for all.

Indeed, the events of the next episode, "The Monster at the End of This Book" (4.18), suggest the productive potential of such agency when employed as a mode of resistance. In this episode, Sam and Dean discover that Chuck Shurley (Rob Benedict), author of a cult series of books called *Supernatural*, has been writing pulp versions of their real lives within the pages of his novels—texts that will one day be known as "The Winchester Gospels." Much of the episode's tension arises from Chuck's unknowing status as a prophet, one with

the ability to prescribe events that will befall the brothers. The import of this gift becomes apparent when Chuck predicts the time, date, and location of Sam's death at the hands of Lilith, a powerful demon determined to raise Lucifer and jumpstart the Apocalypse. The brothers manage to prevent Chuck's vision from coming true; using the foreknowledge the prophet provides and an off-the-record assist from Castiel—an element that Chuck did not foresee—the brothers banish Lilith, at least temporarily.

The felicity of these actions, of Sam and Dean's ability to temporarily "make the fiction" of their own lives, underscores the potential malleability of the boys' prescribed destiny and provides a model for the subsequent actions of the Winchesters, Bobby Singer (Jim Beaver), and Castiel, a group Dean nicknames Team Free Will ("The Song Remains the Same" 5.13). The team's tactical resistance, their refusal to let the brothers fall victim to complete narrative objectification, culminates in Sam's death in "Swan Song" (5.22). Holding Lucifer at bay, Sam throws himself into the Pit, dragging the Devil and Michael, in the body of the Winchesters' half-brother Adam (Jake Abel), with him. His sacrifice of body and soul prevents the Apocalypse as written from ever coming to pass. Sam's seizure of narrative agency, and the wider rending of God's original narrative that it represents, appears to remove the Winchesters from the grips of anyone else's story. In this act of subversion, the brothers have finally gained the ability to control their own lives. However, as the end of the episode suggests, Sam's act of self-sacrifice is almost immediately overwritten; in the final frames, Sam appears in the street outside of Dean and his girl-friend Lisa's house, gazing in on his brother's new life ("Swan Song"). In time, the events of "The Man Who Would Be King" (6.20) reveal that the one responsible for rewriting Sam's most significant act of free will is none other than Castiel.

From Castiel's perspective, the choices that he makes in the two years after the Apocalypse—in the year Sam walks the earth without a soul, and in the months after the brothers are reunited—are intended to keep both the Winchesters and the legacy of Team Free Will safe from those who would see their work destroyed. As Castiel observes, God's will was subverted by "two boys, an old drunk, and a fallen angel," a rag-tag bunch who "ripped up the ending" to the "grand story," shredding both "the rules and destiny" along the way ("The Man Who Would Be King"). For Castiel, participation in those events is a source of pride; for many of his heavenly colleagues, however, the erasure of a long-expected climax is a source of consternation

and fear. Facing an uncertain future, Castiel believes that it is his responsibility to act in the tradition of the Winchesters, the humans who "taught me how to stand up [and] what to stand for," even with the knowledge that the reward for such actions is usually a quick and bloody end, like the one Lucifer visits on him in the moments before Sam sacrifices himself ("The Man Who Would Be King").

With those stakes in mind, the most significant choice that Castiel makes in his attempts to uphold the Winchesters' legacy is his decision—as suggested by Crowley (Mark Sheppard), the self-appointed King of Hell—to wage civil war in Heaven against the forces of Raphael, an archangel determined to restore God's original will. In their first confrontation after the Apocalypse sputters, Raphael demands that Castiel "kneel before [him] and pledge allegiance to the flag" in front of an angelic assembly. When Castiel protests, Raphael reminds him why such a public show of fealty is required: "You rebelled. Against God, Heaven, and me. Now you will atone." Faced with the potential destruction of Team Free Will's legacy, Castiel is defiant, even in the face of Raphael's overwhelming strength; however, when he refuses to obey, Raphael promptly knocks Castiel "into next week" ("The Man Who Would Be King").

Ultimately, it is the immediacy of Raphael's threat, coupled with the realization that no other angels plan to stand against him, that drives Castiel to start a civil war. Rather than resist the role of rebel Raphael assigns to him, Castiel once again embraces that identity, one he believed the destruction of God's original "grand story" rendered unnecessary. He is initially convinced that his fellow angels will embrace the opportunity to exercise free will as he did. However, many of his colleagues are fearful of the uncertainty that a future driven by free will presents. Returning to Heaven after Michael and Lucifer's defeat, Castiel encounters Rachel (Sonya Salomaa), one of his loyal lieutenants from the garrison. She and the other angels are amazed to see Castiel alive since they saw Lucifer destroy him. When Castiel tells them that he was somehow resurrected, Rachel ascribes a particular significance to that event: "God brought you back. He chose you, Cas, to lead us." Castiel tries to defer: "No one leads us anymore. We're all free to make our own choices…God wants you to have freedom." "But," Rachel asks, "what does he want us to do with it?" ("The Man Who Would Be King"). At first, Castiel is discouraged by this response. However, reflecting upon his own experience, he recognizes that what his brothers and sisters need is guidance. They need someone who can teach them how and why they should

embrace, rather than resist, the opportunities that free will presents. And who better to offer such instruction, Castiel reasons, than himself, given the lessons about the value of freedom he learned while fighting at the Winchesters' side?

Because of the import he places on his role as a rebel, Castiel is unable to acknowledge or accept his own position as part of the system of power; his actions, no matter how "pure" he believes his motives to be, serve to objectify Sam and Dean by reinscribing them as mere characters in someone else's story, one that Castiel sees as his own ("The Man Who Would Be King"). Muckelbauer's notion of oppositional postmodernism provides a useful lens through which to examine Castiel's exercise of narrative agency in season six. In his book, *The Future of Invention: Rhetoric, Postmodernism, and the Problem of Change*, Muckelbauer argues that, although different in their aims, the three "dominant styles of engagement" that have marked postmodern thought—advocacy, critique, and synthesis— share the same foundation: negation, or the substitution of one set of beliefs for another (4). Of most interest here are the ideologies of the critique style of engagement, one that "seeks to change things by critiquing the conservative position; hoping to overcome its hegemony by supporting the concepts that have been historically derided" (7). Fundamental to critique is an opposition to "the privileging of a universal truth…[and] the privileging of the object," while promoting "the contingency of opinion" and "things like point-of-view and perspective" (7). Those who make use of critique, Muckelbauer argues, intend for their work "to overcome the conventional power structure by inverting the valence within any given binary," to shift power from those who have dominated to those who have been treated as subordinate (7).

Although these attempts at reversal can alter the content of a binary, "the difference offered by such oppositional postmodernism only functions through the repetition of the very dialectical structure it is attempting to overcome" (Muckelbauer 8). That is, in practice, the critical mode of engagement "only accomplishes…change by reproducing the oppositional structure itself…[and] the very dynamics that enabled that conservative position" (Muckelbauer 7, 8). In this way, critique, like the other "supposedly innovative [and] anti-foundationalist" modes of postmodern engagement, is unable to transform a binary without resorting to what Muckelbauer calls the "structural repetition…of refusal and negation" (4, 11).

Read in the context of Muckelbauer's analysis, Castiel's actions over the course of season six are suggestive both of his orientation toward critique and of the oppositional strictures that Muckelbauer argues define postmodern engagement. In "The Third Man" (6.3), for example, during his first conversation with the Winchesters since the not-Apocalypse, Castiel is careful to position himself in direct opposition to what he characterizes as Raphael's "traditionalist," and therefore dangerous, views. When Sam grumbles about Castiel's unresponsiveness to their previous prayers, Castiel explains that his attentions have been elsewhere: "Raphael and his followers, they want him to rule Heaven. I, and many others, the last thing we want is to let him take over." Raphael's succession "would be catastrophic" for the Winchesters in particular, Castiel argues, for his primary goal is to "end the story the way it was written" by putting Armageddon "back on the rails" ("The Third Man"). Although he does not identify himself as the leader of the opposition, the events of "The Man Who Would Be King" underscore that Castiel's understanding of the significance of the civil war is couched in terms of critique. That is, where Raphael and his followers would restore the old regime rendering moot the Winchesters' many sacrifices, those who stand with Castiel are rebels in the style of Team Free Will, anti-foundationalists fighting for freedom and choice.

But, as Castiel himself acknowledges, he is not the first angel to resist what others see as the will of God. Initially, he rejects Crowley's suggestion that he take on Raphael because it is akin to "asking [Castiel] to become the next Lucifer" ("The Man Who Would Be King"). Crowley, however, underscores how Castiel's kind of rebellion is superior to Lucifer's: "Lucifer was a petulant child with daddy issues... You love God. God loves you. He brought you back. Did it occur to you that maybe he did this so you could be the new sheriff upstairs?" ("The Man Who Would Be King"). Indeed, where Lucifer rejected God's will, Crowley suggests, opposing Raphael will actually allow Castiel to restore it. According to Crowley, Castiel's unexplained resurrection is proof that what God *really* wants is for Castiel to lead Heaven himself.

Central to Castiel's confidence in the rightness of his actions is his refusal to recognize that he, like Raphael, is already part of the power structure of Heaven. As Foucault argues in *Discipline and Punish*, although the power apparatus may appear to have a "head" because of its "pyramidal organization... it is the apparatus as a whole that

produces 'power' and distributes individuals in this permanent and continuous field" (177). In Heaven, particularly in the wake of God's sustained absence, power is a distributed and circulating force. Although some angels may possess more brute strength than others, each one is part of that field of power. Thus, Castiel's actions, just like those of his big brothers, enact "discipline [that] makes possible operation of a relational power that sustains itself by its own mechanism," through the actions of all within it (Foucault, *Discipline* 177). In such a model, what Foucault calls "the hierarchized surveillance of the disciplines," power "is not possessed as a thing, or transferred as a property; it functions like a piece of machinery," one which operates in the same manner no matter whose face appears temporarily at its head (Foucault, *Discipline* 177).

Whether one reads Castiel as already a creature of power, as a Foucaultian reading would suggest, or as engaged in a oppositional postmodern struggle within a binary as defined by Muckelbauer, both of these interpretations underscore Castiel's confinement within a system of power, one that renders his identity as a rebel against the forces of Heaven moot even before he starts down the path that will transform him into the self-proclaimed new God. Although he tells himself that his actions are designed solely to protect the gains made by Team Free Will, the story that Castiel sketches during season six leaves no room for the Winchesters to retain the very agency that he is ostensibly attempting to defend. His unwillingness to recognize his own position within Heaven's system of power leaves Castiel blind to the ways in which his actions repeat, rather than resist, the "very dialectical structure" that he believes he is working to destroy (Muckelbauer 7).

For much of season six, the Winchesters remain oblivious to the objectifying effects of the angel's actions; for, until the depth and breadth of Castiel's machinations are revealed in "The Man Who Would Be King," many of his actions appear to underscore his loyalty. In "Caged Heat" (6.10), for example, Castiel rescues the boys via a classic angel-*ex-machina*. Just before Crowley can crush the Winchesters' windpipes, Castiel swoops in and torches the bones of the demon's original human form, sending Crowley up in a blaze of ignominy—a performance staged solely for the brothers' benefit. Later, in "My Heart Will Go On" (6.17), Castiel represents himself once again as Sam and Dean's protector, this time in the face of what Castiel claims is Balthazar (Sebastian Roché) rogue decision to "unsink" the *Titanic*; in truth, Balthazar took this action on Castiel's behalf in order to create "50,000 new souls for [Castiel's] war machine" in Heaven. The

Winchesters, however, know none of this. They only know that when they awaken from what they believe was a nightmare, Castiel presents himself as their savior: "I insisted that [Balthazar] go back in time and correct what he had done. It was the only way to be sure you were safe" ("My Heart Will Go On").

Ironically, it is in the season's most humorous and ostensibly "meta," or consciously self-referential episode that the destructive potential of Castiel's exercise of authorial control becomes apparent. As "The French Mistake" (6.15) begins, it seems to once again underscore Castiel's willingness to protect the Winchesters at all costs. Balthazar, on the run from Raphael's (Lanette Ware) ally Virgil (Carlos Sanz), the weaponskeeper of Heaven, bursts into Bobby's home and casts a spell that hurls the brothers into an alternate reality, one in which "Sam and Dean Winchester" exist only as fictional constructs on a semipopular television show called *Supernatural*. On its face, this "Bizzaro Earth," as Dean dubs it, appears to represent the very sort of fate from which Castiel wishes to protect them: a kind of commercialized version of the Apocalypse in which the Winchesters exist only as vessels for someone else's story. Here, the brothers are just fiction, creatures whose lives are dictated by the show's weary creative team. Like the row of Impalas the boys discover outside the stage door, the constructs of "Sam and Dean" are "friggin' prop[s]! Just like everything else" ("The French Mistake").

In this episode, among an army of grips, three-quarter walls, and a garishly besweatered actor called "Misha Collins," the Winchesters confront a universe in which their narrative objectification has been fully realized. Stuck in a world where magic and the supernatural do not exist, the real Sam and Dean find themselves locked into a script more rigid in its structure and bewildering in its demands than that of the Apocalypse. The show's producer is a character named Bob Singer, a self-referential version of *Supernatural*'s real-life producer and director of the same name. He instructs the boys that the Winchesters are now in a world where "You cannot make up your own lines" ("The French Mistake"). Thus, the constraints of this universe appear to both the audience and the boys to underscore the importance of the narrative agency Sam and Dean believe they possess within their own universe.

Despite the comedic character of many of their initial adventures, the grotesque nature of this alternate universe rapidly becomes apparent. After their attempt to recreate Balthazar's spell fails, the Winchesters discover that their survival depends upon their ability to

Figure 5.1 As "The French Mistake" closes, Team Free Will has become anything but.

act like "Sam and Dean," rather than to be them. In the episode's signature sequence, the boys attempt to perform themselves through the lenses of Jared Padalecki and Jensen Ackles, the two "douchy" actors who play Sam and Dean. Despite Dean's efforts to ape Collins-as-Castiel's growl and Sam's desperate attempts to avoid looking at the camera, the brothers are unable to convincingly play themselves, to perform the characters of "Sam and Dean" as defined by the show's writers and producers. Like the fierce-looking knife that Dean finds on set, only to discover that it is made of rubber, in this TV reality, the Winchesters are "fake. Everything's fake" ("The French Mistake").

At first glance, this ultimate narrative objectification of Sam and Dean appears to stand in stark contrast to the kind of autonomy that the boys believe they possess in their real lives. However, as "The Man Who Would Be King" reveals, "The French Mistake" instead offers an exaggerated take on the kind of behind-the-scenes manipulation Castiel engages in throughout season six. The makeup of Bizzaro Earth exposes the destructive potential of Castiel's decision to write his own story, one in which the Winchesters cannot possess free will. Unbeknownst to the brothers, the lack of autonomy they experience in "The French Mistake" parallels their stealthy objectification within their own reality. Reduced to mere characters in TV's *Supernatural*, Sam and Dean have become the empty vessels that the archangels so desperately desired; they say other people's lines, stand where they are told, and keep their mouths shut. As Sam observes, "we just don't mean the same thing here," and, ill-equipped to negotiate both the demands of acting on camera and the everyday lives of Padalecki and

Ackles, the brothers lack the narrative agency they need to transform the meaning of "Sam and Dean" within that "unmagicked" reality ("The French Mistake"). Although neither the brothers nor the audience realize it, the Winchesters' lack of agency in this episode is ultimately a repetition of, rather than a variation from, the narrative objectification that now marks their everyday lives. In this way, "The French Mistake" serves to highlight the totality of Castiel's authorial control and hints at the potentially destructive consequences of the choices that the angel has made.

At its core, the story of season six is Castiel's own. The angel concedes this reality when, at the beginning of "The Man Who Would Be King," he looks into the camera and begs the audience, "Let me tell you my story. Let me tell you everything." Here, Castiel acknowledges both the terrible burden he has borne since he lifted Sam's body from Hell and the ramifications of his subsequent, repeated exercise of narrative power over his friends' lives. As Chan's discussion of "It's a Terrible Life" suggests, Zachariah's "intervention...succeeds [only] until Dean looks past the metaphorical curtain" and sees the angel "operating the controls" (Chan, par. 2.5). That moment, she argues, illustrates Foucault's assertion that "power is tolerable only on condition that it mask a substantial part of its self. Its success is proportional to its ability to hide its own mechanisms" (qtd. in Chan, par. 2.5). For much of season six, Castiel manages to keep his exercises of power—narrative agency—behind the "metaphorical curtain" of his familiar identity as rebel, as the Winchesters' most loyal ally. However, the fiction of this narrative, this story that Castiel chooses to tell about himself, begins to crack, what Crowley characterizes as "The big lie," that of "The good Cas. The righteous Cas"; Not only must he lie repeatedly to keep the facade intact, but he must kill, cheat, and, in the end, even murder one of his comrades, Balthazar ("The Man Who Would Be King").

Castiel's story, then, mirrors what Foucault describes later in the same passage from which Chan draws; the idea that individuals accept power because they "see it as a mere limit placed on their desire, leaving a measure of freedom—however slight—intact," a fiction which power's relative invisibility makes possible (*History* 86). Once he is forced to admit his duplicity to the Winchesters, Castiel's carefully constructed narrative falls in ashes, forcing him to let go of the fiction of the "measure of freedom" that has driven his decision making for almost two years. In its absence, Castiel's subsequent actions in "The Man Who Knew Too Much" (6.22) serve to make manifest the identity he has been practicing all season. After cracking Purgatory open

and absorbing the power of the millions of souls within it, Castiel looks into the faces of the Winchesters, his "pets," and declares: "I'm not an angel anymore. I'm your new God. A better one. So you will bow down and profess your love unto me...or I shall destroy you" ("The Man Who Knew Too Much").

In effect, the angel has been acting as the Winchesters' God ever since he lifted Sam's body from Hell; absorbing the souls of Purgatory, and the power that they possess allows him to become the new God in name as well as deed. In this moment, Castiel stakes rhetorical claim to his position within the dynamistic system of heavenly power, erasing any notion that his exercise of power leaves open any "measure of freedom" (Foucault, *History* 86). He gives up the identity of rebel to which he has so studiously clung, and chooses instead to reperform himself as the new head of Heaven, a foundationalist who will rule through domination, through "the privileging of a universal truth," and through the objectification of Sam and Dean (Muckelbauer 7).

Ultimately, the events of season six prove cruelly ironic for both the Winchesters and Castiel. After all of the sacrifices that have marked their struggle to disrupt destiny and gain authorial control over their own lives, Sam and Dean find themselves betrayed by the one angel whose loyalty to their cause was without question, the one angel whom they called friend. Indeed, from his perch at their side, Castiel is able to achieve what the archangels could not: the transformation of the Winchesters into narrative objects, characters in a tale that Castiel alone controls. That said, Castiel's reign as the new God proves quite brief, coming to an abrupt end in "Hello Cruel World" (7.2) when the power of the Leviathan dissolves both the angel's vessel and his grace.

However, it is in season eight that the ramifications of Castiel's actions in season six become particularly disastrous. First, against his will, Castiel is raised from Purgatory by Naomi (Amanda Tapping), an angel working to lead some of Heaven's remaining forces. Naomi then sends the newly resurrected Castiel back to the Winchesters as a spy—no longer a master of his own story, but as a narrative object of Naomi's own. In this way, Castiel is made to repeat the same fate he imposed upon Sam and Dean. With his own agency removed and his free will disrupted, Castiel is made a pawn in the same play of "unceasing manipulation" that marked the Winchesters' lives before Team Free Will halted the Apocalypse (Gray, par. 6). In the end, then, the story of Castiel, the rebel who reached for the crown, is a pantomime of freedom and choice, one that underscores how much of an illusion free will in *Supernatural*—in our own "unmagicked" reality—can be.

Works Cited

"Caged Heat." *Supernatural: The Complete Sixth Season*. Writ. Brett Matthews. Dir. Robert Singer. Warner Brothers, 2010. DVD.

Chan, Suzette. "*Supernatural* Bodies: Writing Subjugation and Resistance onto Sam and Dean Winchester." *Transformative Works and Cultures* 4 (2012). n. pag. Web. 20 Sept. 2012.

Corder, Jim W. "Argument as Emergence, Rhetoric as Love." *Rhetoric Review* 4:1 (1985). 16–32. Print.

Foucault, Michel. *Discipline and Punish.* New York: Vintage, 1991. Print.

———. *The History of Sexuality. Volume 1: An Introduction.* New York: Vintage, 1990. Print.

"The French Mistake." *Supernatural: The Complete Sixth Season*. Writ. Ben Edlund. Dir. Charles Beeson. Warner Brothers, 2010. DVD.

Gray, Melissa. "From Canon to Fanon and Back Again: The Epic Journey of *Supernatural* and its Fans." *Transformative Works and Cultures* 4 (2010). n. pag. Web. 13 Aug. 2013.

"It's a Terrible Life." *Supernatural: The Complete Fourth Season*. Writ. Sera Gamble. Dir. James L. Conway. Warner Brothers, 2008. DVD.

"The Man Who Knew Too Much." *Supernatural: The Complete Sixth Season*. Writ. Eric Kripke. Dir. Robert Singer. Warner Brothers, 2010. DVD.

"The Man Who Would Be King." *Supernatural: The Complete Sixth Season*. Writ. Ben Edlund. Dir. Ben Edlund. Warner Brothers, 2010. DVD.

"The Monster at the End of This Book." *Supernatural: The Complete Fourth Season*. Writ. Eric Kripke and Julie Siege. Dir. Mark Rahl. Warner Brothers, 2008. DVD.

Muckelbauer, John. *The Future of Invention: Rhetoric, Postmodernism, and the Problem of Change.* Albany: State U of New York P, 2008. Print.

"My Heart Will Go On." *Supernatural: The Complete Sixth Season*. Writ. Eric Charmelo and Nicole Snyder. Dir. Phil Sgriccia. Warner Brothers, 2010. DVD.

"Of Grave Importance. *Supernatural: The Complete Seventh Season*. Writ. Brad Buckner and Eugenie Ross-Leming. Dir. Tim Andrew. Warner Brothers, 2011. DVD.

"The Song Remains The Same." *Supernatural: The Complete Fifth Season*. Writ. Sera Gamble and Nancy Weiner. Dir. Steven Boyum. CBS, 2009. DVD.

"Swan Song." *Supernatural: The Complete Fifth Season*. Writ. Eric Kripke. Dir. Steve Boyum. Warner Brothers, 2009. DVD.

"Sympathy for the Devil." *Supernatural: The Complete Fifth Season*. Writ. Eric Kripke. Dir. Robert Singer. Warner Brothers, 2009. DVD.

"The Third Man." *Supernatural: The Complete Sixth Season*. Writ. Ben Edlund. Dir. Bob Singer. Warner Brothers, 2010. DVD.

II

"Killing Evil Things" or Not—*Supernatural*'s Complex Considerations of Monstrosity

All Dogs Come from Hell: *Supernatural*'s Canine Connection

Sharon D. King

The blood-longing became stronger…He was a killer, a thing that preyed, living on the things that lived, unaided, alone…surviving triumphantly in a hostile environment where only the strong survived.

—Jack London, The Call of the Wild

The issue of monstrosity lies at the heart of the TV series *Supernatural*. It is not simply that monsters are what the Winchester brothers, with their earnest yet world-weary modus operandi, track down and destroy. It is what constitutes the monstrous that gives their pursuit meaning, edge, and terror. The alien-looking, merciless creatures such as the Wendigo are not only, perhaps not even primarily, what strikes fear into the series' spectators, but rather the creatures with ostensible proximity to humanity—shapeshifters cloaked in lamb's clothing whose savagery soon belies itself. Scholars have long defined monsters as the commingling of two or more different types of creatures (Burke), noting that the hybrid nature of entities with both animal and human elements creates a source of "confusion and horror" that "threaten[s] to destabilize all order, to break down all hierarchies" (Hanofi 2–3). Such creatures are as often rendered pity-inspiring victims as formidable enemies, whose demise poses ethical dilemmas. These monsters bring life to *Supernatural*'s fundamental questions: Are Sam (Jared Padalecki) and Dean (Jensen Ackles)—having both

taken on a demigod's burden of guilt, Hell-harrowing, and losing and regaining of a soul—not themselves beings of a dual nature? Are they killers first or saviors? Moral or heartless? Worthy of trust or forever a potential threat?

Such questions are thrown into even brighter relief when the Winchester brothers confront the numerous monsters of the genus *Canis*. For dogs themselves, having walked many thousands of years in the company of humankind, are quintessentially hybrid creatures, products of both "nature and culture" (Van Sittert and Swart 1). Few other creatures enjoy such a prized, beloved status among humankind. Mark Derr has analyzed the step-by-step march from wild wolf to tame pet, theorizing that dogs may be the result of the two species—wolves and humans—having an empathetic comprehension of the other in the process of hunting large game, in effect "recognizing themselves" in each other (29, 85–98). Certainly, humans' early domestication of dogs to assist in hunting and defense,[1] their use of artificial selection to produce animals for show and companionship, has led to "a breed apart": dogs occupy a very privileged, if conflicted, niche in human civilization. Yet while apotheosized in the arts, sports, and culture as faithful, playful, comforting companions, the dog never lets us forget its hybrid nature, its groomed appearance and tamed behavior still permitting glimpses of the fierce beast lurking beneath. Primal fears of predatory wolves and wild dogs, cloaked in mythic or paranormal guise, continue to cast shadows over human consciousness.

In *Supernatural*, the fundamental concepts of companionship, loyalty, and even family, that are symbolized by human–canine interaction both parallel and contrast with the complex, often troubled relationship between the brothers—devil-may-care Dean and educated Sam. Such parallels work within a long tradition of animal spectacle in Western discourse: "The animal act configures the human in the company, in the obscure language and thought, of the animal" (Ham and Senior 1). Self-identified as professional predators known as "hunters," the Winchester siblings are constantly "other" than those with whom they mingle, among them yet apart. As they hunt monsters, they must confront friends, lovers, parent figures, and mentors who turn on them or abandon them, leaving few on which they can rely. Over the course of the series, Dean is sent to Hell and emerges a changed man; Sam drinks demon's blood, giving him demonic powers, and later has his soul stolen from him. Trust between the siblings is in constant flux. Their emotional

upheavals—the deep sadness of rejection, the agony of betrayal, the loss of their ever-mortal companions—strike a deep primal chord with audiences. So does the constant tension between the pair's need for familial bonds vis-a-vis the need to survive. The canine monsters hunted by the pair, some more misguided than evil, are juxtaposed with Sam and Dean's own often-monstrous acts, calling into question the brothers' very identity as human beings.[2]

Some of the chief qualities of canine species become focal points for the brothers' confrontations and conflicts. Dogs are traditionally considered brave protectors and defenders, known to provide help (in behavior called "succorant") to distressed or endangered individuals other than their progeny (de Waal 41). Such rescuing behavior is as well known in real life—St. Bernards and guide dogs—as in cinematic figures such as Rin Tin Tin, Lassie, and Jack in *The Artist*. Canine creatures in the wild show a form of partnership, an altruistic support for each other: African wild dogs as well as wolves are known to "beg food from one another in a reciprocal manner" (qtd. in Wilson 120). The savagery of wild canine animals is also well established: wolves will "bring down prey far in excess of food needs, destroy sick pups, and…have killed humans in North America, notably Inuit and other Native American hunters, who share territory and prey" (Antonio 217). In the wild packs of wolves are dominated by one creature, though observers have noted that the wolf leader generally "controls his subordinates…without any display of overt hostility [Schenkel, 1947]" (qtd. in Wilson 280). The veneration of the archetypical figure of the hunter in American culture goes hand-in-paw with dog culture, in recognition of a long-standing partnership: "Cooperation between a hunter and a dog…has existed ever since the Mesolithic, perhaps one reason why the wolf was tamed" (Jennbert 87). Perhaps chief among the qualities humans ascribe to the dog, however, is its companionship, its loyalty, constancy, and trustworthiness among its human masters and comrades (Bergler 9–14).

Fittingly for a horror series, and setting the tone for future terrors in *Canidae*, the first significant canine creatures to appear in *Supernatural* are anything but domesticated beasts (albeit in fantastical guise) living in harmony with humankind. A pack of hellhounds, in the atmospheric episode "Crossroad Blues" (2.8), sounds the infernal tocsin: snarling, shadowy creatures that stalk those unwise enough to have made pacts with the devil, mauling them to pieces as they descend into Hell. Demonic dogs in general, and hellhounds in particular, have a long pedigree in human folklore. They are symbolic

of the feral, the tamed part of the dog having reverted and abandoned its human connection, leaving them with even more ferocity than the wildest of wolves. Arguably less popular in cinematic media than werewolves, infernal dogs are well represented in Western narratives—Cerberus guarding Hades, Faust's demonic black poodle, the Gytrash of *Jane Eyre*, the diabolical dog in "The Hound of the Baskervilles," and the hellish pursuers in *All Dogs Go to Heaven*. *Supernatural*'s hellhounds are hunters by nature, not unlike the Winchester brothers: enforcers relentless in their pursuit of those bound over to the devil. *Supernatural*'s huge black hellhounds are terrifyingly visible to those they pursue. The series' mode of presentation makes their alterity obvious: we see the world from the hounds' point of view as they rush past a terrain desaturated of color, furthering our sense of their monstrous otherness.

"Crossroad Blues" traces the hellhounds' terrifying attacks on those who sell their souls for talent, starting with 1930s blues guitarist Robert Johnson, then on modern-day artists and professionals—an architect, a doctor, a painter. But the fury of the hellhounds signals a flashpoint in the brothers' own relationship, ironically highlighting the stereotype of the faithful person—dog or human—that risks his life for another, long a staple of Western narrative (Brown 133). During the pair's investigation of the spectral dogs—Dean commenting with characteristic dry wit that the dogs doubtless "could hump the crap out of your leg"—Dean suggests that those making such pacts should perhaps be left to clean up "their own messes." Sam shrinks from the idea that anyone should be left to die in agony. That such a bargain could be turned into a sacrifice for the sake of another is brought home when they find another hounded soul, Evan Hudson, who has traded his life to spare that of his cancer-stricken wife. Though Dean questions the selfishness behind such a pact ("What if she knew you lost your soul?" he asks Evan), he insists on confronting the demon at the crossroads to cancel the contract. Although Sam doubts Dean's intention, not trusting where his brother's "head is at," Sam finally acquiesces to Dean's proposal. The audience discovers Sam's intuition was correct: during her confrontation with Dean, the crossroads demon insinuates that the brothers' own father made just such a bargain, selling his soul to spare Dean's life. "Like father, like son," she taunts Dean when he offers his soul to save Evan. Though Dean does win Evan's release without it, Dean is tormented by thoughts of the self-sacrifice he proposed—one that will come back to haunt them both.

For Dean will make just such a bargain, selling his soul to bring his brother back to life when Sam is killed, in the second season's final episode, "All Hell Breaks Loose Part 2" (2.22). Given only a year of life, Dean again confronts the hellhounds, this time summoned by Lilith (whom he calls "Queen Bitch," and who refers to him sarcastically as "puppy chow") when the debt comes due, in "No Rest for the Wicked" (3.16). Dean is torn to pieces by these baying demon dogs that enforce the death of the older brother that the younger sibling, Sam, might live. Such sacrifice for the sake of others occurs in other episodes with hellhounds, notably "Abandon All Hope…" (5.10), in which hunters Jo Harvelle (Alona Tal) and her mother Ellen (Samantha Ferris), one mortally wounded and the other determined her death shall not be in vain, lure the hellhounds into a trap and destroy them, both perishing in the process.[3]

The dog's ancestor and brother, the wolf, albeit in mythical guise, also features in several canonical canine episodes of *Supernatural*. Longtime rival predator and foe of humans, the wolf, "living symbol of wildness and wilderness" (Preso), remains the enduring emblem of the persistence of the wild and untamed in the Western world. The werewolf, known to popular Western fantastical literature since well before Marie de France's lay *Bisclavret*, first appears in season two's episode "Heart" (2.17). The episode treats this iconic, terrifying shapeshifter tied to the phases of the moon in a classical manner, with a few postmodern twists. As is typical for *Supernatural*, this hybrid creature "human by day, freak animal killing machine by moonlight" is not seen at first. Its presence is merely evoked: at a bar in San Francisco, a young woman, Madison (Emmanuelle Vaugier), senses a threat and abruptly departs. Outside, in the series' recurrent use of foreshadowing, she is startled by a crash that turns out to be from a dog-creature rummaging through a garbage can. The next day at her office, she finds her boss, an attorney who had obliquely flirted with her, dead, with his heart ripped out. A security guard in an alleyway is similarly ravaged by an unseen creature that barks and snarls viciously. The Winchester brothers uncover a pattern of death (mostly involving prostitutes) around the lunar cycle, with Madison's ex-boyfriend Kurt the werewolf suspect, or as Dean cynically terms him, "our dog-faced boy" and later "our Cujo."[4]

But the ex-boyfriend emerges as one of the series' trademark misdirections. When Kurt is slaughtered, Dean discovers that Madison, recently a mugging victim, is the werewolf, though unaware of it; she had slipped out of the house to dispatch the menacing Kurt while

Sam, who had been guarding her, slept in the next room. Though she denies being the hybrid creature, she is found with a cut on her arm; Dean had slashed her arm with a silver knife, the traditional metal used to destroy werewolves. The tale is, among other things, a twisted, upended feminist revision of power relations; Madison explains to Sam that the mugging had a positive outcome for her, prompting her to "take control of her life." Yet, though Madison in werewolf form can certainly address threats with force, she has, in fact, been assaulted by her own monstrous, irrevocable transformation, done without her knowledge and against her will.

While both venerating and innovating the traditional werewolf legend, "Heart" underscores the fundamental characteristics of the wolf—savagery, bravery, and predatory prowess, both in groups and individually—that form the brothers' "work" ethic as hunters. These characteristics are intrinsic to both man and beast: wolves in the high arctic, according to *National Geographic* researchers, have been observed showing patience, intelligence, and resourcefulness in pack hunting (qtd. in Antonio 220–221). While both brothers show near-total ruthlessness in their pursuit of the killer, Dean takes the initiative for monster-slaying, even taunting Sam for taking the side of those they are supposed to hunt, calling him the "Dog Whisperer." Sam, in turn, seems the more "human" of the two, suggesting that he might "understand" Madison and showing compassion for her, unwittingly changed and with no control over who she has become. Both brothers show the anthropomorphized quality of bravery so often ascribed to wolves: Dean tracks down and destroys the original werewolf who turned Madison; Sam, having just made love to Madison, nevertheless—though against his will—shoots her with a silver bullet once she discovers she will still devolve into the wolf-monster[5] and begs him for release.

The hybrid Madison also affects the brothers' relationship, her canine characteristics often paralleling their own. The siblings bicker, argue, and fight for dominance both in protecting Madison—playing a game of rock/paper/scissors to decide who will guard her—as well as destroy her. Upon learning Madison's identity, Dean wants to kill "the monster" summarily; Sam insists they first track down the one who turned her, to see if she might turn back. They show rivalry as well in their overt sexual attraction for her, something Madison herself manipulates (in one scene she deliberately folds lacy panties in front of Sam) and to which Sam tragically succumbs.

The fundamental concepts of family and loyalty are again at stake in "All Dogs Go to Heaven" (6.8), an ironic reference to the 1989 film of a dog that risks eternal damnation to protect the little girl he loves. From the start, this episode poses questions about what constitutes true family and who deserves kindness. The audience witnesses a vicious assault perpetrated on a stereotypically genteel "family man" asking after his child; the man is later identified as a heartless slumlord. A dockworker "with enemies" is similarly slain. In the series' classical ploy of misdirection, both killings are identified as "animal attacks" and tentatively blamed on a werewolf. More significant to issues of family is the back story of the brothers' ongoing, and worsening, quarrel over the devil's bargain that forces them to work for the blackmailing "King of Hell" Crowley (Mark Sheppard), in hopes of one day restoring Sam's soul. During the brothers' stop at a rib joint, a meal simultaneously evoking canine food and an opportunity for social bonding, Crowley appears and tries to drive a wedge between them, taunting that the soulless Sam would sell his own brother for a drink were he thirsty. Later, in their Impala, Dean questions Sam's trustworthiness, his very essence: "I don't know even know who you are." Sam's defensive protest that he is still Dean's brother and will prove it comes just after Crowley's revelation that the first victim's chest was savagely ripped open, heart missing, an image paralleling Dean's worst fears about the spiritual fate of his brother.

The true nature of the killer is revealed slowly. We see a "typical" family: doting if disorganized mother Mandy (Janet Kidder), innocent child, and their dog, a German shepherd that protectively growls when the irresponsible, hungover boyfriend Cal (Jason Diablo) enters the kitchen. Questions of familial and social bonds again rise to the fore as the brothers question Mandy: the first victim was Cal's slumlord brother, with whom he had had a violent confrontation. The second victim is revealed to have been the family's landlord, who was evicting them for perennially late rent payments. The brothers assume Cal is the werewolf since he has been the only link to the two victims; significantly, here it is Dean who insists on proof before consigning Cal to hell. Though they wait all night, proof does not come. Instead, once the brothers have departed, it is the dog, ironically named Lucky (Andrew Rothenberg), that attacks Cal and rips him apart, then transforms into a naked, blood-spattered man. The naked man is next seen wistfully watching over Cal's girlfriend as she sleeps, and later, changed back into the German shepherd, curling up next to her on the

Figure 6.1 "Oh, Lucky…honestly, you are the only decent boyfriend I've ever had."

bed as if to shield her from harm. The pose is iconic, harking back to the unique, intimate bond between women and their faithful pet dogs in Western art and narrative (Brown 65–89), and poignantly sets up both character and audience for the heartbreak to come.

The revelation that Lucky is a shapeshifter and yet a beloved member of the family who kills only in order to protect those he loves makes this show's canine connection especially troubling. Lucky is eminently a dog, one that runs to fetch a plaything for the little boy ailing with flu, one scolded for possibly "killing a bird" when blood (from killing Cal) is found on his fur, one whose keen sense of smell tells him that Sam, who witnesses his transformation, is tracking him. In their characteristic satirical banter, the brothers toy with the stereotypes of such a hybrid creature, teasing the man-beast to "speak," taunting him with "snausages," scolding him for being a "bad dog" and wanting to play with his food. Sam even whistles and feigns tossing a ball to Lucky in man form, showing a lack of compassion that Dean gently reprimands him for. Yet there is a definite sense of transgression in the man-side of this "werewolf cousin" monster, the fear of bestiality that is one of the more lasting of human taboos. Praised unwittingly by Mandy as "the only decent boyfriend" she's ever had, Lucky wakes her with doggie kisses and stares while she disrobes and showers, all demonstrating an interest as much sexual as it is familial. The brothers themselves reflect this unease when they ask if Lucky's choice to live with the family is a "kinky thing" and wonder if he may need to be "neutered."

Lucky's final confrontation with Mandy, once his hybrid nature has been revealed, only confirms his transgressive presence. When

he appears in human form at her door to apologize, stammering that hers was "the only family"[6] he had ever had, she recoils in horror and disgust, calling him a "psycho." There is more than a hint of past abuse in Mandy's reactions to both Cal and to Lucky in human form, evoking perhaps the "contingent...status of woman and animals in patriarchal culture" evidenced by such abuse that levels both types of creatures to positions of violability (Adams 79). But Mandy's response to Lucky's plea for understanding is unambivalent: ordering him never to contact her family again, she slams the door in his face.

The dual nature of the shapeshifter calls to mind the selfsame problem of divided loyalties raised in London's novel *The Call of the Wild*.[7] For the creature Lucky is neither unique nor alone. Though devoted to the human companions that gave him shelter, the man who became Lucky had long ago sold his soul as a way of improving his homeless, miserable existence, throwing in his lot with other fellow shapeshifters in similarly dire straits. This relationship is an eerily literal interpretation of the communion many find with their companion animals: "Those humans who are outcast from established power structures find strength and freedom in the absolute otherness of the animal...communion with animals can be translated into community" (Scholtmeijer 252). Joined to a society of peers, the transformed, strengthened Lucky becomes one of a savage hybrid pack, who, upon a signal (a "psychic dog whistle," Dean terms it) will "turn" his family into hybrids like himself, wreaking havoc upon humankind. Lucky's faithfulness to those he cares about remains an open question for most of the episode. In the final confrontation, during which his human family is taken hostage and he is commanded to "turn" them, Lucky does ultimately succor and shelter Mandy and her son from his fellows, all different breeds, some more wild-looking than others. Lucky is even mocked for "protecting" mother and son by the quintessential "leader of the pack" of shapeshifters, who derides Lucky's devotion by calling him "a dog"—a conscious evocation of the "lesser half" of his divided nature. Yet Lucky's actions to help mother and child escape are precipitated as much by the timely intervention of the Winchesters as by his own initiative. The creature's questionable trustworthiness is directly paralleled to Sam's lack of humanity in an earlier interchange between the brothers. While they ponder if Lucky will lead them to the pack or betray them, Sam candidly admits that were it him, "I'd double-cross us." Dean's wry response, "Thanks, Dexter," registers his recognition of his brother's soullessness.[8]

Lucky's exposure as a shapeshifter not only destroys his own sole claim to family, exiling him to wander the streets looking for a new home. Mandy's horrified response to his apology makes it clear that he has shattered the bonds of trust within what remains of her household. It is ironic, then, that it is precisely the brothers' dealings with this rejected creature, neither fully human nor animal, that prompt their own reconciliation, as well as a vow to restore Sam's humanity. In the episode's last scene, Sam confesses he is empty inside, uncaring about everyone, including Dean; he has killed the innocent and feels no remorse even though he knows social mores say he should. Although still able to work efficiently as a hunter, Sam resolves to try to retrieve his soul: "I was the other Sam for a long time…I should go back to being him." "It's a step," Dean concedes with relief, pledging to help restore his brother's spiritual integrity.

As if to highlight *Supernatural*'s exploration of canine concerns, season eight abounds with dog-related motifs, characters, and plot twists. Some are subtle: the barking of neighborhood dogs in "What's Up, Tiger Mommy" (8.2) establishes the apparent normality of the prophet Kevin's (Osric Chau) mother's suburban home, in which she is ironically being kept prisoner by demonic guards awaiting her son. Some are overt, illuminating the Winchester brothers' shifting priorities and challenges. The lone survivor at the end of the love-triangle-caught-on-tape werewolf story "Bitten" (8.4) banishes herself, vowing to survive on animal flesh; the brothers, moved by her story, allow her to escape. Hellhounds—now made blurrily, horrifically visible via special spectacles—again emerge to terrorize those who make pacts with Crossroads Demons in "Trial and Error" (8.14). Though Dean attempts to "spike Fido" in order to bathe in its blood, thus initiating the three divine tests intended to seal the Gates of Hell, it is Sam who ends up slaying the hellhound and being covered in its blood, setting him up for a sacrificial role Dean is loath to cede to him.

Indeed, the story arc of season eight brings a dog and its associations—the responsibility of caring for a pet, the devoted presence at hearth and home—front and center into the brothers' relationship. While Dean is in Purgatory, Sam hits a stray dog with the cherished Impala, rushes the dog to a veterinarian—and falls in love with the woman (Amelia, a war widow) who gives it care. Utterly alone and despairing, Sam does the unthinkable and turns his back on his former life, hanging up his hunter's tools and ignoring his phone. Through flashbacks across numerous episodes (8.1, 8.3, 8.6, 8.8), we see the traumatized Sam and the broken Amelia gain a momentary

sense of family, something which, with Dean gone, Sam believed was forever lost. The dog's omnipresence in the scenes of homey comfort during Sam's year emphasizes its emblematic status of "normal" human existence long denied the supernatural-hunter brothers. The dog even serves as irresistibly charming icebreaker for Sam to gain Amelia's skeptical father's trust during the father's dinner in the pair's new house ("Hunteri Heroici" 8.8). But Sam's shift from predatory existence to domesticated bliss cannot last: Amelia's husband unexpectedly turns up alive, and Sam leaves his newfound home. Equally miraculously, Dean reappears. Dean is outraged at Sam for abandoning him, and for so easily giving up the "family business" during his brother's absence. This sense of betrayal makes Dean confront Sam repeatedly ("Southern Comfort" 8.6), sarcastically challenging Sam's "deep, abiding love" for him ("We Need to Talk about Kevin" 8.1). But when Dean dares Sam to prove his loyalty and choose his life— something Amelia also demands—Sam elects to remain with Dean and resume hunting. The episode's final scene shows them sharing the creature comforts of food and drink ("Torn and Frayed" 8.10), hallmark of the fragile truce between them.

Truce, but not yet trust. That must wait for another case also revolving around a dog: "Man's Best Friend with Benefits" (8.15). The brothers are summoned to solve a series of murders implicating their friend, policeman James Frampton (Christian Campbell), who has turned to witchcraft to solve his cases. They discover they were contacted by James's "familiar" Portia (Mishael Morgan), a beautiful woman who can assume the shape of a Doberman bitch (in a comical misdirection, Sam pleads with Dean to "let her stay the night," indicating the dog, which has become the woman). Portia reveals the "unbreakable bond" she shares with James, in which "familiar and master…become inseparable" and they would "die for each other." This both describes the dog–human relationship and parallels the way the two brothers are inextricably knit together, despite separations and despair. Yet James and his familiar are more closely tied than most: they are sexually involved—shown in an explicit scene of lovemaking, with bondage (James in chains) standing in for the unspoken possibility of bestiality. This transgression is something even the witch community finds beyond the pale. It leads to James's betrayal by former friend and fellow witch Spencer (Curtis Caravaggio), who has been framing him for the murders. But while a dog-human connection was cause for James's woes, it is also cure: Portia in canine guise savages Spencer's throat, enabling Sam and Dean to destroy him. And

this canine encounter, culminating with the lovers having to leave and "start over" somewhere else like the peripatetic Winchesters, also prompts a reconciliation between the brothers. Dean acknowledges his distrust of Sam was wrong and insists the only way to survive is by "hanging together." In keeping with the series' sense of wrenching irony, it is at this moment we see that Sam is desperately ill from the first divine test, but like a stricken animal hides the illness from view.

According to the Dreamtime Aboriginal saying, "The dog is what we would be if we were not what we are" (qtd. in Derr 23). The divided nature of dogs themselves and of other canine creatures in supernatural guise reflects the Winchester brothers' struggle, their ceaseless quest for humanity's deliverance from malevolent creatures while both have had their humanity, and its innocence, ripped away from them. Yet like the domesticated dog, there is no turning back from who they have become. Perhaps *Supernatural*'s greatest strength is that the omnipresence of the paranormal reveals the best, as well as the worst, of natural relationships. Sam and Dean are inextricably linked to each other; empathy and mercy prove as strong as cruelty and terror. The Winchester brothers may ever contend with the dogs of immortal combat, but they remain equally bound to the hounds of Heaven.

Notes

1. Scholars debate when the divergence from wolf to dog occurred: archaeological research posits 10,000–14,000 years ago; mitochondrial evidence suggests closer to 135,000 years (Naficy).
2. The brothers' quest to put down canine and other monstrous creatures parallels the fate of deviant animals of monster movies, creatures viewed as abject, "out of place," and subject to "re-ordering, regulation, and management to re-establish boundaries" (Molloy 165). Such a fate also constantly befalls Sam and Dean.
3. Hellhounds also appear as guards or otherworldly hitmen in episodes 3.15, 5.20, 6.4, and 6.10.
4. Sly homages to masters of print and film horror are a *Supernatural* hallmark, here Stephen King's novel about a rabid dog. The brothers also pose as "detectives" Landis and Dante, a nod to 1980s werewolf film directors John Landis and Joe Dante.
5. Madison does not always change during the full moon, indicating another departure from the traditional werewolf legend.
6. The episode reifies the stereotype of humans treating pets better than their fellow humans, Dean commenting, "I'll never look at a dog the same again."

7. Critics note that London's novel paints an anthropomorphized portrait of the dog–master relationship; here it reiterates stereotypes about dogs in human culture.
8. Sam's loss of soul manifests as a loss of personality and role reversal; he lacks both judgment—making him jump to conclusions—and empathy, making flippant comments heretofore Dean's forte (i.e., the *Ghostbusters* quote "Dogs and cats living together. Mass hysteria.") While Dean stresses their mission is to "destroy monsters," Sam coldly considers using the leader as leverage to compel Crowley to return his own soul.

Works Cited

"Abandon All Hope…" *Supernatural.* Writ. Ben Edlund. Dir. Phil Sgriccia. CW. 19 Nov. 2009. Television.

Adams, Carol J. "Woman Battering and Harm to Animals." *Animals & Women: Feminist Theoretical Explorations.* Eds. Carol J. Adams and Josephine Donovan. Durham: Duke U P, 1995. 55–84. Print.

"All Dogs Go to Heaven. " *Supernatural.* Writ.Adam Glass. Dir. Phil Sgriccia. CW. 12 Nov. 2010. Television.

"All Hell Breaks Loose Part 2." *Supernatural.* Writ. Eric Kripke. Dir. Kim Manners. CW. 17May 2007. Television.

Antonio, Diane. "Of Wolves and Women." *Animals & Women: Feminist Theoretical Explorations.* Eds. Carol J. Adams and Josephine Donovan. Durham: Duke UP, 1995. 213–230. Print.

Bergler, Reinhold. *Man and Dog: The Psychology of a Relationship.* Trans. Brian Rasmussen and Dana Loewy. Oxford: Blackwell, 1988. Print.

"Bitten." *Supernatural.* Writ. Robbie Thompson. Dir. Thomas J. Wright. CW. 24 Oct. 2012. Television.

Brown, Laura. *Homeless Dogs and Melancholy Apes*: *Humans and Other Animals in the Modern Literary Imagination.* Ithaca: Cornell, 2010. Print.

Burke, Peter. "Frontiers of the Monstrous: Perceiving National Characters in Early Modern Europe." *Monstrous Bodies/Political Monstrosities in Early Modern Europe.* Eds. Laura L. Knoppers and Joan B. Landis. Ithaca: Cornell, 2004. 25–39. Print.

"Crossroad Blues." *Supernatural.* Writ. Sera Gamble. Dir. Steve Boyum. CW. 16 Nov. 2006. Television.

Derr, Mark. *How the Dog Became the Dog: From Wolves to Our Best Friend*s. New York: Overlook Duckworth, 2011. Print.

de Waal, Frans. *Good Natured: The Origins of Right and Wrong in Humans and Other Animals.* Cambridge: Harvard, 1996. Print.

Ham, Jennifer, and Matthew Senior. *Animals Acts: Configuring the Human in Western History.* New York: Routledge, 1997. Print.

Hanofi, Zakiya. *Monster in the Machine: Magic, Medicine and the Marvelous in the Time of the Scientific Revolution.* Durham: Duke U P, 2000. Print.

"Heart." *Supernatural.* Writ. Sera Gamble. Dir. Kim Manners. CW. 22 Mar. 2007. Television.

"Hunteri Heroici." *Supernatural.* Writ. Andrew Dabb. Dir. Paul Edwards. CW. 28 Nov. 2012. Television.

Jennbert, Kristina. *Animals and Humans: Recurrent Symbiosis in Archaeology and Old Norse Religion.* Lund: Nordic Academic Press, 2011. Print.

London, Jack. *The Call of the Wild.* Norman: Oklahoma, 1995. Print.

"Man's Best Friend with Benefits." *Supernatural.* Writ. Brad Buckner. Dir. John F. Showalter. CW. 20 Feb. 2013. Television.

Molloy, Claire. *Popular Media and Animals.* Basingstoke: Palgrave Macmillan, 2011. Print.

Naficy, Siamak. *Inside of a Dog: What Dogs Can Tell Us About Human Evolution.* Los Angeles: UCLA Dissertation, 2011. Print.

"No Rest For The Wicked." *Supernatural.* Writ. Eric Kripke. Dir. Kim Manners. CW. 15 May 2008. Television.

Preso, Tim. "Protecting Wyoming's Gray Wolves." *earthjustice.org.* earthjustice, 8 Oct. 2012. Web. 9 Nov. 2012.

Rychner, Jean. *Les Lais du Marie de France.* Les Classiques Français du Moyen Age 93. Paris: Champion, 1973. Print.

Scholtmeijer, Marian. "The Power of Otherness: Animals in Women's Fiction." *Animals & Women: Feminist Theoretical Explorations.* Eds. Carol J. Adams and Josephine Donovan. Durham: Duke UP, 1995. 231–62. Print.

"Southern Comfort." *Supernatural.* Writ. Adam Glass. Dir. Tim Andrew. CW. 7 Nov. 2012. Television.

"Torn and Frayed." *Supernatural.* Writ. Jenny Klein. Dir. Robert Singer. CW. 16 Jan. 2013. Television.

Thompson, Nato, ed. *Becoming Animal: Contemporary Art in the Animal Kingdom.* North Adams: MIT Press, 2005. Print.

"Trial and Error." *Supernatural.* Writ. Adam Dabb. Dir. Kevin Parks. CW. 13 Feb. 2013. Television.

Van Sittert, Lance, and Sandra Swart. *Canis Africanis: A Dog History of Southern Africa.* Boston: Brill, 2008. Print.

"We Need To Talk About Kevin." *Supernatural.* Writ. Jeremy Carver. Dir. Robert Singer. CW. 3 Oct, 2012. Television.

"What's Up, Tiger Mommy?" *Supernatural.* Writs. Andres Dabb and Daniel Loflin. Dir. John Showalter. CW. 10 Oct. 2012. Television.

Wilson, Edward O. *Sociobiology.* Cambridge: Harvard UP, 1975. Print.

"This Isn't Wall Street, This Is Hell!": Corporate America as the Biggest *Supernatural* Bad of All*

Erin Giannini

Across *Supernatural*'s first six seasons, brothers Dean (Jensen Ackles) and Sam (Jared Padalecki) Winchester have faced threats from Heaven and Hell, ancient gods, and primal beasts. They have lost friends, enemies, and all of their immediate family. Both brothers have died and been resurrected. They did, however, have each other, their beloved '67 Chevy Impala, and a father figure in the person of Bobby Singer (Jim Beaver). Season seven, however, offers villains— the Leviathans—released from Purgatory and capable of passing as human, against whom most of the Winchester's usual weapons do not work. What is more dangerous, however, is that the leader of the Leviathans, Dick Roman (James Patrick Stewart), situates himself as the head of a powerful corporation. This positioning allows the season's villains to wreak far more damage on the Winchesters, on both a practical and emotional level, by separating them from home (Bobby's house, the Impala), their identities (both real and assumed), their income, their remaining friends and associates, and finally, one another. Despite the other-worldly context of the threat, the loss of home, money, and family mirrors the real-world contemporary economic situation of recession, foreclosures, and job losses caused by corporate and Wall Street malfeasance.

This focus on corporate misbehavior speaks directly to the contemporary American sociopolitical moment. As Naomi Klein writes, "Financial self-interest in business is nothing new... What is new is

the reach and scope of these megacorporations' financial self-interest, and the potential global consequences" (174). With an antagonist masquerading as a CEO, who targets two characters that are (culturally) working class (Wright, par. 3), the season's narrative arc comments on corporate culture and its effect on the broader American context. In essence, *Supernatural* literalizes the idea of a small group (1%, if you will) living off of, and eventually devouring, the rest (99%). This chapter examines how season seven of *Supernatural* engages with these concerns, by presenting us with villains who use food additives to create a disease free, complacent and overweight population, and in doing so remake the earth into their personal abattoir.

As head Leviathan Dick Roman says, "I believe in good old American values, like unlimited growth. But it's like I always say—if you want to win, then you got to be the shark. And a shark's gotta eat" ("How to Win Friends and Influence Monsters" 7.9). Featuring a monster that espouses this type of corporate philosophy allows *Supernatural* to make manifest a corporate culture that Alan Dershowitz describes as a "monster that can swallow civilization—greedy, exploitative, and unstoppable" (qtd. in Bakan 1). By situating the "monsters" of the season within this structure, *Supernatural* offers a timely critique of these corporate philosophies and practices, in a season that ran concurrently with both the Occupy Wall Street protests and a Republican presidential nomination process that tapped venture capitalist Mitt Romney as its nominee.

For a series that attempts to use actual folklore, mythology, and other cultural source material for its development of various monsters, demons, and narrative arcs (Koven and Thorgeirsdottir 187–89), the Leviathans as corporate villains represent an appropriate device to make particular points about American culture. Indeed, there is ample biblical evidence as to why *Supernatural* would pick the Leviathans to textually illuminate this narrative. In the Book of Job, Leviathan is described thus: "Upon earth there is not his like . . . He beholds everything that is high; he is king over all the sons of pride" (*New Oxford Annotated Bible*, Job 41.33–34). Joel Bakan argues that if a corporation were really a person (as the Citizens United decision underscored ["Citizens" 3–6]), it would be clinically diagnosed as a psychopath. Bakan uses a checklist created by Robert Hare, a psychologist specializing in psychopathy and finds, "The corporation is *singularly self-interested . . . irresponsible . . . manipulate[s]* everything, including public opinion, . . . *grandiose*, always insisting 'that we're number one, we're the best.' . . . [displays a] *lack of empathy* and *asocial*

tendencies... and *...* refuse[s] to accept responsibility *...* and *...* feel remorse [italics in original] (Bakan 56–57).

While Bakan is referring specifically to the *actions* of a corporation as psychopathic, the characterization of Dick Roman fits neatly into the Hare checklist. The self-interest and lack of empathy are evident even in the ways he treats his own kind, particularly the punishment called "bibbing"—that is, making a fellow Leviathan literally devour himself or herself. While the series has shown numerous instances of high-ranking demons (and angels) destroying their own kind, all of them carried out the punishment themselves. By delegating consequences to subordinates, Dick Roman has literally no blood on his hands in his quest to remove any obstacles to power.

The Winchesters are one such obstacle, but the way in which they are targeted is less supernatural and more fraught with "real-world" consequences than previous threats they have faced in the series. If one removes the supernatural elements from the Winchester brothers' upbringing, one can see their downward class trajectory as an analog for similar situations in contemporary society. A family tragedy leaves father and sons homeless and reduces them to an itinerant existence. Yet the military-style training John Winchester (Jeffrey Dean Morgan) subjects his sons to and the large weapons cache they travel with offer numerous parallels to survivalist or militia cults. The show makes this connection explicit when the brothers are targeted by FBI Agent Victor Henriksen (Charles Malik Whitfield) throughout seasons two and three. His view of John makes perfect sense without the supernatural context: "Ex-marine, raised his kids on the road, cheap motels, backwood cabins...I just can't get a handle on what type of whacko he was" ("NightShifter" 2.12). Henriksen's analysis positions the Winchesters so far outside any class context—that is, akin to fringe militia groups or Ted Kazinski—that they must, as a consequence, pose a threat.

Julia Wright discusses class issues within the first two seasons of the series, particularly the way the series uses the "supernatural to gothically tie downward class mobility to the heightened vulnerability of children" (par. 3). Her analysis is germane to season seven in the way in which the Winchesters' vulnerability, particularly on an economic level, is migrated to the greater population of the U.S. In addition, over the course of the series each threat the brothers faced often threatened all of humanity. For example, the demon Azazel wanted to lead a demonic army to destroy humanity and rule the earth ("All Hell Breaks Loose, Part 1" 2.21) and the angels wanted to wage war

between Heaven and Hell regardless of the human cost ("Lucifer Rising" 4.22, "Swan Song" 5.22).

The Leviathans, however, just want to eat; they offer no philosophical, ethical, or moral justifications for their actions and therefore the Winchesters are viewed not as vessels or pawns but irritants. The Leviathans target them as they would any other individuals who stand in the way of their goals; consequently, the way to remove the Winchesters is to strike at them socioeconomically by destroying their homes or making it necessary for them to vacate. Furthermore, season seven reintroduces their fugitive status, resolved when both Winchesters faked their death in the season three episode "Jus in Bello." By having two Leviathans take on the brothers' physical characteristics and engage in a crime spree through towns where the Winchesters had previously fought supernatural threats ("Slash Fiction" 7.6), the Leviathans manage to turn the brothers into serial killers. The Winchesters are essentially forced underground and rendered homeless.

These "consequences" mirror what many Americans were experiencing as part of the economic crises brought about by subprime loans, Wall Street speculation, and high unemployment. While other seasons have had both demons and angels hunting the brothers, the Leviathans as antagonists are targeting everyone. Except for the relatively small number of the Leviathans (as compared to the earth's human population), the rest of the world (including Sam and Dean) exists solely to literally enrich the top tier, an inequality that the Occupy Wall Street protests sought to redress ("Occupy Wall Street"). As Bobby claims, "This is about them Levis living here forever, 1 percenter-style, while we march our dopey, fat asses down to the shiny new death camps at every corner" ("The Girl with the Dungeons and Dragons Tattoo" 7.20).

Bobby's observation is proven right early in the season when Bobby, Sam, and Dean discover that Biggerson's Pepperjack Turducken Slammer includes a Leviathan-produced food additive that creates apathy, lethargy, and cravings. Such a wide-ranging plan is theoretically possible within a real-world context, because, as Eric Schlosser writes: "The centralized purchasing decisions of the large restaurant chains and their demand for standardized products have given a handful of corporations an unprecedented degree of power over our nation's food supply" (5). The control of conglomerates means that any additive or pathogen is easily passed into the general population (Schlosser 193–195); rulings such as the U.S. Department of

Figure 7.1 The nasty surprise in the Biggerson's Turducken Slammer.

Agriculture's (USDA) proposed change that put the onus of meat inspection in the hands of the meat industry rather than the USDA also undermines consumer safety and protection (73589). Further, despite the supernatural genesis of the food additive in the Turducken Slammer, its effects are similar to that of high-fructose corn syrup (HFCS), which is currently in approximately 40 percent of food products sold in the U.S. (Duffey and Popkin 1725S), particularly in fast food. The use of an HFCS-like substance also ties the plot to issues of income and class, since these chains often explicitly target low-income areas where healthy or fresh goods are not readily available or affordable (Spurlock 12–13).

If the Turducken Slammer Dean eats in the episode had not started oozing grayish goo, the symptoms he (and others) displays in the episode (apathy, euphoria, and cravings) could be attributable to the high levels of HFCS found in fast food, thus tying the Leviathans' food additive with HFCS even before Richard Roman Enterprises buys SucroCorp, a company that manufactures HFCS in "The Girl with the Dungeons and Dragons Tattoo."

These symptoms stand in ironic contrast to the episode's title, "How to Win Friends and Influence Monsters," which is a nod to the Dale Carnegie motivational best seller. Even before the events of the episode unfold, Dean is struggling with the enormity of constantly having to save the world: "We're on our third 'the world is screwed' issue in what, three years? And we've steered the bus away from the cliff twice already…What if the bus wants to go over the cliff?" While Dean's eating habits, established throughout the series as poor, guarantee that he will be exposed to the additive, it also ends up

being harder to diagnose because of his attitude. Sam, who had more educational opportunities, is both more motivated and not exposed to the additive because he is consistently shown eating salad and other fresh foods. The series then adds a somewhat problematic class-based gloss on the aforementioned targeting of low-income customers; it is the brother with the "GED and give 'em hell attitude" ("Sympathy for the Devil" 5.1) who is at risk, not the Stanford graduate, despite their similar economic circumstances.

In contrast, the Leviathans, particularly Dick Roman, are extremely motivated. The corporate video "The Rise of Dick" featured in "How to Win Friends and Influence Monsters," indicates that even before being killed and cloned by the Leviathans, Dick Roman was a driven and ruthless individual. His book *When in Rome* offers a classic bootstrap tale of "starting out in the mail room" and rising so high he can "steer nations in trade policies" with a "personal drive [that]…changed the course of world events." In the current economic climate, it is easy to posit a CEO as a villain, and it is narrative territory that the series has touched on in earlier seasons. I have written previously that season five drew a connection between corporate culture and Heaven. While I argue that archangel Zachariah's (Kurt Fuller) fall from grace mirrors that of a "formerly powerful, disgraced executive" (169), which fit well with the sociopolitical situation during the season that episode aired (2009–2010), it is also fitting that season seven (2011–2012) would revisit and expand this view of corporate culture as something that is not only unconcerned with any collateral damage, but also devours everything that stands in its way.

It was in 2011–2012 that the unsuccessful presidential candidate Mitt Romney touted his business experience as a reason he knew how to lead. As Matt Taibbi writes in his analysis of Romney's years at Bain Capital: "Four years ago, the Mitt Romneys of the world nearly destroyed the global economy with their greed, shortsightedness and…irresponsible use of debt…[for] personal profit…Today that same insane greed ethos…[is] back out there running for president." Although *Supernatural* makes no explicit reference to Romney, the narrative does make it easy to draw a connection between the "sociopathic set" that Romney represented and Dick Roman. The video "The Rise of Dick" even suggests that Roman has long-standing political aspirations, including showing him laughing with George W. Bush in the Oval Office. While this video posits that Roman is someone special, "The Girl with the Dungeons and Dragons Tattoo" complicates that reading, particularly when Roman indicates that the

Leviathans cannot clone those with a "spark"—that is, something that makes them "Payton Manning" as opposed to "Tim Tebow." This suggests that the Leviathans could have chosen any ambitious CEO, recalling Grover Norquist's assertion at the 2012 Conservative Political Action Conference that all they needed to do was "pick a Republican with enough working digits to handle a pen...we just need a president to sign this stuff. We don't need someone to think it up or design it" (Frum). This is worth noting, given Roman's ultimate fate; Dean and Castiel (Misha Collins) kill Roman, but the majority of the Leviathans are still alive. Crowley (Mark Sheppard), the King of Hell, reassures Sam that "cut off the head, and the body will rot" (i.e., the perils of having only "one king since the dawn of time" means that the Leviathans are in a "kerfuffle" without Roman), but does warn him to "keep them from organizing," seeming to imply that another Leviathan could take the reins of leadership.

Despite Crowley's insistence that the Leviathans are potentially directionless and therefore "just another monster" (albeit harder to kill than most), the show draws a distinction between the usual monstrous threats of the series (demons and angels) and the Leviathans. They were released when Castiel absorbed all the souls from Purgatory and declared himself God. When his vessel (body) cannot hold everything he absorbed, Castiel sends the souls back into Purgatory, but is unable to banish the Leviathans. The Leviathans exited the vessel and established themselves in advantageous positions to achieve their ultimate objective. Crowley tries to create an alliance with the Leviathans, only to be referred to as a "bottom-feeding mutation" by Roman ("Slash Fiction").

It could be argued that as Crowley manages Hell and Dick Roman leads the Leviathans, they represent the clash between the Fordist and post-Fordist styles of management, that is, institutionalized and standardized mass production, based on Henry Ford's model of running his manufacturing plants (Fordism) versus an economic model based on technology, niche marketing, and global financial markets (post-Fordism). When Crowley unseats Lucifer as King of Hell, he institutes changes to help it run more efficiently. When Castiel visits him there, Hell is an endless corridor full of souls, each holding a number. Crowley tells him that most of Hell's inhabitants were "masochists already" and consequently the usual tortures do not work. As a result, Crowley's Hell is an endless line with no purpose. As Crowley explains, once souls reach the front, "they get right back to the end again" ("The Man Who Would Be King" 6.20). Crowley's

Hell is a model of Taylorist efficiency[1] where souls are tortured by being part of an endless, mass machine that produces the same torture each time—waiting in line for an eternity.

It is telling that the Leviathans will not work with demons; Richard Roman Enterprises is a model of post-Fordism, with specialized and diversified interests, operating within the knowledge economy. Dick wants nothing to do with the manufacturing sector while Crowley becomes contemptuous of the type of economy that the Leviathans operate in. When Crowley discovers that a couple of his demons have exploited a loophole in the contracts they are making with humans and use it to collect more souls in a shorter time, he insists that no one will make deals with them if the demons do not play by the rules. Crowley draws an obvious, but still pertinent conclusion about the ethics of demons versus the ethics of corporate America: "This isn't Wall Street, this is Hell! We have a little something called integrity" ("Season Seven, Time for a Wedding!"). Despite the easy target of Crowley's sarcastic joke, Crowley, from his first appearance in "Abandon All Hope…" (5.10), has been remarkably consistent in honoring his agreements and contracts—although like all "deals with the devil," usually by honoring the letter rather than the spirit of the deals.

The corporate setting of the Leviathans necessarily stands in sharp contrast to Crowley's methods. Crowley and his demons broker deals on a face-to-face level and literally seal them with a kiss. Richard Roman Enterprises already operated on a global scale before being appropriated by the Leviathans so it stands to reason that it would be the most advantageous setting for their worldwide plan. Even the "charitable" work of Richard Roman Enterprises (working to cure all known human diseases) recalls Bakan's analysis of the motives behind many corporations' philanthropy, that is, so they can "present themselves as compassionate and concerned about others when…they lack the ability to care about anyone or anything but themselves" (57). Dick Roman's desire to provide these cures is nothing more than "engineering the perfect herd" ("The Girl with the Dungeons and Dragons Tattoo"), because unlike many of the meat-packing companies in the U.S., the Leviathans want healthy and disease-free food. Knowing this, every cliché uttered by Roman thus takes on an extra resonance—"a shark's gotta eat" ("How to Win Friends and Influence Monsters") and "the world is my dinner plate" ("The Girl with the Dungeons and Dragons Tattoo") are particular standouts. By literalizing a corporate culture in which smaller companies are either destroyed or absorbed

into larger conglomerates and a corporate philosophy that encourages monetary gain over human cost, the narrative arc of season seven and its focus on the intersection of corporate America and the nation's health via the food supply explicitly condemns such rhetoric through its association with monsters whose primary purpose is to devour.

In order to defeat these consumption-based enemies, the Winchesters must essentially enter their den. Indeed, it is only when they make a connection with someone within Richard Roman Enterprises—Charlene Bradbury (Felicia Day)—that they start to succeed. "Charlie" is signaled by the narrative as an ally when the viewer sees her use work hours to transfer funds from Republican SuperPACs to animal shelters and environmental nonprofits. The shiny, modern office building is a rare departure for the series, in which most of the action takes place in small towns and rundown motels (that the sole exception occurs in the season four episode "It's a Terrible Life (4.17), where the setting is revealed as an alternate reality, is not accidental[2]).

"The Girl with the Dungeons and Dragons Tattoo," despite the fortuitous discovery in an earlier episode that sodium borate slows the Leviathans down ("Slash Fiction"), represents major progress in the fight against them. The Winchesters finally confront the Leviathans on their own turf and with their technology and know-how. The usual demon-fighting methods the brothers use—examining old legends and lore, making temporary alliances with other humans and occasionally demons, and shooting or stabbing—are of no use against the scope of the post-Fordist, information-age enemy. Charlie helps the Winchesters by expunging a drive with pertinent information about both them and the Leviathans, hacking into Dick Roman's e-mail in order to find out the full scope of the Leviathans' plans, and misleading them in order to facilitate the Winchesters' theft of a tablet (the "word of God") that provides the method for killing Dick Roman. It mirrors, to a certain extent, the methods of groups like Anonymous that in 2012 used its technical skills to launch sustained attacks on the Department of Justice and the Federal Bureau of Investigation during the shutdown of the MegaUpload site, and disabling the websites of Recording Industry Association of America and the Motion Picture Association of America during the Stop Online Piracy Act protests ("Internet Strikes Back").

"The Girl with the Dungeons and Dragons Tattoo" is also notable for a fake commercial for Richard Roman Enterprises' newest acquisition, SucroCorp, a corporation that manufacturers HFCS. Given the ubiquity of HFCS in American food products, it is presumably going

to serve as the primary delivery method for the food additive tested earlier ("How to Win Friends and Influence Monsters"). The language and visuals of the SucroCorp commercial within this episode recall the Corn Refiners' Association's (CRA) recent attempts to rebrand HFCS throughout multiple media. They targeted "mommy bloggers," offering gift certificates to those who would attend a webinar and post on the subject of HFCS as "natural" and "healthy" (Edwards). They also launched a series of television advertisements making these same claims, showing fields of growing corn, and a pleasant-voiced man (or woman) talking about how they "did the research" and found that HFCS "has the same natural sweeteners as table sugar" and "your body can't tell the difference" ("Corn Refiners").

The SucroCorp commercial in this episode is stylistically similar to the CRA's campaign. As the episode goes into a commercial break, an advertisement for SucroCorp ends the first act. Although "SucroCorp" exists only in the diegetic world of *Supernatural*, this commercial offers no indication that it is not real; it apes the form and content of commercials like CRA's so efficiently it could conceivably be mistaken for one. Indeed, it is not for another two episodes ("There Will Be Blood" 7.22) that SucroCorp is revealed as a fictional corporation. In hardly veiled language to a news reporter, Dick explains that they'll be "dialing back the additives" in SucroCorp's HFCS to "deliver the highest quality product" that will "keep Americans living longer...and tasting better."

The commercial itself is given no framing within the episode; unlike the "Rise of Dick" video (viewed on a laptop), the SucroCorp commercial is what leads into the actual commercial interruptions for the episode as broadcast. The commercial airs without comment a week before the revelation that SucroCorp exists only within the *Supernatural* universe temporarily allowing viewers to mistake SucroCorp for a legitimate company. Both the SucroCorp and the CRA commercials start with an aerial pan of a cornfield. The CRA commercial then focuses in on a man or woman talking about how HFCS is just the same as sugar. The SucroCorp commercial is instead structured in generalities, offering nostrums like "America: A Nation of Greatness...of hard-working individuals" over American flags, workers on the factory floor, scientific laboratories, and city- and country-scapes. Seen as (temporarily) separate from the season's narrative arc, the commercial operates less as parody and more as a metatextual reference to commercials similar in style and structure as well as a subtle foreshadowing of coming events. There is not a moment

within the SucroCorp commercial that necessarily flags it as parodic; it is only when it is revealed that the company has been acquired by Richard Roman Enterprises that the darkly satirical resonances of SucroCorp's slogan "Eat Well, Live Well" become manifest.

If one puts aside the Leviathans' plan to cure humans so that they "taste better," using HFCS as the delivery system to cure cancer, AIDS, and other terminal illnesses would be a branding dream for the CRA, which was legally prohibited from using the term "natural" to describe its product in advertisements (Jacobson). Yet, much like the corporate CEO that Dick Roman represents, despite a bad reputation, both HFCS and the corporate culture *Supernatural* critiques throughout the season remain ubiquitous. While Dick Roman might insist that it is an "us-eat-dog world" (a mentality not out of place in the corporate sector), Joel Bakan argues that corporate ideology is "animated by a narrow conception of human nature that is too distorted and too uninspiring to have lasting purchase on our political imaginations" and will fall when we "remember who we are and what we are capable of as human beings" (166, 167); that is, working together to shift the social construct from a corporatist mentality to a more cooperative and humanist one.

In the final episode of the season, appropriately named "Survival of the Fittest," Dick Roman is finally dispatched by a weapon that could only be made through a collaboration of the best and worst of human, angelic, and demonic nature—the bone of a righteous human dipped in the blood of an angel and the King of Hell. In the social Darwinian construct of the corporate culture, not only must the "fittest" survive but they must dominate. So why was the "fittest" (Dick Roman) so easily dispatched? Because corporations, CEOs, and others who live by that philosophy, Bakan argues, are "our own creation" (164). He writes: "They have no lives, no powers, and no capacities beyond what we…give them" (164). While writer Sera Gamble and director Robert Singer claim to have chosen the corporate context for the Leviathans because "corporations are scarier than the government" and therefore represent a "perfect fit for these ultimate monsters" ("Survival of the Fittest" commentary), they do not allow the "monster" CEO to win. Despite the fact that the consequences of dispatching Dick Roman send Dean and Castiel to Purgatory and leave Sam on his own, Dick is defeated by the unlikely alliance of a demon Meg Masters, two hunters, Sam and Dean, an angel, Castiel, the new prophet Kevin Tran, Charlie a hacker, and Bobby's ghost. The eventual message of the season thus reaffirms one of the main ideas of the

Occupy Wall Street protests brought into the national dialogue: the power of unified action. Without that, we too risk becoming nothing more than a meal.

Notes

*Although Leviathan is correct for both the single and plural of the word, and they are used interchangeably in *Supernatural*, when discussing the Leviathan as a group, for clarity, Leviathans is used in this chapter.

1. Taylorism is a management style developed by Frederick Winslow Taylor that insisted on precise procedures and studies of worker efficiency to develop the best and least time-consuming way to manufacture or develop goods and services.
2. Indeed, the office setting was used as a way to convince the brothers that such normality is not only out of their reach, but not even desirable, since hunting is "in [their] blood."

Works Cited

"Abandon All Hope…" *Supernatural: The Complete Fifth Season*. Writ. Ben Edlund. Dir. Phil Sgriccia. Warner Home Video, 2009. DVD.

"All Hell Breaks Loose Part 2." *Supernatural: The Complete Second Season*. Writ. Eric Kripke. Dir. Kim Manners. Warner Home Video, 2006. DVD.

Bakan, Joel. *The Corporation: The Pathological Pursuit of Profit and Power*. New York: Free Press, 2004. Print.

Citizens United v. Federal Election Commission (Docket No. 08–205) 588 US 310. Decided January 21, 2010: 1–183. Print.

"Corn Refiners Association Commercial—Maze. Midgica Channel," *You Tube*. July 17, 2011. Web. 19 Sept 2013.

"Department of Agriculture: Semiannual Regulatory Agenda." *Federal Register* 65 (30 Nov. 2000): 73540–624. Print.

Duffey, Kiyah J. and Barry M. Popkin. "High-fructose Corn Syrup: Is this What's for Dinner?" *American Journal of Clinical Nutrition*, 88 (suppl) (2008): 1722S–32S. Print.

Edwards, Jim. "Inside the Mommy-Blog-Industrial Complex, Where Chemical Companies Write Posts for Parents." *CBS Moneywatch*. CBS Interactive Inc. 13 Sept. 2010. Web. 19 Sept 2013.

Frum, David. "Norquist: Romney Will Do As He's Told: Is Mitt Romney so Weak He Won't be Able to Stand Up to Congress?" *The Daily Beast*. Daily Beast Company LLC. 13 Feb, 2013. Web. 19 Sept 2013.

Giannini, Erin. "'There's Nothing More Dangerous than Some A-Hole Who Thinks He's on a Holy Mission': Using and (Dis)-Abusing Religious and Economic Authority on Supernatural." *TV Goes to Hell: An Unofficial Road Map of Supernatural*. Eds. Stacey Abbott and David Lavery. Toronto: ECW Press, 2011. 163–75. Print.

"The Girl with the Dungeons and Dragons Tattoo." *Supernatural: The Complete Seventh Season*. Writ. Robbie Thompson. Dir. John MacCarthy. Warner Home Video, 2011. DVD.

"How to Win Friends and Influence Monsters." *Supernatural: The Complete Seventh Season*. Writ. Ben Edlund. Dir. Guy Bee. Warner Home Video, 2011. DVD.

"Internet Strikes Back: Anonymous' Operation MegaUpload Explained." *RT.com*. TV Novisti. 20 Jan. 2012. Web. 18 Sept. 2013.

"It's a Terrible Life." *Supernatural: The Complete Fourth Season*. Writ. Sera Gamble. Dir. James L Conway. Warner Home Video, 2008. DVD.

Jacobson, Michael F. "Corn Refiners' Ad Campaign Called Deceptive: Statement of CSPI Director Michael F. Jacobson." Center for Science in the Public Interest. 23 June 2008: n. pag. Web. 19 Sept. 2013.

"Jus in Bello." *Supernatural: The Complete Third Season*. Writ. Sera Gamble. Dir. Phil Sgriccia. Warner Home Video, 2007. DVD.

Klein, Naomi. *No Logo: No Space, No Choice, No Jobs*. New York: Picador, 2002. Print.

Koven, Mikel J., and Gunnella Thorgeirsdottir. "Televisual Folklore: Rescuing *Supernatural* from the Fakelore Realm." *TV Goes to Hell: An Unofficial Road Map of Supernatural*. Eds. Stacey Abbott and David Lavery. Toronto: ECW Press, 2011. 187–200. Print.

"Lucifer Rising." *Supernatural: The Complete Fourth Season*. Writ. and Dir. Eric Kripke. Warner Home Video, 2008. DVD.

"The Man Who Would Be King." *Supernatural: The Complete Sixth Season*. Writ. and dir. Ben Edlund. Warner Home Video, 2010. DVD.

"Meet The New Boss." *Supernatural: The Complete Seventh Season*. Writ. Sera amble. Dir. Phil Sgriccia. Warner Home Video, 2011. DVD.

New Oxford Annotated Bible With the Aprocrypha. Eds. Herbert G. May and Bruce M. Metzger. Rev. Standard Ed. New York: Oxford UP, 1973, 1977. Print.

"Nightshifter." *Supernatural: The Complete Second Season*. Writ. Ben Edlund. Dir. Phil Sgricca. Warner Home Video, 2006. DVD.

Occupy Wall Street. "*About*." occupywallst.org. n. pag. n.d. Web. 19 Sept. 2013.

Schlosser, Eric. *Fast Food Nation: The Dark Side of the All-American Meal*. New York: Houghton-Mifflin Co, 2001. Print.

"Season Seven, Time for a Wedding!" *Supernatural: The Complete Seventh Season*. Writ. Andrew Dabb and Daniel Loflin. Dir. Tim Andrew. Warner Home Video, 2011. DVD.

"Slash Fiction." *Supernatural: The Complete Seventh Season*. Writ. Robbie Thompson. Dir. John Showalter. Warner Home Video, 2011. DVD.

Spurlock, Morgan. *Don't Eat This Book: Fast Food and the Supersizing of America*. New York: Penguin, 2005. Print.

"Survival of the Fittest" [commentary]. *Supernatural: The Complete Seventh Season*. Writ. Sera Gamble. Dir. Robert Singer. Warner Home Video, 2011. DVD.

"Swan Song." *Supernatural: The Complete Fifth Season*. Writ. Eric Kripke. Dir. Steve Boyum. Warner Home Video, 2009. DVD.

"Sympathy for the Devil." *Supernatural: The Complete Fifth Season.* Writ. Eric Kripke. Dir. Robert Singer. Warner Home Video, 2009. DVD.

Taibbi, Matt. "Greed and Debt: The True Story of Mitt Romney and Bain Capital. *Rolling Stone.* Wenner Media. 29 Aug. 2012: n. pag. Web. 19 Sept. 2013.

"There Will Be Blood." *Supernatural: The Complete Seventh Season.* Writ. Andrew Dabb and Daniel Loflin. Dir. Guy Bee. Warner Home Video, 2011. DVD.

Wright, Julia M. "Latchkey Hero: Masculinity, Class and the Gothic in Eric Kripke's *Supernatural.*" *Genders Online Journal* 47 (2008): n. pag. Web. 19 Sept. 2013.

The Hunter Hunted: The Portrayal of the Fan as Predator in *Supernatural*

Cait Coker and Candace Benefiel

Of the genre shows on contemporary television, *Supernatural* is perhaps the most savvy in its knowledge and use of contemporary fan practices. In a number of episodes, the writers make it clear that they are fully cognizant of their fan community by establishing a self-referential dialogue and promoting active viewership among their fan base. On the other hand, some fans view the depictions of fan practices as unkind parodies of their activities. Given the depiction of some fans on the show, such as the nameless, shapeshifting film buff of "Monster Movie" (4.5) and the socially awkward and Sam-obsessed Becky Rosen (Emily Perkins), fans view their depiction on the show with some trepidation. While the *Supernatural* fandom is proud of the open relationship it has with the show's creators, the use of such plot lines reinforces both the creators' awareness of fan practices as well as their discomfort with these activities. The characterization of Dean Winchester (Jensen Ackles) as a man who has fannish tendencies but denies them ("it's a guilty pleasure," he says in "Changing Channels" 5.8) and mocks them in others (in "Let It Bleed" 6.21, he comments that while Sam and Bobby were reading H. P. Lovecraft he was "having sex. With women") provides the most straightforward of the writers' surrogates. The appearance of Chuck Shurley (Rob Benedict), fictional pulp writer and prophet, as an exasperated and put-upon (and possibly literal) God-creator[1] is another instance of the writers' reaction to fans and fan practices.

This chapter articulates and examines the friction between fan activity and the creators and production staff of *Supernatural* as it is expressed in the show's fictional context to demonstrate the complex relationships of fans and media producers.

Contemporary fandom exists in a quasi-acknowledged state among corporate authors. Thanks to the omnipresence of the Internet, locating fan boards and communities is easy—a few words typed into the search engine of your choice, and you quickly become inundated with analysis, art, discussions, and fiction. The authors of *Supernatural* are unusual in that they openly acknowledge their fan base, but they do so strictly on their terms. Laura Felschow makes an argument for viewing fans on *Supernatural* through the lens of author/producer power dynamics:

> For while Kripke and company may be laughing at themselves, they do so from the comfort of the writers' room, a serious position of power…But jokes made at the writers' and fans' expense have unequal costs, as the writers have nothing to lose by making fun of themselves…The acknowledgment of fan behavior…is not an overt invitation to participate, but a demonstration that the producers/writers of the program are aware of exactly what their fandom is doing *without* an invitation. Whatever the producers' stated intentions, whether their die-hard fans view this as an inclusive or exclusive act, a compliment or an insult, the end result is the same. The cult fan is reminded that s/he cannot decide what is to be included and excluded, who can be complimented or insulted.

To the authors and producers of *Supernatural*, fans can legitimately be seen as a form of adversary. Whether the *Supernatural* writers are laughing with or at the fans, there seems to be a basic distrust of the fan's motives. Even more, as fans appropriate the characters, mythology, and style of the series for their own fanworks, they edge into the more threatening realm of the predator, and this attitude seems to appear thematically across multiple seasons of the show. Repeatedly, viewers see depictions of fans as very real, physical threats to the main characters. As fictional author-creator Chuck says to Dean and Sam when they show up on his doorstep in "The Monster at the End of This Book" (4. 18), "Is this some kind of *Misery* thing? Ah, it is, isn't it? It's a *Misery* thing!" Chuck is referencing the well-known Stephen King novel-turned-film in which a psychotic fan holds her favorite author captive and demands he write a new novel to her specifications

while intermittently torturing him. Between the text and the subtext, it is clear that to be a fan is to be a dangerous and unpredictable quantity in the series.

"It was Beauty...killed the Beast"

The depiction of fan devotion and fan practices in *Supernatural* is frequently cautionary. In the episode "Monster Movie," the relationship of the series to broader fandoms works in several ways. The episode itself is a tribute to the classic Universal monster movies of the early 1930s. Filmed in black and white, the episode immediately removes the Winchester brothers from their "normal" world and places them within the stylized environs of a classic film, or, as it happens, a series of classic films. From the first moments, the titles and music are strongly reminiscent of the old monster movies. For example, as the brothers, driving along a desolate road on a stormy night, pass a sign reading "Welcome to Pennsylvania," a lightning flash causes it to read "Welcome to *Transylvania*." With the usual "meta" humor of the series, however, Dean comments on the dramatic soundtrack by snapping off the car stereo (and the background music), with the comment, "The radio around here sucks."

Sam and Dean arrive in a small, oddly European town in the midst of its annual Oktoberfest celebration, expecting a straightforward hunt for a nest of vampires. The atmosphere is both bacchanalian and ominous, which is underscored by the black and white cinematography. Polka music plays, and buxom beer maids in short skirts and high heels carry large tankards of beer to the largely male crowd. While there is no indication that the Winchesters or the other characters are seeing the events of the episode in black and white, the use of black and white foregrounds the relationship of the events to the 1930s movies being referenced and recreated. The "monster" of this movie, however, takes an unusual stance with regard to the films. A shapeshifter (Todd Stashwick), rejected and nearly killed by his family, has begun reenacting the horror movies he watched as a child, but he uses the monsters not only as templates for his physical body, but as psychological justifications for his actions. As the Wolfman, he stalks a couple on Lover's Lane, killing the boy and sparing the young woman. As Dracula, he first stalks and later abducts a pretty barmaid, expecting that she will play along with his scenario and be his eternal bride. He has cast the Winchesters,

particularly Dean, into the roles of bumbling interlopers, who may try to interfere with the realization of his script, but who are destined to be minor characters.

The shapeshifter is a fan of the movies that feature creatures with whom he can identify. His personal script calls for the monster to be victorious over the traditional heroes. The episode juxtaposes the shifter's devotion to his model monsters with the mundane facts of his everyday life, as when "Dracula," interrupted at a crucial moment, walks out of an elaborately decorated vampire's lair to answer the front door of what is actually his modest ranch-style house to accept a pizza delivery. Yet the monster has chosen, he says, the "elegance" of the movies over reality. When Dean reminds him of what happens at the end of every monster movie, he replies, "Ah, but this is my movie. And in it, the monster wins."

The monster of "Monster Movie" is the ultimate fan, so immersed in his fandom that he does not even have a name. His devotion to the monsters he emulates is mocked not only by the Winchesters, but also by the soundtrack music, which, during the final confrontation, quotes from the iconic score of Mel Brooks's classic parody *Young Frankenstein* (1974). While the monster aspires to the tragic heights of his idols, he is reduced to a caricature of the originals. Therefore, the fan in *Supernatural*, regardless of his or her devotion, is ultimately either a figure of derision or misguided desire. In addition, the use of fan practices, such as cosplay (in fannish language, short for costume play) and live action role play, or LARPing, for predatory purposes, will end in destruction—as it does for the monster of this episode and others. In "The Real Ghostbusters," for example, assistance from fictional fans almost ends in tragedy as the role players cannot distinguish between a real haunting and a game. Therefore, the relationship between fans and the series remains ambiguous and problematic.

If the writers of "Monster Movie" are positing that fandom and fannish practices, carried to extremes, are bad things, what does it say of them that they were able to write an episode replete with the sort of detailed knowledge of the genre that only a true fan would have? If being an overly devoted fan is bad, and one must be a fan to understand the text and subtext of the episode, then the writers use of the traditional *mise-en-scène*, from the settings, to the use of black and white, and the stylized title credits prove that the writers are just as guilty of slavish fandom as the series viewers.

Twilight of the Idols

The episode "Live Free or Twi-Hard" (6.05) looks at another aspect of negative and predatory fan practices, while lampooning the fans of teen heartthrob vampires such as those depicted in *Twilight* and other popular works. Even the title uses a nickname for fans of Stephenie Meyer's popular romances, Twi-hards, that often has pejorative connotations in mainstream popular culture, particularly when used by those outside the core group of enthusiasts. The episode opens with a young woman, "Kristin" (who bears more than a passing resemblance to Kristen Stewart, star of the *Twilight Saga* films), entering a Goth bar to meet with "Robert," a handsome young man she met online. Doing a very creditable impression of Rob Pattinson's Edward Cullen, he convinces her he is a sensitive vampire, which turns out to be half-correct. He *is* a vampire—and she joins the ranks of over half a dozen young girls who have disappeared in a small town over the course of a week. One of the interesting aspects of this scene is not only how gullible the girl appears, but that much of the dialogue between the two is virtually lifted from *Twilight*. Here is the following exchange from the episode:

KRISTIN: (*Pause.*) Hi.
ROBERT: (*With a slightly creepy smile.*) Hi. (*After a pause, while Kristin's bosom starts heaving.*) I shouldn't be here.
KRISTIN: So why are you? (*He slides in next to her.*)
ROBERT: I can't stop thinking about you. (*The intensity between them grows.*)
KRISTIN: Then…don't.
ROBERT: We can't do this. We can't be together.
KRISTIN: There has to be a way…
ROBERT: No! You think you know me…but you don't. (*He leans in closer.*) I've done bad things. You should run. NOW.
KRISTIN: I can make my own decisions. I'm seventeen. (*She leans in to kiss him, but he turns his head away.*)
ROBERT: I have to show you something.
KRISTIN: Okay…(Robert *quickly looks around to check if anyone is watching. Satisfied, he lifts his lip with his hand to reveal sharp fangs.* Kristin *gasps.*)
KRISTIN: I knew it.
ROBERT: Are you scared?
KRISTIN: (*Quickly*) No.
ROBERT: You should be. ("Live Free or Twi-Hard")

This exchange is more than slightly similar to one from the *Twilight* screenplay by Melissa Rosenberg:

EDWARD: Bella, we—we shouldn't be friends.
BELLA: You really should have figured that out a little earlier...
EDWARD: I only said it'd be better if we weren't friends, not that I didn't wanna be.
BELLA: What does that mean?
EDWARD: It means if you were smart...you'd stay away from me.

Finally, the dialogue from the famous scene where Edward and Bella discuss his true nature reinforces *Supernatural* parody of the couple:

BELLA: I know what you are.
EDWARD: Say it. Out loud. Say it.
BELLA: Vampire.
EDWARD: Are you afraid?
BELLA: (*Turns to face* Edward) No.

Clearly, this episode plays on the viewer's knowledge of the *Twilight* franchise and the fan popularity surrounding it, implying that the audience—and the writers—are sharing the joke, fostering a sense of community between the fans and the producers.

In due course, Sam and Dean arrive to investigate the disappearances. With their usual panache, they convince the parents of the latest victim to allow them to inspect her room. As they speak with the parents, the girl's father comments that "girls are hard," leading Sam to wonder if he means that the girl is taking drugs. Entering her room and surveying the vampire posters, books, and many Gothic accessories, Dean's response is, "Oh, it is so much worse." Fandom is construed, therefore, as analogous to drug abuse or addiction, and Dean is derisive of it. In this scene, both he and Sam comment negatively on the craze for romantic, "sparkly" vampires. Part of this is because of men's general disdain for the fannish enthusiasms of teenaged girls, and part to the fact that, in the world of the series, the Winchesters have dealt with vampires on numerous occasions, and know quite well that the real vampires of their universe have no relation to the romanticized vampires of *Twilight*. As Randall M. Jensen points out:

In the world Eric Kripke has created, there just are demons, ghosts, and so on, even if most folks aren't in the know about this. What we regard as the supernatural realm is for Sam and Dean part of nature. The supernatural has thus been "naturalized." (30)

In other words, for Sam and Dean, the "supernatural" exists and vampires are to be feared and destroyed, not pitied or loved. For them, fandom is dangerous because mistaken perceptions of a monster transform fans into victims of predation. Such skewed perceptions can also lead fans to become predators, just as Kristin, beguiled by a charming vampire, is turned into a vampire herself and then assists in the seduction of other innocents.

And yet, there is a subcurrent within Dean's commentary. For someone who purports to despise all such popular interpretations of the vampire, a creature that he knows to be a dangerous predator, Dean also displays a fairly detailed knowledge of the popular sources. For example, when Sam is attempting to guess the log-in password of Kristin's computer, it is Dean who suggests they try "Lautner," a reference to actor Taylor Lautner who plays a werewolf in the *Twilight* movies. Sam is apparently also quite conversant with the *Twilight* saga, as he immediately replies, "Wait—he's a werewolf," followed by an incredulous "How do you even know who that is?" Dean covers by scoffing, "That kid's everywhere. It's a freakin' nightmare." The password, not coincidentally, is "Pattinson."

Moreover, Dean's association with the *Twilight* trope of the handsome, sexy young vampire goes much further in this episode. During the search of Kristin's room, Dean runs across a copy of the fictional vampire novel, *My Summer of Blood*. As he takes in the cover art, he comments, "He's watching her sleep. How is that not rape-y?" This entire idea, of course, comes straight out of *Twilight* and Edward's practice of sneaking into the bedroom of teenaged Bella to watch her during the night. Later in "Live Free or Twi-Hard," Dean is forced to ingest vampire blood and under its influence visits the home of his girlfriend, Lisa, with the intention of saying goodbye. The blocking of the scene closely resembles the book cover seen earlier, as Dean stands over the sleeping figure of a woman. The setting even includes the white curtains blowing behind the male figure. Dean is cognizant of the parallels; later in the scene, after Lisa wakes up, and he is struggling with his urge to drink her blood, he mutters "God—I'm Pattinson." Dean, therefore, reenacts the very scene and plot he mocked earlier. Given the references to the vampire craze popularized by *Twilight* and its imitators, it is clear that the fictional *Twilight* exists in the world of *Supernatural*. Edward Cullen may not be "real" in terms of *Supernatural*, but Stephenie Meyer certainly is, bringing the "meta" aspect full circle.

The connections with fans and fan culture in this episode, however, are not limited to snarky references to the *Twilight* franchise. The handsome young vampire Rob's online seduction of Kristin, which

Figure 8.1 Dean is becoming the predator.

culminates with her being bitten not just by him, but also by a far less attractive vampire named Boris (Joseph D. Reitman), is carefully plotted to take advantage of the young woman's gullibility. Boris, leader of a nest of vampires, has a cadre of new vampires working to bring in recruits by trolling vampire fan communities for likely victims. These victims, in turn, become part of an assembly line of vampire recruitment that creates more of the same romantic lies that seduced them. So fans—especially female fans—and fan practices are both used as weapons against impressionable young victims. Therefore, obsession becomes not only disturbing, but dangerous.

How Do You Solve a Problem Like Becky?

If the introduction of Chuck threatens the fourth wall, the appearance of "Becky the Fan Girl" absolutely breaks it. Becky Rosen (Emily Perkins) is initially shown in her bedroom working on a computer writing slash fiction about Sam and Dean. She receives a video message from Chuck, who anxiously informs her that she has to get a message to the Winchesters—because she's the only person who would ever believe him:

> BECKY: Yes, I'm a fan, but I really don't appreciate being mocked. I know that *Supernatural* is just a book, okay? I know the difference between fantasy and reality.
> CHUCK: Becky, it's all real.
> BECKY: I knew it! ("Sympathy for the Devil" 5.1)

Early in the series, Becky is presented as a helpmeet to the Winchesters providing them with clues to the locations of Michael's sword in "Sympathy for the Devil" and later the Colt in "The Real Ghostbusters." Her initial characterization recalls that of the fans from such films as *Galaxy Quest* who are, if laughable, also key to saving our heroes.

On the other hand, she also manifests all the negative traits of rabid fangirls. She writes slash (specifically "Wincest," widely considered to be a fannish "low point" outside of direct *Supernatural* fandom) and invades the physical space of the men she adores. When Sam opens the door of his motel room, she quickly progresses from recognizing him as the actual embodiment of her idol to caressing his chest. Sam is clearly disturbed by this and asks, "Becky, do you think you could stop touching me?" Her breathless response is—"No!" ("Sympathy for the Devil"). She is seemingly more concerned with meeting the objects of her devotion than the coming Apocalypse. Fans were not entirely comfortable with either Becky or how she was portrayed. As Lynn Zubernis and Katherine Larsen note, "Part of the objection was that the portrayal buys into the dominant trope of fangirls as sexually needy and deviant and part was to the disclosure of the practices that are seen as coding them this way in the first place. Some fans felt exposed and some felt outed by Kripke" (165). Within the text of the show, the brothers themselves are obviously uncomfortable with Becky from the beginning, though they are eager enough to make use of the information she provides. Becky is also socially awkward; as she will later say of herself, "The only place people understood me was on the message boards. They were grumpy and overly literal but at least we shared a common passion" ("Season Seven, Time for a Wedding!"). Unfortunately, the socially maladjusted and obsessed seldom come to a good end in *Supernatural* and Becky's case is no different.

Her obsessive crush on Sam reaches its lowest point in "Season Seven, Time for a Wedding." In this episode, Becky actually marries Sam while he is under the influence of a magical potion he likens to Spanish Fly. Becky the Fan Girl, then, is finally represented as, to borrow Chuck's terminology, "a *Misery* thing." Though at the episode's conclusion Becky is ultimately sent away postannulment, Sam comforts her with the parting words that she is "not a loser"—but he also does not want to see her again.

Becky's final portrayal as a physical threat to Sam—raping him while he is drugged— changed the show's relationship with the fans, many of whom found the episode incredibly harsh. The science

fiction website io9 analyzed the episode in an article entitled "Wow, *Supernatural*—Feeling a Little Bitchy this Week?" as a "hate letter to the show's fans" concludes:

> The thing is, these kinds of characters are only funny if you assume their very existence is the equivalent of a banana peel on the ground. It's the trash that other characters slip on to make you laugh. Usually *Supernatural* does make me laugh. But not this week. (Newitz)

Site user TVholic agreed, commenting in response:

> I thought this was an incredibly mean-spirited attack on the fans. The same ones who have kept this show on the air and kept it being talked about when mainstream media didn't even know it existed. Yes online fans are critical and obsessive but if well-paid, professional screenwriters are that thin-skinned, they need to get out of the business or stop reading message boards.

Clearly, both fans and reviewers took this episode to be an affront to the large *Supernatural* fandom and one fan site voted it the worst episode of the season (Jester). Becky's transformation from being a joke to a very real predator is a disconcerting one, and while ideologically problematic for the show's real fans, perhaps it makes sense in the broader thematic context of the series. If the other fans depicted onscreen were dangerous, why not Becky?

Other comparatively innocuous fans appear within Becky and Chuck's orbit. In "The Real Ghostbusters," Becky steals Chuck's phone to text the Winchesters about a "life and death situation"—a fan convention she has organized. At the convention, lovers and LARPers Demian (Devin Ratray) and Barnes (Ernie Grunwald), who role-play as Sam and Dean, are integral to defeating the murderous ghosts haunting the convention's hotel site. In 2009, or prior to the events of seasons six and seven, Melissa Gray wrote:

> As a nod to the importance of fandom to *Supernatural*, TPTB [The Powers That Be] have not been committing gratuitous fan portrayal. In every episode in which they've appeared, not only have fans played a role vital to the plot, but their fannishness is also vital to their role...This usefulness ameliorates some of the antipathy displayed toward the portrayal of the fans.

There is no doubt that the fans as written on the show have a purpose, but at the same time the issue of their portrayal is more complex

than just "good" or "bad." Some seem to be written to acknowledge *Supernatural*'s debt to its devoted fan base, but at the same time there is always that edge of irony, of derisiveness aimed at those who not only support the show, but also feed off its themes and characters to create works of their own. Implicit in the writing is that fans, by appropriating *Supernatural*'s characters in fan fiction, role-playing games, and other unauthorized uses, prey on the series for their own gratification, exemplified by Becky's refusal to abide within the boundaries of spatial and romantic propriety. The creators thus cast their own fans as monsters with dangerous intent, but as we will see, this is hardly the case.

Predatory Practices: *Supernatural* Fandom Itself

In 1992, the seminal media theorist Henry Jenkins articulated the terminology of fan practices as a form of "textual poaching" that rewrites the fan–creator relationship as a power struggle:

> The relationship between fan and producer, then, is not always a happy or comfortable one and is often charged with mutual suspicion, if not open conflict. Yet lacking access to the media, lacking a say in programming decisions, confronting hostility from industry insiders, fans have nevertheless found ways to reclaim media imagery for their own purposes. (32)

In the years since Jenkins's observations, the majority of fan studies scholarship has focused on this "resistant" relationship in which fans rewrite texts as a form of art or critique. *Supernatural*'s authors co-opt this strategy to write critiques of their fans.

The series is known for being mind-bendingly self-referential, or as critics and fans call it, "meta." This is nowhere more apparent than in the sixth season episode "The French Mistake," when the fourth wall between authors and audience is obliterated. In this episode, Sam and Dean are sent to an alternate universe where they are actors—Jared Padalecki and Jensen Ackles—on a genre television show called *Supernatural*. "The French Mistake" blurs the lines of metanarrative to the point of insensibility with actors representing characters pretending to be the actors. However, it is telling that in the end of this episode, the author-creator "Eric Kripke" is destroyed—the death of the author writ large. And yet, as we all know, in the real world he is far from dead. Fans' imaginations may run rampant, but "The Powers

That Be" will always remain firmly present in one way or another. The final text always reminds fans who the ones with the real power are—not the ones with magic, angelic powers, or super abilities, but those with legitimated creative control.

Additionally, in the power struggle between participatory fans and the media producers, there appears to be a pronounced gender divide, creating discomfort among the predominantly male cadre that is responsible for *Supernatural* (the addition of Sera Gamble, who rose through the ranks as a writer before graduating to the status of executive producer in 2009, seems to be an exception) with the idea of female fans having input, positive or negative, in the creative direction of the series. The fan practices of appropriating content and concepts for the creation of fan art, fiction, and videos, may seem predatory; and this is how many media producers view them. And yet, in *Supernatural*, the fan who exemplifies the predatory impulse is Becky, who initially appears to be a harmless, if overly devoted, young woman. Other male fans are seen as essentially harmless geeks. For instance, Demian and Barnes in "The Real Ghostbusters" are shown first as pathetic in their attempts to emulate the Winchesters, but they later serve to assist the "real" Sam and Dean in the struggle to eliminate several malevolent ghosts, and later still, provide Dean with an object lesson in the intrinsic value of his life and work. These fans want nothing more from the objects of their admiration than for them to continue to be, well, admirable. Becky, on the other hand, is shown as deriving much of her identity and self-worth from her pursuit of Sam. When she realizes that her tactics have crossed over from fan to stalker, she characterizes herself so negatively that even Sam objects:

> BECKY: I know what I am, okay? I'm a loser. In school. In life. I guess that's why I like you so much.
> SAM: Becky—Becky, you're better than this.
> BECKY: That's sweet, but... I'm not so sure. ("Season Seven, It's Time for a Wedding!")

The "Becky the Slash Writer" story line, while at best a minor arc within the trajectory of more weighty story arcs, both delighted fans with the idea that their existence was known and recognized by the series cast and production crew and also dismayed those who felt that their active participation in *Supernatural* fandom had been portrayed as a sad and potentially harmful obsession. In effect, one may

reasonably assert that portraying Becky as a misguided loser who is unable to relate to the world except through the lens of her obsession with Sam, is a slap on the wrist from the series producers, telling all the Beckys out in the audience to sit back and let the big boys run the show.

Based on the evidence provided by the canonical portrayal of fans and fan practices within *Supernatural*, while these activities bring a sense of pleasure and belonging to those who engage in them, they are seen as potentially disturbing to the balance of creator/consumer, by the media producers. In *Supernatural*, the series has taken the step of bringing this discomfort with fandom front and center and displaying that unease—particularly with the female portion of fandom—for all to see, and for the fans themselves to interpret as they will.

Note

1. He says he is a cruel and capricious God in "The Monster at the End of This Book" and the ending of "Swan Song" strongly hints he is *actually* God.

Works Cited

"Changing Channels." *Supernatural: The Complete Fifth Season*. Writ. Jeremy Carver. Dir. Charles Beeson. Warner Brothers, 2010. DVD.

Felschow, Laura E. ""Hey, Check it Out, There's Actually Fans": (Dis) empowerment and (mis)representation of Cult Fandom in *Supernatural*." *Transformative Works and Cultures* 4. 2010. n. pag. Web. 26 Sept. 2013.

"The French Mistake." *Supernatural: The Complete Sixth Season*. Writ. Ben Edlund. Dir.

Charles Beeson. Warner Brothers, 2011. DVD.

Gray, Melissa. "From Canon to Fanon and Back Again: The Epic Journey of *Supernatural* and Its Fans." *Transformative Works and Cultures* 4. 2010. n. pag. Web. 26 Sept. 2013.

Jenkins, Henry. *Textual Poachers: Television Fans & Participatory Culture*. New York: Routledge, 1992. Print.

Jensen, Randall M. "What's Supernatural about *Supernatural?*" *In the Hunt: Unauthorized Essays on* Supernatural. Eds. Supernatural.tv and Leah Wilson. Dallas: Benbella Book, 2009. 27–38. Print.

Jester, Alice. "The Winchester Family Business Supernatural Season 7 Fan Awards." *The Winchester Family Business*. JesterZnetmedia, 19 June 2012. Web. 11 Dec. 2012.

"Let It Bleed." *Supernatural: The Complete Sixth Season*. Writ. Sera Gamble. Dir. John F. Showalter. Warner Brothers, 2010. DVD.

"Live Free or Twihard." *Supernatural: The Complete Sixth Season*. Writ. Brett Matthews. Dir. Rob Hardy. Warner Brothers, 2011. DVD.

"The Monster at the End of This Book." *Supernatural: The Complete Fourth Season*. Writ. Julie Siege and Nancy Weiner. Dir. Mike Rohl. Warner Brothers, 2009. DVD.

"Monster Movie." *Supernatural: The Complete Fourth Season*. Writ. Ben Edlund. Dir. Robert Singer. Warner Brothers, 2009. DVD.

Newitz, Annalee, "Wow, *Supernatural*—Feeling a Little Bitchy This Week?" *io9. com*. io9, 12 Nov. 2011.Web. 11 Dec. 2012.

"The Real Ghostbusters." *Supernatural: The Complete Fifth Season*. Writ. Eric Kripke and Nancy Weiner. Dir. James L. Conway. Warner Brothers, 2010. DVD.

"Season Seven, Time for a Wedding!" *Supernatural: The Complete Seventh Season*. Writ. Andrew Dabb and Daniel Loflin. Dir. Tim Andrew. Warner Brothers, 2012. DVD.

"Sympathy for the Devil." *Supernatural: The Complete Fifth Season*. Writ. Eric Kripke. Dir. Robert Singer. Warner Brothers, 2010. DVD.

TVholic. "Re: Wow, *Supernatural*—Feeling a Little Bitchy This Week?" *io9.com*. io9, 12 Nov. 2011.Web. 11 Dec. 2012.

Twilight. Writ. Melissa Rosenberg. Dir. Catherine Hardwicke. Summit Entertainment, 2008. DVD.

Zubernis, Lynn, and Katherine Larsen. *Fandom at the Crossroads: Celebration, Shame, and Fan/Producer Relationships*. Newcastle: Cambridge Scholars Publishing, 2012. Print.

"A Shot on the Devil": Female Hunters and the Identification of Evil in *Supernatural*

Ralph Beliveau and Laura Bolf-Beliveau

For from her is the race of women and female kind: of her is the deadly race and tribe of women who live amongst mortal men to their great trouble ... Zeus who thunders on high made women to be an evil to mortal men, with a nature to do evil.

—Hesiod, Theogony *(ll. 590–612)*

Supernatural relates to the Gothic ancestry of horror, where terror arises from supernatural agents rather than the atrocities of crime and war. But one element ties the Gothic to the contemporary: the emphasis on the vulnerability of family. Robin Wood observes that in the 1970s horror moved from the Europe of the (Gothic) past to contemporary (post-1970s) America, where family is the source of both security and threat. The obsession with family relations and their vulnerability drives much of *Supernatural*. Sam (Jared Padalecki) and Dean (Jensen Ackles) Winchester's desire for family—and connections with significant women—is consistently thwarted by the dangers around them. They live in the world of the "hunter" where family is vulnerable. Evil often invades "the life" and malevolency follows. The series can be read as Sam and Dean's constant quest to keep each other safe while they protect the normal world from the world of monsters. Domesticity, then, creates an opportunity to study how evil is constructed in the show. At the same time, as both Julia M. Wright and Lorrie Palmer have argued, *Supernatural* presents a primarily

masculine point of view and the understanding of evil in *Supernatural* is almost exclusively masculine, with only a few exceptions.

Sam and Dean's masculine perspectives raise interesting issues about gender—especially given the dominance of women in the program's fanbase and in the writing (both academic and popular) about the program (Boggs 103). What accounts for the ideas of gender surrounding the show? We believe a step toward answering this question comes from investigating the way evil is gendered; therefore, we analyze *Supernatural*'s articulation of evil through the theoretical context of Nel Noddings's work on gender, evil, and care. By using her analysis we show *Supernatural*'s effectiveness in speaking to an audience for whom the hegemonic discourse of the program is an appealing space to locate themselves in the cultural imaginary. We also demonstrate how the show ultimately fails to realize Noddings's desire to see evil defined in other than patriarchal terms, which might be accomplished through the actions of strong female characters.

Noddings's Phenomenology of Evil

Noddings, in *Women and Evil*, suggests that traditional views of evil are patriarchal. Reflecting on both Aristotle and the Judeo-Christian tradition, she argues that these views elevate and glorify traits that favor men (2). From Noddings's perspective, women often fall into a duality: "woman as evil (because of her attraction to matters of the flesh) and good (because of her compassion and nurturing)" (3). Noddings develops a phenomenology of evil reconstructed from a women's perspective and suggests that, through history, a patriarchal notion of evil has been used as a tool to control both the bodies and the psyches of women. These psyches were simultaneously considered profane and sacred: profane through a reductive fear of the sexualization of women combined with a construction of the sacredness of women as both the nurturer in the home and the source of human reproduction. Patriarchy's control over women was justified as a necessary move to maintain a sense of duty and honor, especially when the actions of men were in the arena of war and violence. The ability of men to act honorably under such conditions required resistance to female allure (Noddings 11). This resistance is codified not merely as a way for men to defend themselves against temptation; this point of view also creates a position of repression that controls the threat of women. The patriarchal understanding then reinscribes itself as the position of God himself (Noddings 35).

Noddings describes a dualism created through patriarchal dominance. One pole associates the body with women, and by extension with earthly nature. The other pole associates men with mind, spirit, and reason (36). Hence the female body and its desires create a home for evil, a "devil's gateway." Positive aspects of women are tied to obedience within the patriarchal order, from God (the Father), to the father of the family, to the leadership of men generally and specifically to the husband. Through this dominance, women are restricted to the domestic sphere and are understood as the "angel in the house" (Noddings 59). Noddings argues that this limitation explains why women have been removed from the public sphere considerations of moral, religious, and philosophical systems (88–89). The participation of women in the public sphere would allow the "angel" out of the house to become the devil's gateway within the patriarchal understanding of evil.

This patriarchal reading of women's roles in the construction of evil is apparent in *Supernatural*. In season four, the demon Ruby (Genevieve Cortese) and angel Anna (Julie McNiven) serve as sexual temptations for Sam and Dean respectively. As a result of these relationships, both of them have difficulty seeing the malevolent plans each woman has to further her own agenda. Conversely, other female characters, also in the roles of love interest, embody the compassionate nurturing mother figure. This is evident in the character of Jessica, Sam's beloved girlfriend, who is killed by the yellow-eyed demon Azazel (Fredric Lehne) in "Pilot" (1.1). Jessica is introduced as compassionate (encourages Sam to go with Dean to find his father) and nurturing, comforting him about his upcoming law school interview: "It's going to go great…I'm proud of you…and you are going to knock them dead on Monday." In a similar way, Dean's former lover and sometime girlfriend Lisa (Cindy Sampson) provides support especially at the end of season five's "Swan Song" (5.22), when Dean returns to her after Sam sacrifices himself to stop Lucifer's rising. She opens the door and says, "Thank god. Are you all right?" With a smile, she invites him in and tells him that it is not too late. He is still welcome in her home and life. The scene ends with her taking him into her arms. Later, in season six's "Let It Bleed" (6.21), Dean opts to keep Lisa safe by asking an angel, Castiel (Misha Collins), to erase all her memories of Dean. The question is whether this actually keeps her safe or simply removes her ability to have agency.

These examples illustrate *Supernatural*'s focus on female characters within this duality of good and evil. But what happens when we

reverse this view? Instead of looking at evil from these perspectives, we can use Noddings's work to draw a phenomenological reconstruction from the perspective of women (3). Using this position, *Supernatural* has the *potential* to offer female characters that do not fall into the binary suggested above. The question remains, however, whether the series manages to escape this duality. The strongest possibility for such an escape could be found in the female characters that play a role in defining evil. Characters like Jo Harvelle (Alona Tal) and Mary Campbell (Amy Gumenick/Samantha Smith) both become hunters and participate, to some degree, in the identification of evil and its eradication.

Noddings is again useful when analyzing the way Jo and Mary reconstruct evil. First, the morality of evil is inextricably tied to the "reflective experience" of how humans interact with each other. Noddings believes that the female experience is often confined to caring, or women's desire to relieve others' pain (99). Jo and Mary's experiences within this context suggest a phenomenological perspective that illuminates the show's exclusively masculine perspective of evil. Noddings suggests that the effects of pain on men and women differ. The language of possession and power, especially when used by males, can be well-intentioned malevolency (228). The key to understanding Noddings's notion of cultural evil is grounded in the relationship between "othering" and projection. Noddings describes how both men and women participate in the perpetuation of cultural evils through a lack of reflexive evaluation, a reduction of seeing one's self in the other, in her example specifically across lines of gender.

The history of the control over women's bodies is maintained by the lack of empathetic linkage between the sources of oppression and the oppressed. Noddings argues that:

> Human beings frequently participate in the practices of their culture without reflective evaluation. A man living in the early days of patriarchy almost certainly did not intend to inflict pain, separation, and helplessness on the female members of his family—as long as they were "good" women. He did not consider the possibility that he was committing evil. His evil acts in this arena were not the deliberate acts of an individual agent. Rather they were accepted and respectable acts that we must now evaluate as *cultural evils*. (104)

Cultural evils are regimented into the way self and other are constructed. In *Supernatural*, the audience is specifically sutured into the world of hunters, and very rarely is that world left for the "normal"

world, which appears to be wholly ignorant of the battle between good and evil. The audience finds itself in the privileged position of seeing what they are not supposed to see—what is actually going on and what hunters protect humanity from. This would include disguising the cultural evils that are a constituent part of the "normal" world. The hunter's world is thus, by definition, excluded, and hunters are not allowed to find a consubstantial relationship with the normal world. Deep consideration of moral and cultural evil—especially as they relate to the pain, separation, and helplessness experienced by female hunters Jo and Mary—allows the viewer to consider two essential questions. First, does a feminine phenomenology of evil provide a substantially different reading of *Supernatural*? Second, do these female characters subvert the masculine perspective of evil? A closer examination of these two characters can bring us closer to understanding how these gender concerns are played out.

Jo Harvelle's Shot at the Devil

In season two, Jo Harvelle is introduced when she points a rifle at Dean and punches him in the face in "Everybody Loves a Clown" (2.2). The daughter of a hunter, Jo aspires to "the life" (the hunter's life), and her first foray is in "No Exit" (2.6). Arriving at Harvelle's Roadhouse, Sam and Dean find Jo and her mother Ellen (Samantha Ferris) fighting about Jo's interest in hunting. Ellen, who already lost her husband to the life, tells Jo, "This family has lost enough. I won't lose you too." Although Ellen caters to the hunters that frequent the Roadhouse, she adamantly craves a different life for her daughter.

Unwilling to choose the normal life of college, Jo leaves for Philadelphia to pursue a case, disobeying the instructions of her mother but acting in a way that she thinks her father, were he still alive, would commend. In Philadelphia she meets up with Sam and Dean who reluctantly allow her to become the bait to catch the ghost of a serial killer, H. H. Holmes. Holmes's ability to kill from beyond the grave and his propensity for torture demonstrate Noddings's moral evil, in this case a malevolent force that causes Jo to react not like a hunter, but like a woman trapped by evil and in need of rescue (204). It is worth noting that the ghost of Holmes is preying on women who are in their domestic space; he appears in hidden spaces that exist between the walls of these "homes," an interesting use of the double meaning in his name. Jo starts her participation in the case by renting an apartment in the building. Noddings ties the fear

of acting like a woman—needing to be rescued by a man—into the notion of helplessness. This is most evident when Jo becomes trapped by Holmes and wakes up in a coffin-like space with finger scrapes on the inside lid. Jo endures Holmes's groping and stabs him with a knife, but in the end, Sam and Dean must rescue her.

The episode concludes with Ellen and Jo finishing their argument, but this time Ellen tells Jo that Sam and Dean's father was responsible for the death of Jo's dad (although in a later episode Ellen says that she had long ago forgiven John for this), a revelation that changes the way the series frames Jo's character. First, she never becomes a love interest for Dean, something that had been previously suggested. Second, Jo never becomes a solo hunter, but instead pairs up with her mother. Whether Ellen, as Jo's mother, did or did not want Jo to become a hunter, she eventually allows Jo to go into the life. By remaining in a role of supervision, she allows Jo to stay an obedient woman, one who often chooses family priorities over those of a pure independent hunter. While moral evil haunts Jo's character in "Born Under a Bad Sign" (2.14) when a possessed Sam tortures her, little more is said of her in the series until a cultural evil intervenes in her family's life.

Jo and Ellen appear together in season five. First, in "Good God, Y'all!" (5.2), Sam and Dean discover Jo and Ellen in Colorado where one of the horseman, War, is wreaking havoc on the small town. Two factions are fighting one another, each believing the other side is possessed by demons. While this may seem like another moral evil, War is part of the looming larger conflict, the one being waged between Heaven and Hell. This horseman's ring becomes a weapon for Sam and Dean, and it figures prominently later in the season. What is particularly interesting for analyzing Jo's character in season five is her choice to hunt with her mother, honoring the familial connection Ellen fought for in season two. Even when she thinks her mother is possessed in "Good God, Y'all!" Ellen only has to say, "Now, you listen up Joanna Beth Harvelle" and Jo's hallucination ends. The Horseman's malevolence cannot stop the dominance of their mother–daughter bond. In Noddings's terms, the recognition of other is grounded in family and the circumstances of care that come with it. While this shows a version of empathetic strength, it carries within it the limits of how evil is defined and thwarted. The mother-daughter bond is defined by its context in a patriarchal system. While the recognition is critical for pulling Jo out of the hallucination, it also pulls her into a relationship defined through the system of care and self-sacrifice that eventually limits Jo's ability to redefine herself in terms outside of the patriarchal system.

Figure 9.1 The Winchesters and the Harvelles deconstructing evil.

Jo and Ellen's demise in "Abandon All Hope..." (5.10) is the ultimate example of how cultural evil provides certain outcomes for female characters. In their quest to find "the Colt" (a gun made by Samuel Colt that can kill demons) and the demon Crowley (Mark Sheppard), Jo uses her beauty (and a very short dress) to gain entrance into the magically protected house where Crowley is hiding. This story arc varies from season two. Now a large-scale war is taking place and Lucifer (Mark Pellegrino) is trying to take over the world. Crowley is trying to stop Lucifer, and he sends Sam and Dean to Carthage, Missouri, where they are to use the Colt and kill the devil. Before getting close to Lucifer, a hellhound gravely injures Jo. When the Winchesters move to help her, she tells them to stop and get their priorities straight. She is near death, but she can still do something, sacrifice herself to buy Dean and Sam time. Ellen decides to stay with her and together they die taking several of the devil's creatures with them. Jo wins one battle within the cultural war of good versus evil but, although Jo Harvelle does become a hunter (under her mother's care), she dies before engaging in "the life" as fully as her male counterparts. Jo's shot on the devil becomes the Winchesters'opportunity to thwart Lucifer and save the world. Her character serves as a reminder that the show's masculinity, especially as it relates to the construction

of evil, only explores a *patriarchal* hunter's world. The possibility of a feminine inscription haunts this world, an inscription that might prevent the suppression of evil from being complicit in the suppression of women and their self-determination. This idea becomes even more relevant when Jo's character is contrasted with another female character, Mary Campbell.

Mary Campbell's Quest to Leave the Life

Another female hunter, of the same age and positioning as Jo Harvelle, is Mary Campbell, the younger version of Sam and Dean's mother Mary Winchester. Like Jo, she is the daughter of a hunter, and also like Jo, family has significant importance for how moral and cultural evil construct and instruct her story arc. This younger Mary differs greatly from Mary Winchester in "Pilot" (1.1). When we first meet this younger Mary, Castiel has just sent Dean back to 1973. As young Mary is introduced in episode 4.3, "In the Beginning," the audience is surprised by the revelation that Mary, not John, comes from the hunter's world. Her father and mother, Samuel and Deanna Campbell, are both hunters. Hunting is, after all, a family business.

The Campbell home, as Dean soon learns, is a portrait of a patriarchal American family: Deanna (Allison Hossack) prepares food and Samuel (Mitch Pileggi) exerts his fatherly role telling Mary, with disdain, that John Winchester is a "naïve civilian." Those outside the hunter's world do not belong at the table, after all. Dean has much more of a right to sit and discuss the business. Samuel is currently working a case at the Whitshire Farm where a man was torn apart by a combine harvester. Samuel and Dean are both suspicious as they discuss demonic possessions and dead crops. A moral evil is apparent, and it turns out to be Azazel, the yellow-eyed demon who kills Mary years later. Samuel insists that Mary accompany him to the farm, and when she says, "I'm here because..." his response is, "Family." Unbeknownst to Samuel, Mary has plans to leave the family business. John, she is certain, will ask her to marry him soon. She is willing to "run away" to escape the hunter's world and find domestic bliss as a married woman with a family. She craves the safety of the normal world, but moral evil interferes.

When Azazel kills Mary's mother, father, and boyfriend, she makes a deal with him in order to bring John back. She pays by letting the demon come to Sam's cradle ten years later. Hence, in the first episode with the younger Mary, the demon represents how an agent of evil causes pain and refuses to alleviate suffering. Instead of bringing back

Mary's mother and father, along with John, Azazel says her parents are "not on the table" as a negotiating point; he prefers to break up the hunter's family. Instead, he promises Mary a station wagon and two children—the family life that hunting denies her. He will bring back John, they can be married, and she will have the freedom she so passionately asked for earlier in the episode. Using Noddings's argument that women are constructed by patriarchy as the gateway to evil, the deal Mary makes, exchanging the role of hunter for mother, means her sons' lives are changed. They will inherit the life she never wanted them to have—a hunter's life. In this case, the moral evil represented by Azazel constructs the menace that the current-day Winchesters are trying to right.

The season five episode "The Song Remains the Same" (5.13) returns to this plot line. Five years have passed since Mary made her deal, and Mary Campbell is now Mary Winchester. Instead of a moral evil trying to harm her and those she loves, this evil is cultural, and the war in Heaven threatens her newfound peace. The angel Anna (Julie McNiven), wants to kill Mary and John (Matt Cohen) to prevent the war in Heaven from ever taking place. Both Sam and Dean are sent back in time to stop Anna from killing their parents. When they first arrive, Sam and Dean interrupt Mary cooking dinner. She immediately says to Dean, "I don't do that any more. I have a normal life now." But the threat of John's death sends Mary back into the life of a hunter. After she fights Anna in front of John, first trying to stab her and then using a crowbar on the angel, Mary fears her normal life is over now that John knows about the hunter's world. Incredulously he asks Mary, Dean, and Sam, "Monsters…And you fight them? All of you?" And, he wonders, how could any parents raise children that way. We know from the series that this is the road he too will take; John raises Sam and Dean to be hunters.

Cultural evil, according to Noddings, looks to poverty, war, racism, and sexism (120). In the case of this episode, the received hegemony that subordinates the role of women rears its head as Mary's role as angel in the house is first established. The possibility of questioning this hegemony is suggested when Mary is forced to play hunter again. As John and Mary fight off Anna and the angel Uriel (Matt Ward), John dies again. Michael, the angel who wants Dean as his vessel in the fight against Lucifer, inhabits John's body. Michael tells Dean that the Winchester bloodline, in essence the entire family, belongs in the war. Mary, therefore, has an opportunity to end the war, this cultural evil, by leaving John. Sam and Dean ask her to walk away so

they will never be born. But it is too late. She's already pregnant with Dean. Mary and John's memories are erased and the episode ends with the reassertion of the traditional gender hegemony, as a very pregnant Mary shows John her latest garage sale purchase: an angel statue bought for fifteen cents. She says, "Angels are watching over us." Viewers see the cruel irony: the angels watch over the characters but fail to intervene. The younger Mary and John think they have found normality, but it is short lived.

Through Mary Campbell as a female hunter, there is an opportunity to disrupt a masculine version of evil in the series. Instead, however, her character falls into patriarchal stereotypes of women: Women as the gateway to evil and angel in the house. Noddings's concepts of moral and cultural evil are evident, but neither moves the series to a female inscription of evil and without this female perspective, *Supernatural's* victories over moral evil inevitably perpetuate cultural evil.

Conclusion

What can be gained from viewing Jo and Mary through this feminine perspective of evil? Critics and fans of the series have often seen its female characters as problematic representations (Calvert 90). By reconceptualizing the notion of evil from a female perspective, especially looking at pain, separation, and helplessness, *Supernatural* might offer an understanding of a text driven by masculine constructions, but of great interest to a female audience, an audience who is concerned about the interrelation of family and gender in the imaginary space of depictions of good and evil. Three other conclusions could be drawn that offer productive ways of thinking about the relationship between *Supernatural* and Noddings's stance on gender and evil.

First, the show is limited by its masculine construction of evil. The construction of evil is gendered, primarily patriarchal, and it could benefit from a feminine reinscription. Here, we want to consider Bakhtin's notion of carnival (66), in which the standard relations of power are displaced, and the normally powerless are given power, though only temporarily. Eventually the traditional relations of power are reinscribed and the world returns to its own sense of "normal." We might understand the potential for Mary or Jo to burst through the limitations on their own power and move beyond the dualism of either the gateway to the devil or the angel in the house, to a position

of fulfilled self-empowerment. In other words, the possibility for a feminine reinscription remains an unrealized potential.

Second, the examples of Mary and Jo could be better understood if examined using issues of care. Mary and Jo are both potential agents of care; Mary gives up the hunter's life for a family life apart from fear, but to do so makes a bargain that guarantees that her ability to care is compromised. Jo could become on object for and source of care, especially in relation to Dean, but cannot achieve that status as an equal. She ultimately destroys herself (as does her mother Ellen) in an attempt to allow Dean and Sam to survive, or, as they admit, to give the Winchesters just a few minutes head start. This seems like a meager return for one's self-annihilation, but more importantly it ends the possibility that a caring relationship can survive the fight against evil. Although it seems that women are taking a step forward, they lose ground because of the patriarchal nature of cultural evil.

Third, *Supernatural* demonstrates that the reinscription of evil from a feminine perspective is an ongoing concern. The series' efforts to move women into positions as "deciders," as hunters, succeeds in making the gendered understanding of evil more palpable, but it remains a path that has not fully been explored. As Noddings notes, "We are simply not going to make the world better by making it possible for women to live like traditional men—that is, to escape the vocation of caregiving—for then *no one* will live with the assurance of compassion and the security of devoted love" (177). Jo's "shot at the devil" falls short since she must ultimately sacrifice herself for the patriarchal construction of evil. Mary's attempts to feminize the role of hunter are thwarted by her own desires to have a family; she is willing to abandon the hunter's life in exchange for freedom from fear, but to accomplish this she ends up bargaining away her long-term freedom for short term gain and condemns those she wants to protect in her roles as wife and mother.

This series is concerned with the problems of two brothers so enmeshed in their own masculine rejection of care that they are unable to move beyond the dynamics of family, to the recognition that the "other" is deserving of care. Noddings discusses how a pedagogy of a morality of evil understood from a women's perspective requires this recognition of the ability to care without the justification of familial loyalty, whether by blood or through love. Perhaps Dean's expression of care for Sam hints toward some of the initial signs of caregiver, but they are limited by the bond of family. This relationship is distinguished from an ability to otherwise care for a nonfamily "other,"

and the self-consciousness of masculine distance always returns to reinscribe the rule of the patriarchal definition of evil. Nevertheless, *Supernatural* offers an opportunity to experimentally explore the possibility of reinscribing evil from a women's perspective before the power of patriarchy reasserts itself and makes martyrs of the disobedient women, like Jo and Mary, who resist being the gateway to the devil but are not satisfied with being the angel in the house.

Works Cited

"Abandon All Hope…" *Supernatural: The Complete Fifth Season.* Writ. Eric Kripke and Ben Edlund. Dir. Philip Scriccia. Warner Brothers, 2009. DVD.

Bakhtin, Mikhail. *Rabelais and His World.* Trans. Helen Iswolsky. Bloomington: Indiana UP, 2009. Print.

Boggs, April R. "No Chick Flick Moments: *Supernatural* as a Masculine Narrative." MA thesis. Bowling Green, 2009. Print.

"Born Under a Bad Sign." *Supernatural: The Complete Second Season.* Writ. Eric Kripke and Cathryn Humphris. Dir. J. Miller Tobin. Warner Brothers, 2006. DVD.

Calvert, Bronwen. "Angels, Demons, and Damsels in Distress: The Representation of Women in *Supernatural.*" *TV Goes to Hell: An Unofficial Road Map of* Supernatural. Eds. Stacey Abbott and David Lavery. Toronto: ECW Press, 2011. 90–104. Print.

"Everybody Loves a Clown." *Supernatural: The Complete Second Season.* Writ. Eric Kripke and John Shiban. Dir. Philip Sgriccia. Warner Brothers, 2006. DVD.

"Good God, Y'all!" *Supernatural: The Complete Fifth Season.* Writ. Eric Kripke and Sera Gamble. Dir. Philip Sgriccia. Warner Brothers, 2009. DVD.

"In the Beginning." *Supernatural: The Complete Fourth Season.* Writ. Eric Kripke and Jeremy Carver. Dir. Steve Boyum. Warner Brothers, 2008. DVD.

"Let It Bleed." *Supernatural: The Complete Sixth Season.* Writ. Eric Kripke and Sera Gamble. Dir. John F. Showalter. Warner Brothers, 2010. DVD.

"No Exit." *Supernatural: The Complete Second Season.* Writ. Eric Kripke and Matt Witten. Dir. Kim Manners. Warner Brothers, 2006. DVD.

Noddings, Nel. *Women and Evil.* Berkeley: U of California P, 1989. Print.

Palmer, Lorrie. "The Road to Lordsburg: Rural Masculinity in *Supernatural.*" *TV Goes to Hell: An Unofficial Road Map of* Supernatural. Eds. Stacey Abbott and David Lavery. Toronto: ECW Press, 2011. 77–89. Print.

"Pilot." *Supernatural: The Complete First Season.* Writ. Eric Kripke. Dir. David Nutter. Warner Brothers, 2005, DVD.

"The Song Remains the Same." *Supernatural: The Complete Fifth Season.* Writ. Sera Gamble and Nancy Weiner. Dir. Steve Boyum. Warner Brothers, 2009. DVD

"Swan Song." *Supernatural: The Complete Fifth Season.* Writ. Eric Kripke. Dir. Steve Boyum. Warner Brothers, 2009. DVD.

Tobin-McClain, Lee. "Paranormal Romance: Secrets of the Female Fantastic." *Journal of the Fantastic in the Arts* 11.3 (2000): 294–306. Print.

Wright, Julia M. "Latchkey Hero: Masculinity, Class and the Gothic in Eric Kripke's *Supernaural*." *Genders*. 47 (2008): n pag. Web. 6 Oct. 2012.

All That Glitters: The Winchester Boys and Fairy Tales

Rebecca-Anne C. Do Rozario

Once upon a time, there were two brothers. Their mother was killed and they were raised by their father, a hunter of demons and other monsters. When their father disappeared, Sam and Dean Winchester hit the road in their '67 Chevy Impala, following the clues left in his journal like so many breadcrumbs. This is no Mother Goose tale, however. It is a tale about "real men," authenticity embedded in masculine performance and feminine performance rendered false.

In *Supernatural*'s second episode, "Wendigo," Dean (Jensen Ackles) establishes the Winchesters' life as "saving people, hunting things—the family business." Like the huntsman in the Grimms' "Little Red Cap," who chooses to cut open the wolf's stomach and save his victims rather than just shoot the wolf, the brothers do not simply hunt monsters, they save people from the monsters. *Supernatural* is more inspired by this fairy tale huntsman than the alternative male role of aristocratic prince who rescues and marries the damsel-in-distress. Like the huntsman, the Winchesters simply move on to the next monster. Yet the family business is as much about the lore that explains monsters and how to kill them as it is about weapons stored in the Impala's trunk and people saved.

The lore is a composite of urban legend, folk tale, and myth, elucidated through the father's journals, hunter networks, research, and interviews with locals. It is understood from the hunters' perspective,

thereby narrated and enacted through a performance of masculinities. As Lorrie Palmer observes, "The rugged settings and the violence required for the Winchesters to stay alive in the battle between good and evil (and their frequently blurred boundaries) situate them within a particular mode of masculinity" (78). Within this mode, female hunters rarely stay alive, as evinced by the deaths of mother and daughter, Ellen and Jo Harvelle, and the brothers' own mother, Mary. The masculinities represented are also aligned with working class, Middle America, articulated through muscle cars, classic rock, guns, bars, fast food, and life on the road. Indeed, the series preserves and promotes masculinities so well that it encompasses heteronormative *and* queered masculinities simultaneously. The close relationships between the brothers or Dean and the angel, Castiel (Misha Collins), are repeatedly queered. In "The Third Man" (6.3), for example, Castiel dryly acknowledges that he is more likely to answer Dean's call because they have a "more profound bond." Nonetheless, masculine heterosexuality is always reasserted as the dominant, "authentic" mode.

The series further relies upon accepting as true a body of lore with such diverse content as ghosts, time travel, and Armageddon. Jan Harold Brunvand asserts, regarding urban legend specifically, that "there is usually no geographical or generational gap between teller and event. The story is *true*" (60). Sam (Jared Padalecki) and Dean drive U.S. highways to hunt down monsters and other beings and their proximity confers truth. If they, as the tellers, can engage with the lore's protagonists, throw salt at them or beat them up and shoot them down, the lore is true. Since this interaction takes place through a performance of masculinities, authenticity in *Supernatural* is gendered masculine.

Judith Butler conceptualizes the performative nature of gender as "the tacit collective agreement to perform, produce, and sustain discrete and polar genders as cultural fictions" (178). Where frequently this is a discreet or obscured process, *Supernatural* aggressively performs its masculinities to compel authenticity. The series, based on the Winchester family business, is about the lore. In making the lore authentic and credible through the performance of masculinities, masculinities have to be generated explicitly. Butler further notes that "the action of gender requires a performance that is *repeated*" (178) and the very nature of series television allows *Supernatural* to repeat its performances of the masculine from one episode to the next, intensifying each performance. Consequently, when the lore informing

an episode rests upon a performance of the feminine, it offers a distinct challenge for the show. Likewise, lore and narrative can involve female characters, but the performance itself may not be particularly feminine since the characters, such as Ellen and Jo, conform to pertinent behaviors and cultural markers of masculinity including flannel shirts and jeans and bar-keeping.

Challenges to Masculinity Met: Angels and Sparkly Vampires

One of *Supernatural*'s greatest story arcs involves angels and demons. The brothers's relationship with Castiel, in particular, has become a key element of the series. While angel lore was an initial challenge to the performance of masculinities adopted by the series' sophomore season, demons posed no such challenge. Demons, including females like Meg, already appeared in the first season. The performance of femininity initially adopted by Meg is quickly uncovered as false and treacherous. Dean explicitly tells Meg "you're no girl" in "Devil's Trap" (1.22). In addition, demon lore is articulated and authenticated through more-or-less masculine references such as guns, violence, and business dealings. Notorious demon, Crowley (Mark Sheppard), for example, wears suits and contrives an endless queue as a more efficient torture for Hell ("The Man Who Would Be King" 6.20).

Midway through season two, angel lore is introduced. In "Houses of the Holy" (2.13), Sam and Dean encounter a series of murders by people claiming to have been visited by angels. Dean emphatically rejects these claims because his mother's reassurances of angelic protection were discredited by her horrific death. While he accepts the existence of demons, Dean rejects angel lore because he connects it to the performance of feminine maternal concern. Sam reports that there is more lore on angels than on the other monsters they hunt, but Dean responds: "There's a ton of lore on unicorns too. In fact I hear that they ride on silver moon beams and they shoot rainbows out of their ass." Angels and unicorns are, in Dean's experience, implicit in a performance of the feminine and therefore unbelievable. He even mocks angel lore with references to fluffy wings. In "Houses of the Holy," the angel is revealed to be false, simply the ghost of a priest, validating Dean's point of view. Later in the series, however, by reasserting more masculinist, biblical narratives—representing angels as warriors of God and losing wings in favor of trench coats and business suits—the

lore is successfully integrated. Indeed Castiel, ironically occupy-
ing the fairy godmother role through his responses to the brothers'
wishes/prayers, is distinguished by a taciturn brand of masculinity
encompassing both queered performance, demonstrated in his close
relationship to Dean, and heteronormative experiences with drunken-
ness and pornography. By season eight, Castiel has become a hunter
himself cementing his performance of masculinity.

However, lore is not consistently narrated throughout the series.
While early seasons of *Supernatural* present vampire lore as mascu-
line performance, in the season six episode "Live Free or Twihard,"
the writers' spoof of Stephenie Meyer's *Twilight* novels, the vampires
have adapted to the feminine performance of gothic tropes associated
with *Twilight* fandom. This is epitomized by the episode's first victim,
a teenage girl obsessed with fictional vampires. Selected for youth and
good looks, new vampires are sired to fulfill the romantic desires of
such girls, so that "true" vampires may easily feed upon them. Dean
is himself turned because he is "pretty," a feminine description under-
lining the qualities of performance required.

Colette Murphy's aptly titled essay, "Someday My Vampire Will
Come? Society's (and the Media's) Lovesick Infatuation with Prince-
Like Vampires" suggests that the contemporary vampire has replaced
the fairy tale prince and, in turn, been removed from associations
"with horror and fear" (57), the very associations that *Supernatural*
commonly exploits. The episode's vampire mastermind, a boor-
ish, middle-aged figure named Boris (Joseph D. Reitman), concurs
with Murphy's thesis: "they've reinvented us as Prince Charming."
However, the reinvention has not included Boris and his particular
performance of masculinity. The "true" vampires have simply taken
advantage of the fairy tale narrative in choosing their new recruits.
Dean, as a new recruit, then reinscribes his performance, in his own
words, as "ugly and violent." By the episode's end, he has horrified
his girlfriend, is covered in blood, and throws up, a performance
of visceral horror that restores the masculine and, incidentally, his
humanity.

Dean scoffs at fairy tale vampires (and scolds a glitter-wearing
young man masquerading as a vampire to attract women) because he
knows that fairy tales are not real. Indeed, the term "fairy tale" has
become a synonym for a lie or fiction, running counter to the innate,
insistent veracity of urban legend that informs the series. As Brunvand
observes, "Urban legends belong to the subclass of folk narratives,
legends, that—unlike fairy tales—are believed, or at least believable"

(59).[1] The series struggles, in effect, to arrive at the veracity of fairy tale lore, while maintaining a performance of masculinity.

A Brief History of Fairy Tale: Femininity and Artifice

The very basis of the series—that the supernatural is believable through the performance of masculinity—is implicitly challenged by narrative and lore that is rooted in the performance of femininity. While angels and vampires are reinscribed through the performance of masculinity, the series has not absorbed fairies and fairy tales in the same way. In the last century, fairies and fairy tales have become synonymous with the performance of femininity; they have become as girly and artificial as glitter and unicorns. As Marina Warner observes fairy tales "with their pinnacled castles and rose-wreathed princesses, their enchanted sleeps and dashing princes showing a leg, [are] also definitely girly" (xiii). Throughout history, fairy tales have been consistently associated with the feminine, particularly the female storyteller. Even before Mother Goose took hold in the popular imagination, tales were cast through the feminine voice, whether through the crones of Giambattista Basile's *Lo cunto de li cunti* (1634–36), or Scheherazade of the *Arabian Nights*' tradition. Roderick McGillis concludes that, "If the female transmits the fairy tale, then the sensibility of these tales must pose a challenge to a male-dominated society" (86). They likewise challenge performances of the masculine.

Yet, the fairy tale canon is formed around male writers and collectors, such as Charles Perrault and Wilhelm and Jacob Grimm, the latter cited in *Supernatural*. These male authors have been lauded for their efforts to maintain the "authenticity" of fairy tales as told by the folk. They often included invented portraits of old, illiterate storytellers like Mother Goose, unrepresentative of the reality of the educated women who frequently wrote tales or passed tales on to collectors. There is a false premise of feminine performance of fairy tale being unsophisticated, necessarily mediated through male authors conferring authenticity. Well-educated, socially influential female fairy tale authors, including those of the pivotal French fairy tale vogue of the late seventeenth century, have been forgotten. These authors include Marie-Catherine d'Aulnoy, whose collection *Les contes de fées* (1697) established the term "fairy tale." Lewis C. Seifert notes

of these authors that "they relate a complex story about the persistence but also the instability of patriarchy at a decisive moment in the history of French literature and culture" (4). Although their tales have been neglected, the genre itself actually continues to chronicle the instability of patriarchy into *Supernatural*'s twenty-first century cultural milieu of American muscle cars, fast food, and classic rock, albeit authenticated through masculine performance.

The genre itself highlights issues of gender. Seifert speculates that "more often than not, fairy-tale plots concern the dynamics of a family... Their adventures force them to assume what turn out to be highly codified attributes of sexual and gender identity" (2). *Supernatural*'s own internal focus on the Winchester brothers and their family is innately masculine: mothers, wives, and girlfriends die, leave or are simply manufactured by monsters and angels leaving the brothers in a highly codified male environment reliant on the fraternal bond and "adopted" family members like Bobby Singer (Jim Beaver), marking this environment as authentic.

The Grim(m) Side of Fairy Tale

There are two particular episodes dealing explicitly with fairy tale and fairies. In season three's "Bedtime Stories" (3.5) a young comatose woman is being read Grimms' fairy tales and projects the narratives through local residents. In season six's "Clap Your Hands If You Believe," fairies have infested a town under the guise of alien activity. In "Bedtime Stories," Callie (Tracy Spiridakos) has been in a coma since childhood. Now a young woman, her dark hair and pale complexion upon the hospital pillows recalls the death-enchantment of Snow White. Her father, Dr. Garrison (Christopher Cousins), reads a book of Grimms' tales to her, which her "spirit" then performs as locals are unwittingly possessed by the fairy tale tropes.[2] She often manifests in these scenes as a child, sustaining a performance of innocent, feminine childishness.

When the Winchester brothers arrive, Sam presents the possibility that they are dealing with fairy tales. He assures Dean: "See, the Grimm brothers' stuff was kind of like the folklore of its day, full of sex, violence, cannibalism. Now it got sanitized over the years, turned into Disney flicks and bedtime stories." The episode title plays ironically upon Sam's assertion, but his statements reflect the popular conceptualization of the Grimms' authenticity, incorporating them into the veracity of folklore. Mikel J. Koven and Gunnella Thorgeirsdottir

support Sam's view: "the Brothers Grimm's *Kinder und hausmarchen* is authentic, the films of Walt Disney are not" (189). Disney, with its troop of ballgowned princesses and saccharine reputation, is referenced to underscore and dismiss the feminine performance of fairy tale. In addition, Sam champions the historical link with the male Grimms as a "return" to authentic folklore. In her discussion of the episode, Catherine Tosenberger poses that "in the realm of popular culture, the 'recovery narrative' is a story we tell about fairy tales, and it's one that both contradicts and relies upon the existence of the 'fairy tales are sweet and innocent' narrative for its power" (par. 5.3). This is the narrative Sam promotes.

Sam's understanding of the Grimms is not entirely inconsistent with the scholarship. Maria Tatar, for example, notes that "Sex and violence: these are the major thematic concerns of tales in the Grimms' collection, at least in their unedited form" (10). As the Grimms continued to edit the collection, though, the stories became increasingly sanitized, in part responding to and exploiting the growing popularity of the tales as children's literature. In fact, the Grimms presided over the very process of "sanitization" against which they are now juxtaposed. As Elizabeth Wanning Harries writes, "The Grimms wanted fairy tales to be simple, 'naïve,' economical, a reflection of their ideas about the folk, and appropriate for the social education of children" (45). Indeed, Dean, rejecting Sam's recovery narrative, infantilizes and feminizes his brother as "fairy tale boy." Tosenberger argues that Sam's use of the recovery narrative "suggests a problematic conclusion: it is the goriness and sexuality of fairy tales that renders them appropriate for masculine interest" (par. 5.9). Furthermore, she equates violence and authenticity (i.e., masculine performance): "Fairy tale horror…makes a truth claim about the nature of the tales themselves: this is what fairy tales really are" (par. 5.4). The efforts to engage this aspect of fairy tales has gained momentum in series like *The X-Files* (1993–2002) and *Grimm* (2011–). But in *Supernatural* the fairy tale is rejected as a performance of the feminine and Callie's enactments of fairy tales, however violent, are "fake" and simply orchestrated through her imaginative response to bedtime stories.

While the perception of the tales originating in oral lore persists in Sam's explanation, the episode does not attempt to verify the lore; it only momentarily animates it through the father's reading of the book. Ironically, fathers in many of the well-known Grimms' tales, including their Cinderella and Snow White narratives, fail their children. In *Supernatural*, too, the performance of fatherhood is consistently

troubled and rendered inadequate through questions about how John Winchester raised his sons and the prevalence of death, estrangement, and abandonment in stories of fathers and father figures like John (Jeffrey Dean Morgan), Bobby, William Harvelle, Crowley, and even God. Dr. Garrison, too, performs the role of ineffectual father figure, failing to realize his daughter was poisoned by his new wife.

Yet, the Winchester brothers cannot defeat Callie with rock salt, a magic gun, or by burning her bones. Her very fairy tale state—like Snow White or Sleeping Beauty, neither dead nor alive—forestalls their action. Silenced in her coma, her mere existence frustrates their efforts to prevent her actions or defeat her. Although Snow White, to whom Callie is linked in both appearance and narrative enmity with her stepmother, is often identified as passive, Callie's own subconscious, fueled by fairy tales, is able to sustain feminine performance as something outside the physical, tangible state.

Throughout the episode, fairy tales are not performed as real, unlike most folklore utilized in *Supernatural*, which is shown to have veracity, immediacy, and physicality. The tales simply become a self-referential narrative technique used by Callie and the motifs clues that can be tracked by the brothers and linked back to the copy of the Grimms that Dr. Garrison reads. Indeed, small touches like Dean refusing to kiss a passing frog lend color to the trope-spotting and allow the brothers to engage with, but not authenticate, the tales.[3]

The Lore of Little, Glowing, Hot, Naked Ladies

Although "Clap Your Hands If You Believe" (6.9) is more accurately an episode based on fairy lore, its references also engage with fairy tales including J. M. Barrie's *Peter Pan*. The episode title echoes Barrie's play, and Peter's exhortation to audiences to save Tinkerbell, the fairy, through belief. Fairy lore and tales are introduced, however, under the guise of alien conspiracy. The mysterious disappearance of first-born sons in the town is initially understood in terms of alien abductions and the town consequently becomes a focal point for alien enthusiasts. Lore on aliens is thus presented as believable at the outset. Indeed, the episode titles spoof those of *The X-Files*, a series about an FBI agent who seeks the truth about aliens. Lore on aliens is given precedence and authority in the title sequence and renders fairy lore by comparison *less* rational.

The irrationality of fairy lore is directly related to the performance of the feminine. During interviews with locals, Sam complains that

everyone is crazy, but it is only when he encounters a soft-spoken, middle-aged woman, Marion, claiming fairy abductions, that he loses it: "flying saucers not insane enough for you?" He continues to ridicule Marion by suggesting that her craziness is related to sniffing glitter glue. Interestingly, just after this scene, Sam and Dean discuss Sam's lack of a soul with allusions to Pinocchio, Collodi's fairy tale puppet who wants to become a real boy. The fairy tale is just a metaphor for their new relationship in which Dean serves as cricket or conscience.

The source for fairy lore, nonetheless, is Marion and she continues to be undermined. Her trailer park house is kitschy and girly, a porcelain unicorn one of the first objects the camera focuses upon. Fairy lore is reduced to knick knacks and tiny tea cups from which the very masculine Winchesters cannot comfortably sip. Marion is given no authority in the episode beyond her enthusiasm for fairy figurines, jingly earrings, and the glitter makeup. After seeing Marion, Dean tries to brush off "the crazy," only for Sam to note that he has glitter on him.

In fact, Dean is once again the focus of the performance of femininity and it again attempts to reconstruct his own performance of gender or at least "queers" him very much against his will. As McGillis observes, "The fairy tale may be a feminine form, but it is so in a queer way. In it a reconfigured masculinity appears" (97). Keeping in mind that Dean is the eldest brother, Marion, suggests that abducted first-born sons are taken to the court of Oberon, the fairy king, to serve him. Sam exuberantly implies this to be a sexual form of service. The inference of queered masculine performance is further elucidated when Dean becomes overwhelmed with his ability to see fairies, which no one else can see. His rage at seeing this feminine world is exaggerated and articulated in the cry "fight the fairies," acknowledging its contemporary implication of homophobia.

Dean's violent response to fairies, to feminine performance and his necessary part in it, is humorously exemplified in the scene shortly after his abduction in which a bright light—in fact a tiny naked woman—invades his hotel room. The scene links alien and fairy lore through the soundtrack of David Bowie's "Space Oddity" (1969). Bowie's gendered performances have their own androgynous history, making the song a particularly pertinent commentary. After Dean boldly stares at the fairy's nipples, underscoring his performance of heterosexual masculinity and explicitly enacting the male gaze of the camera itself, they fight and Dean traps "Tinkerbell" in a microwave,

turns on the power, and she explodes. Dean's response to the overt performance of the feminine here is to sexualize it and then nuke it.

Yet there is a suggestion that the fairies are themselves more powerful than angels, those other made-over figures of feminine lore. A leprechaun offers to get Sam's soul back. Sam treats his offer as "adorable," again feminizing the fairy. The leprechaun scoffs: "Angels, please, I'm talking about real magic, sonny." Sam does not believe him, though, for fairy lore has lost its veracity. Ensuing violent bouts with human-sized, male fairies—Sam fighting the leprechaun, Dean fighting a red cap—finally realign the brothers in masculine performance. The irrationality of fairy lore, embedded in feminine performance, is ultimately, violently rejected.

Geek Lore and Real Fairy Tale

Supernatural also engages with feminine performance through geek culture. Although commonly regarded as masculine, the articulation of feminine geek performance is evolving because of prominent figures like Felicia Day, well-known for her web series, *The Guild* (2007–). Day is a reoccurring guest star on the series as Charlie Bradbury. On *E!*, Day described her initial impression: "It was a big blast of testosterone in my face when I walked on that set. It is such a guy set" (Moorhouse). Her remarks suggest the show's performance of masculinity is evident even behind the scenes. Charlie's entrance in "The Girl with the Dungeons and Dragons Tattoo" (7.20) provides an immediate, visceral counter to the performance of masculinity. Wearing a Princess Leia t-shirt, Charlie arrives at work on a bright yellow, daisy covered Vespa and dances to Katrina and the Waves's "Walking on Sunshine" (1983). Unlike Callie or Marion, however, she is introduced as an active, rational woman. She has no glitter or unicorns, but is surrounded by female geek icons including Princess Leia (*Star Wars*), Arwen (*Lord of the Rings*), and Hermione (*Harry Potter*).

The show had previously represented its own female "geek" fans with Becky Rosen, featured in a series of meta-episodes in which Dean and Sam encounter a fan community for Chuck Shurley's *Supernatural* novels, which prophesize the Winchesters's actions. Becky is a self-referential performance of a female tale-teller, writing slash fiction of Shurley's *Supernatural*. Her writing is positioned as inauthentic, though, and she often represents deluded feminine desire. In "Season Seven, Time for a Wedding," she performs the role of the

fairy tale ugly stepsister by tricking Sam into marrying her. This is an old fairy tale trope, traceable to tales including Basile's "The Three Fairies" in which the heroine's hideous stepsister takes her place at the altar, heavily veiled, resulting in such an unpleasant wedding night that the groom ends up in a chamber pot. Sam's predicament is not so abject. However, the true bride in this case is not a bride at all. Becky has taken Dean's place, making Dean the "true bride," which is ironic in view of Becky's authorship of the Winchesters' queered performance. Unlike fairy tales, however, in which the stepsister is punished, Becky acts to undo the damage she causes. She returns Sam to Dean, and also to the authorized *Supernatural* narrative, by tricking the crossroads demon into thinking she has accepted his deal to sell her soul. She clarifies that "we seal the deal with a kiss," playing ironically on the fairy tale trope of a kiss of true love, and in the moment just before the kiss, she traps the demon and redeems herself. By transforming and tricking Sam into playing her real groom, she threatens to break the *Supernatural* narrative until she returns to her inauthentic authorial position.

The problem identified in "Season Seven, Time for a Wedding"—that either Winchester brother's relationship with a woman ultimately destabilizes the performance of masculinity—is partially solved through the performance of Charlie's queered femininity. Charlie shares Dean's sexual desire of women. In "The Girl with the Dungeons and Dragons Tattoo," they share an attraction to Scarlett Johansson. This initial bonding develops in "LARP and the Real Girl" (8.11), both checking out female LARPers and, in unison, mistaking Belladonna the poison for Belladonna the porn star. In fact, the show uses their relationship as a handy means of cross-gendering Dean. In Charlie's first episode, she is on a mission to break into the e-mail of the season's ultimate bad guy, Dick Roman, leader of the Leviathans, and encounters a security guard. She does not know how to flirt her way past a man. Dean feeds Charlie the necessary flirtatious banter through an earpiece, but he also performs accompanying feminine expressions, even though Charlie cannot see him. Dean immediately enforces a silencing of this performance, saying to Sam, "this never happened."

Queering and cross-gendered performance continues in "LARP and the Real Girl." Sam and Dean trace a series of inexplicable murders to a local LARPing (live action role-playing) group and their game, Moondor. Arriving at the field where Moondor is enacted, the brothers witness a sword fight between role-playing knights, visors

Figure 10.1 Dean Winchester as handmaiden with the queen in "LARP and the Real Girl."

concealing their faces. The victor takes off her helmet and shakes out her long hair—an exaggerated performance of the feminine that reintroduces Charlie. Although cross-dressed in masculine faux-medieval costume, she is clearly a woman. Cross-dressing is a common fairy tales theme used to destabilize gender categories. Charlie continues this destabilization, responding to the fallen knight's profession of love, she quotes *male* romantic lead, Han Solo, from *The Empire Strikes Back* (1980), "I know." As the role-playing Queen of Moondor, Charlie usurps the male lead. She discovers that behind the murders of several LARPers is a captured fairy, forced by her master to kill, and announces, "I'm the one who saves damsels in distress around here." She then makes out with the fairy, unlike Dean who nukes fairies in the microwave. Charlie also designates Dean as one of her handmaidens, smoothly drawing Dean again into her cross-gender-performance.

This is all possible because, of course, the entire story is set in a LARP game in which everything is performance and play. The episode even begins with Dean expressing a desire to take time off from their real life of fighting demons and monsters. Good fairies and the performance of the feminine itself can exist, because they are on a "break" from *Supernatural*'s construction of reality. Charlie herself

is not real, since she has assumed the name Charlie Bradbury and she consistently quotes popular culture, adopting, in effect, a fictional voice that draws on fairy tales like *The Princess Bride* (1987). By the episode's conclusion, Dean is leading Charlie's troops and delivers a stirring rendition of Mel Gibson's speech from *Braveheart* (1995), interrupted only by a stray frisbee. Charlie has since become a reoccurring character, even going to Oz as a friend of Dorothy in the season nine "Slumber Party." Her disruptions to the performance of the masculine are contained, but perpetuated.

Supernatural rejects the performance of the feminine as inauthentic, relying upon the performance of the masculine to verify the truth of the lore on which the series is based. This is, in many ways, the series' vulnerability. While the Winchester brothers can battle vampires, djinn, archangels, gods, demons, and all manner of other strange monsters, fairy tales and fairy lore remain elusive and imaginary interludes.

Notes

1. Koven and Thorgeirsdottir refute the concept of "fakelore" in relation to *Supernatural*: "The series' use of folklore is self-conscious, not creating an artificial 'folksy'-like narrative, but presenting the legends in a new, contemporary way, as an organic and dynamic extension of the process that legend tellers and their audiences have undertaken since storytelling began" (200).
2. The episode is not consistent with the Grimms' tales. The Cinderella references, for instance, include a pumpkin, actually part of the Perrault narrative that informed the later Disney feature (1950).
3. In the Grimms' tale of the frog prince, the princess does not kiss the frog—she throws it against a wall. The kiss was a later innovation, underscoring that it is a lore based on the recovery narrative of fairy tale.

Works Cited

"Bedtime Stories." *Supernatural: Season Three*. Writ. Cathryn Humphris. Dir. Mike Rohl. Warner Brothers, 2007. *iTunes*. 23 Jan. 2013.

Brunvand, Jan Harold. "New Legends for Old." *Popular Culture: An Introductory Text*. Eds. Jack Nachbar and Kevin Lause. Madison: The U of Wisconsin P, 1992. 58–67. Print.

Butler, Judith. *Gender Trouble: Feminism and the Subversion of Identity*. 2nd ed. New York: Routledge, 1999. Print.

"Clap Your Hands If You Believe." *Supernatural: Season Six*. Writ. Ben Edlund. Dir. John F. Showalter. Warner Brothers, 2011. *iTunes*. 23 Jan. 2013.

"Devil's Trap." *Supernatural: Season One*. Writ. Eric Kripke. Dir. Kim Manners. Warner Brothers, 2007. *iTunes*. 23 Jan. 2013.

"The Girl with the Dungeons and Dragons Tattoo." *Supernatural: Season Seven*. Writ. Robbie Thompson. Dir. Johan MacCarthy. Warner Brothers, 2011. *iTunes*. 23 Jan. 2013.

Harries, Elizabeth Wanning. *Twice Upon a Time: Women Writers and the History of Fairy Tale*. Princeton: Princeton UP, 2001. Print.

"Houses of the Holy." *Supernatural: Season Two*. Writ. Sera Gamble. Dir. Kim Manners. Warner Brothers, 2006. *iTunes*. 23 Jan. 2013.

Koven, Mikel J. and Gunnella Thorgeirsdottir. "Televisual Folklore: Rescuing *Supernatural* from the Fakelore Realm." *TV Goes to Hell: An Unofficial Road Map of* Supernatural. Eds. Stacey Abbott and David Lavery. Toronto: ECW, 2011. 187–200. Print.

"LARP and the Real Girl." *Supernatural: Season Eight*. Writ. Robbie Thompson. Dir. Jeannot Szwarc. Warner Brothers, 2012. *iTunes*. 23 Jan. 2013.

"Live Free or Twihard." *Supernatural: Season Six*. Writ. Brett Matthews. Dir. Rod Hardy. Warner Brothers, 2011. *iTunes*. 23 Jan. 2013.

"The Man Who Would Be King." *Supernatural: Season Six*. Writ. and Dir. Ben Edlund. Warner Brothers, 2011. *iTunes*. 23 Jan. 2013.

McGillis, Roderick. "'A Fairy tale Is Just a Fairy tale': George MacDonald and the Queering of Fairy." *Marvels & Tales* 17.1 (2003): 86–99. Print.

Moorhouse, Drusilla. "*Supernatural* Scoop: Does Dean Have a New Girlfriend?" *E!* 27 Apr. 2012. Web. 1 Sept. 2013.

Murphy, Colette. "Someday My *Vampire* Will Come? Society's (and the Media's) Lovesick Infatuation with Prince-Like Vampires." *Theorizing Twilight: Critical Essays on What's at Stake in a Post-Vampire World*. Eds. Maggie Parke and Natalie Wilson. Jefferson: McFarland, 2011. 56–69. Print.

Palmer, Lorrie. "The Road to Lordsburg: Rural Masculinity in *Supernatural*." *TV Goes to Hell: An Unofficial Road Map of* Supernatural. Eds. Stacey Abbott and David Lavery. Toronto: ECW, 2011. 77–89. Print.

"Season Seven, Time for a Wedding!" *Supernatural: Season Seven*. Writ. Andrew Dabb and Daniel Loflin. Dir. Tim Andrew. Warner Brothers, 2011. *iTunes*. 23 Jan. 2013.

Seifert, Lewis C. *Fairy tales, Sexuality, and Gender in France 1690–1715: Nostalgic Utopias*. Cambridge: Cambridge UP, 1996. Print.

"Slumber Party." *Supernatural: Season Nine*. Writ. Robbie Thompson. Dir. Robert Singer. Warner Brothers, 2013. *iTunes*. 29 Oct. 2013.

Tatar, Maria. *The Hard Facts of the Grimms' Fairy Tales*. 2nd ed. Princeton: Princeton UP, 2003. Print.

"The Third Man." *Supernatural: Season Six*. Writ. Ben Edlund. Dir. Robert Singer. Warner Brothers, 2011. *iTunes*. 23 Jan. 2013.

Tosenberger, Catherine. "'Kinda Like the Folklore of Its Day': *Supernatural*, Fairy Tales, and Ostension." *TWC: Transformative Works and Cultures* 4 (2010). n. pag. Web. 1 Sept. 2013.

Warner, Marina. *From the Beast to the Blonde: On Fairy Tales and Their Tellers*. London: Vintage, 1995. Print.

"Wendigo." *Supernatural: Season One*. Writ. Eric Kripke. Dir. David Nutter. Warner Brothers, 2007. *iTunes*. 23 Jan. 2013.

III

Men, Women, and *Supernatural*

A Man and His 1967 Impala: *Supernatural,* U.S. Car Culture, and the Masculinity of Dean Winchester

Susan A. George

In *Men in the Middle: Searching for Masculinity in the 1950s,* James Gilbert observes that "Historians have found concern and even the evidence of a 'male panic'—intense uncertainties about masculine identity—in almost every era of American history" (2). These U.S. masculinity crises manifest themselves at times of rapid social and political change. This was true of the 1950s when the residual ideologies of the rugged individualist were challenged by the new standard of the time—the team player. The 1990s and the start of the twenty-first century have been an equally turbulent times because of events such as the Gulf War, the continuing war on terror, and the wars in Afghanistan and Iraq, the government bailout of Wall Street, the recession, the Oklahoma City bombing, and perhaps the most significant event of the new millennium, the terrorist attacks of September11, 2001. All of these social, political, and economic upheavals have created a great deal of anxiety in twenty-first century America and given rise to another crisis of masculinity.

The 1970s was another tumultuous decade. Simon Brown argues that events of the late 1960s and 1970s, including "Vietnam; the assassinations of JFK, Bobby Kennedy, Malcolm X, and Martin Luther King; Watergate; economic recession and the Oil Crisis...all combined to fracture American society" (62). The 1970s, as Robin Wood observes, also marked a significant shift in the horror genre. Wood notes that "In the 30s, horror is always foreign. The films

are set in Paris (*Murders in the Rue Morgue*) [and] middle Europe (*Frankenstein, Dracula*)" (77). When the site of horror films moved from the castles and cities of Europe to the U.S. in the 1970s, horror invaded the American home. It is no coincidence that horror movies focused on the family "in a period of extreme cultural crisis and disintegration" (Wood 76). When *Supernatural*, heavily influenced by 1970s' sensibilities as Brown argues, debuted on the WB in 2005 (four years after 9/11 and two years before the beginning of the recession), family and the construction of masculinity were again major preoccupations of horror (60–61). In an interview with Maureen Ryan of the *Chicago Tribune*, creator and executive producer Eric Kripke comments that:

> [Now] for me, the story is about, "Can the strength of family overcome destiny and fate, and can family save the world?"…If I had a worldview…[That worldview] is that the only thing that matters is family and personal connection, and that's the only thing that gives life meaning.

Therefore, *Supernatural*, a show that is part postmodern horror genre, part road movie, part Western, and part family melodrama, focuses on family—though one markedly without women—and masculinity at a time of crisis.

Much has been made, and with good reason, about *Supernatural*'s violence and violent rejection of (almost) all that is feminine. As Mary Borsellino writes, *Supernatural* "is distressingly easy to read as an attempted regression away from the new frontiers *Buffy* opened up" and in many ways it ignores the work of series like *Buffy the Vampire Slayer* (1997–2003), *Xena: Warrior Princess* (1995–2001), and *Dark Angel* (2000–2002) did in presenting more active roles for women in TV horror and fantasy (108). The show's representation of race and masculinity (or masculinities) "also participates in [a] larger gothic tradition, particularly in its depiction of white, blue-collar masculinity" (Wright, par. 1). Dean Winchester (Jensen Ackles) and his father, John (Jeffrey Dean Morgan), seem to typify a blue-collar type of masculinity that Jackson Katz refers to as violent white masculinity. Katz argues that whiteness, masculinity, and violence are often linked in U.S. media including the action-adventure films of the 1970s and 1980s featuring "White male icons such as Arnold Schwarzenegger, Sylvester Stallone, Jean-Claude Van Damme, Bruce Willis, et al"—a tradition

that has continued into the new millennium (surprisingly with some of the same actors) and is a large part of *Supernatural* (351).

In *Supernatural*, masculinity is always defined "in opposition to femininity... One of the ways this is accomplished, in the image system, is to equate masculinity with violence, power, and control" (Katz 351–2). Despite all this, it is through the narrative trajectory of the womanizing, burger eating, beer swilling Dean, not his softer, more thoughtful, and educated younger brother Sam (Jared Padalecki), that aspects of the feminine are brought into and validated in the series. Through Dean's character arc the construction of masculinity in the U.S. is scrutinized. However, the critique does not stop with Dean, but extends to one of the other powerful symbols of white masculinity in the series, the now iconic 1967 Chevrolet Impala. In this way the show's critical, if inconsistent, examination of masculine power goes beyond the individual to reveal the constructed nature of masculinity in the larger cultural context as it also suggests ways to redefine what it means to be a man in this post-9/11 crisis of masculinity.

From the start the series uses aspects of the *mise-en-scène*, outward signifiers of masculinity to connect Dean to his father and the more traditional, authoritarian masculinity he represents. Various characters, including Dean himself, comment on how Dean is trying to be just like his ex-Marine, Vietnam veteran father—just another example of Katz's violent white masculinity. For example, in the season three episode "Dream a Little Dream of Me" (3.10), Dean's dark dream self tells him: "I mean your car, that's Dad's. Your favorite leather jacket, Dad's. Your music, Dad's....Dad knew who you really were. A good soldier and nothing else." While Dean does incorporate some of his father's characteristics into his persona, they are only a small part of who he is by season nine. As early as this season three episode, Dean makes it clear that he understands his father's shortcomings and works to be, and in many ways is, a better man. He tells his dream self, "My father was an obsessed bastard....He was the one...Who wasn't there for Sam. I always was...I didn't deserve what he put on me," a point even John acknowledges before his death.

The most important signifier of masculinity in *Supernatural* is the Impala. The Winchester brothers' Impala, or Baby as Dean refers to it, is more than a mode of transportation. It is, as Jules Wilkinson observes, "a character with as much depth and emotional resonance as Sam or Dean" (198). It is also a symbol of U.S. autonomy and mobility or automobility (as Mark Osteen and others refer to it) and

the American males' love of cars. America's long love affair with the automobile blossomed in the 1950s with the establishment of the suburbs and the Federal Highway Act of 1956. Like the horse before it, the car has become an icon in U.S. stories, myths, and songs about masculinity, open spaces, and freedom. In his study of the Corvette in popular culture, Jerry W. Passon notes that "with the advent of...affordable cars, the automobile rapidly became the single most powerful signifier of independence and freedom of the American people" (49). He further observes that

> there is a romance of the road that works to seduce men, making them think that masculinity does not just promise autonomy and mobility, but is to a great degree defined by them. Since our society values patriarchal power, the automobile has become a tangible sign, the proof of masculine authority, which only recently could be appropriate by "others"—those who are not white, mainstream, heteronormative males. (49–50)

Early in the series, the Impala is the quintessential "tangible sign" of "white," if not entirely mainstream, "heteronormative males."

The symbolic power of the Impala is not accidental, but part of Kripke's concept for the series. Kripke has frequently commented that his vision for the show was to "do it as *Route 66*; Just two boys on the road driving in and out of a different horror movie every week" ("Pilot" Commentary). *Route 66* (1960–1964) featured "two young, attractive, American males enjoy[ing] the freedom and adventure of the open road" (Passon 60). However, the similarity to *Supernatural* does not stop there because *Route 66* had its own signature car—a Chevrolet Corvette. And like the Impala, the series executive producer, Herbert B. Leonard, "and Stirling Silliphant, its writer/cocreator, referred to [the Corvette as a] third character" (Passon 60–61). Therefore, the Impala and Kripke's concept for the show establish a particular type of masculinity—one more representative of the mid- to late twentieth century rather than the twenty-first.

While the Impala is certainly no Corvette nor technically a classic American muscle car, which is strictly defined as a two-door sports coupe, like the Camaro, Mustang, Challenger, Charger, or GTO, it is still a symbol of U.S. car culture and the hard masculinity it signifies. Jacob Clifton notes that for Dean "the Impala is a symbol of masculinity, both as a virile signifier in its own right and as a sign of the family's legacy of protection and violence" (132). In her essay,

"Impala Meta: Season One," Andie Masino further observes that "as Dean start[s] to internally deteriorate, so [does] the Impala's exterior condition" solidifying the link between Dean and the masculinity represented by the Impala early in the series (qtd. in Bruce, par. 3.5). However, the season four time travel episode, "In the Beginning," significantly changes all we know about the legacy of the Winchesters' 67 Impala.

In this episode, the angel Castiel (Misha Collins) sends Dean back to Lawrence, Kansas, 1973 where he meets his parents before they are married. Initially the events surrounding the Impala's purchase appear to be just another postmodern, self-reflexive joke, a series trademark. However, by centering the joke on the acquisition of the Impala so inextricably linked to John as "proof of masculine authority" and Dean's identity as no more than "daddy's good little soldier" (Passon 50), it becomes more than a joke but a poignant and significant moment in Dean's character arc and the representation of hegemonic blue-collar masculinity.

After Dean finds himself in 1973 he meets John in the local diner. The scene then cuts to a medium shot of a salesman at the Rainbow Used Car Lot. The salesman is in the background looking at John and John is in the foreground looking at something off screen as the salesman says, "A fine young man like yourself just starting out. How about I take off another 250?" John replies, "Let's do it." When the salesman leaves to get the paperwork started, John starts to examine and run his hands over his new purchase—not a black '67 Chevy Impala, but a white and tan 1964 Volkswagon van! From off-screen Dean says, "That's not the one you want," and the camera pans to a medium long shot of Dean leaning against a less than pristine black Impala. Their conversation, as they look under the hood, is both funny and telling:

> DEAN: This is a great car. Three-twenty-seven, 4-barrel, 275 horses. Little TLC, this thing is cherry.
> JOHN: You know, man, you're right.
> DEAN: Well, what are you buying that thing for?
> JOHN: Kind of promised someone I would.
> DEAN: Over a '67 chevy? I mean, come on, this is the car of a lifetime. Trust me, this thing's still gonna be badass when it's 40.

With that Dean has convinced John to buy the Impala and secured his legacy.

John, of course, has promised Mary (Samantha Smith) he would buy the van—a symbol of family and not masculinity in this context. Surprisingly, this episode reveals that Mary is from a hunter family and John knows nothing about the supernatural beings in the world around him. Mary wants to leave "the life" and plans to run away with John. The van, then, becomes her ticket out and a symbol of the normal, "apple-pie life" she so desires and attains if only for a short time. The VW van, however, is no symbol of U.S. car culture, virile masculinity, and it certainly does not measure up to other important TV cars such as *Route 66*'s Corvette, the Batmobile, *Night Rider*'s KITT, or the Green Hornet's Black Beauty. A van does not fit in with cultural expectations about hard masculinity nor the *Supernatural* worldview, which is made clear as early as the second season episode, "Everybody Loves a Clown" (2.2).

While Dean is still rebuilding the Impala after it is wrecked in the season one finale, the brothers have to borrow a car from longtime family friend Bobby Singer (Jim Beaver) to investigate a message Sam finds on one of their father's phones. The only car working is a late 1980s early 1990s faux wood paneled Dodge Caravan. A long shot shows the van in a cloud of exhaust and dirt as its squeaky brakes eventually bring it to a halt. A medium shot of Dean through the van window shows him embarrassed and irritated as the van keeps "dieseling" after he turns off the ignition. Even the tinny sounding music coming from the van radio is unusual for *Supernatural*. Instead of the full sound of classic hard rock the song playing on the radio is the Captain and Tennille's, "Do That To Me One More Time." As he gets out of the van Dean comments, "This is humiliating. I feel like a friggin' soccer mom." The van, therefore, is no "tangible sign…of masculine authority" as is the American muscle car or the Impala, but of feminization and motherhood (Passon 50).

The car sequence from "In the Beginning" is a joke and a self-serving one. Dean, after all, does not want to spend his future riding around the country hunting evil things in a 1964 VW van. Significantly, this sequence also makes it clear that Dean, no matter what anyone says, is more than a younger replica of his father. He does not merely inherited his father's car, one that is a symbol of U.S. automobility and masculinity, but he ensures that John purchases the Impala because of what it represents to him—a home. In addition, the Impala, as Melissa N. Bruce writes, "allows certain emotional exchanges to be negotiated that may not be typically acceptable in the realm of the masculine within our culture, thus directly connecting the brothers to

melodrama" (1.1). It is safe to say, as Bruce and Masino do, that Dean and the Impala are directly and metaphorically linked in a way that allows them to be both sites where traditionally feminine characteristics are introduced into the *Supernatural* universe and the construction of hard masculinity is disrupted.

For example, the season two episode "In My Time of Dying" (2.1) demonstrates that Dean is more than a good hunter; he is also the family caregiver. John notes this in his apology to Dean before he completes his deal with Azazel, the yellow-eyed demon, to save Dean's life. He tells Dean:

> ...I'd come home from a hunt. And...I'd be...wrecked. And you'd come up to me and you'd put your hand on my shoulder, and you'd look me in the eye. And you'd...say, "It's okay, Dad."...You took care of Sammy, and you took care of me...And you didn't complain, not once.

Not only does Dean serve as John and Sam's caregiver when he is just a child himself, but he also proves to be a good, if not perfect, parent and protector of children in the series—roles traditionally given to women in horror and science fiction film and TV. In the season seven episode "Adventures in Babysitting," he tries to redirect the life of Krissy (Madison McLaughlin), the young daughter of a hunter, while he helps her look for her missing father. Although in season eight's "Freaks and Geeks," he finds out that his attempt has failed when he meets up with the now orphaned Krissy and a group of other hunter children, he does manage to liberate them from the exploitative, bad substitute father of the episode. However, it is in his relationship with Ben (Nicholas Elia), his sometime love interest, Lisa's son, that his role as parent is most evident. In the first episode of season six, "Exile on Main St.," a montage of Dean's year with Lisa (Cindy Sampson) and Ben shows Dean cooking family breakfasts and teaching Ben to work on the Impala.[1]

Dean, as keeper of the Winchester home, has had to rebuild the Impala twice—once in season two and again in season seven. Both times he is trying to deal with great personal loss and his "feelings" and the Impala works as "a negotiating tool" for Dean's emotions (Bruce 1.2). In the season seven opener, "Meet the New Boss," Dean must restore the Impala as he struggles with his ailing brother, who is having hallucinations caused by his time in Hell, and Castiel's betrayal when Cas decides to make a pact with the current King of

Hell, Crowley (Mark Sheppard), to open the door to Purgatory. At the beginning of season two he reforges the Impala as he works through the pain of his father's death. Early in the same season he is forced to rethink his attitudes and black and white worldview, taught to him by his father, regarding "evil things." In the third episode and the first to showcase the gleaming, newly restored Impala, "Bloodlust," Dean begins to question his own violent masculinity when he is forced to compare it with that of another hunter, Gordon Walker (Sterling K. Brown).

Dean and Sam are looking for a nest of vampires when they run across Gordon who is already hunting them. While Dean and Gordon celebrate and bond over the gory killing of one of the vampires, Lenore (Amber Benson), the leader of the nest, kidnaps Sam and tells him that they no longer feed on humans and that they are planning on relocating now that Gordon has found them. When Sam is returned, he tells Dean and suggests that they call off the hunt. Dean makes his position clear: "if it is supernatural, we kill it. End of story. That's our job." When Sam reminds him that their job is "hunting evil. And if these things aren't killing people they're not evil," Dean tells Sam, "Of course they're killing people... They're all the same, Sam. They are not human, okay? We have to exterminate every last one of them." During their argument, Gordon leaves to find the nest. By the time Dean and Sam arrive, Gordon is taking great pleasure in torturing Lenore. Dean sees his darker impulses reflected back at him in Gordon's display of sadism and he does not like what he sees.

In the light of the next morning, when the nest is safely on its way, Dean reconsiders his own belief system. Leaning on the shiny, newly rebuilt Impala's roof and speaking across to Sam in a shot-reverse shot sequence he says:

> DEAN: Think about all the hunts we went on... What if we killed things that didn't deserve killing?... the way Dad raised us... to hate those things? And, man, I hate them... When I killed that vampire at the mill I didn't even think about it. Hell, I even enjoyed it.
> SAM: You didn't kill Lenore.
> DEAN: ...I was gonna kill her. I was gonna kill them all.
> SAM: Yeah, Dean, but you didn't. And that's what matters.

In this episode as in other popular culture texts, such as the *X-men* films and the pronouncements and violence against anyone who

looked "Middle Eastern" after 9/11, the rhetoric of hate and racism is foregrounded. Having a black actor play Gordon adds another layer of meaning to the language used by him and Dean about those marked as Other, thus commenting not only on the representation of race in horror and science fiction TV, but in U.S. culture and public discourse as well.

This violent episode ends quietly with a close-up shot of Dean from behind in profile still leaning against his car and symbol of hard masculinity, thoughtfully considering the events of the past several days. The Impala, the show's symbol of a narrowly defined type of masculinity, becomes the site where Dean, the proponent of "no Chick Flick moments," learns to reexamine his own belief system. No longer just a good soldier who repeats what he is told and takes action based on the ideologies behind what he is told, Dean rethinks his position and that of the Other in ways his father never could.

The most significant example of how the Impala and Dean's character development acknowledge the need for U.S. men to be more than violent and tough appears in the season five finale "Swan Song" (5.22). This episode marks both the completion of Kripke's Apocalypse narrative and also his stepping down from the day-to-day running of the show. Interestingly, the end of Kripke's "five-season storyline" is as much the Impala's story as it is one about the Winchesters overcoming their destiny and thwarting Heaven and Hell's machinations by stopping the Apocalypse (Ausiello). In "Swan Song," Kripke's original concept for the show and his homage to other masculine genres and texts are displayed and effectively undermined to reveal not only the constructed nature of masculinity, but also to provide a narrative about it that allows for a more complete definition of what it means to be a man in post-9/11 America.

At various times in the episode, the current action is broken by sections where Chuck Shurley, pulp fiction writer and prophet of the Lord, tells us about the Winchesters and the Impala when they are not hunting. He tells us, over images that fetishize the Impala, about the joys of automobility and family both crucial components of Kripke's *Supernatural* worldview:

> They could go anywhere and do anything. They drove a thousand miles for an Ozzy show...And when it was clear, they'd park her in the middle of nowhere. Sit on the hood and watch the stars for hours....It never occurred to them that, sure, maybe they never really had a roof and four walls. But they were never, in fact, homeless. ("Swan Song")

While Chuck's claim may seem like an overstatement, for the Winchester brothers the Impala is more than a "bitchin' ride" and icon of U.S. car culture. Since their house burned down when Dean was a young child and Sam only six months old, the Impala is the only home they have had. The Impala's shift from symbol of hard masculinity to home is foreshadowed in the "Pilot" when the Winchester men are huddled on its hood as they watch their home burn and realize their wife and mother, Mary, is dead. However, it is only in the hands of Dean, the family caregiver after Mary's death, that the Impala becomes a home.

As early as the beginning of season two Dean is established as the "gear head" who maintains the car no matter what shape it is in. For instance, when Sam calls Bobby to come and get the Impala Bobby tells him: "Look, Sam. This just ain't worth a tow…There's nothing to fix. Frame's a pretzel. The engine is ruined. There's barely any part worth salvaging" ("In My Time of Dying"). And yet, Dean manages to rebuild the car, as he does again in season seven. As he says both times, "I'm gonna fix this car. Because that's what I can do" ("Meet the New Boss"). Significantly, Dean does not restore the car as most car enthusiasts would. Instead of making the car cherry and pristine, Dean preserves the "flaws" that make the Impala a home rather than just another restored classic car.

For example, "The army man that Sam crammed in the ashtray. It's still stuck there. The Legos Dean shoved into the vents. To this day, heat comes on they can hear them rattle." And "Even when Dean rebuilt her from the ground up he made sure all these little things

Figure 11.1 In *Supernatural* the values and ideologies of hard masculinity, represented by Dean, and U.S. car culture are both disrupted.

stayed" ("Swan Song"). Dean, then, successfully makes the Impala a home, thereby undermining the symbolic power it exerts in U.S. culture and in other film genres as well. Mark Osteen, in "Noir's Cars: Automobility and Amoral Space in American Film Noir," notes how "automobiles…become overdetermined symbols of characters' aspirations and disappointments" and that "unending automobility becomes a traveling prison cell" (184, 186). He further notes how cars frequently serve as temporary homes for noir's characters, but in the end cars fail to provide the homes the characters desire resulting in the tragic end to their dreams and/or their lives (185).

Unlike the men and women of film noir, Dean makes the Impala into a viable alternative to a white picket fence home—if an antiquated and masculinist version. Therefore, he is more than a regressive 1970s blue-collar car guy; he is also a masculine equivalent of a good housewife. He manages, even in the most extreme of conditions, to keep the Impala, the family home running and looking great. Like the good civically minded 1950s mom, who was to keep the home nice for her husband and children as well as be ready for any eventuality the Cold War could throw her way, including keeping the family bomb shelter well stocked, Dean keeps the Impala purring and the trunk stocked for any monster emergency. Although it is a pointedly male version of hearth and home, Dean's role as caregiver crosses the boundaries of stereotypical gender roles thus providing a more complete definition of masculinity.

The importance of Dean, family, and the Impala is demonstrated visually in the climax of "Swan Song." Sam and Dean's plan to imprison Lucifer has failed and Armageddon, the battle between Lucifer, who has taken Sam as his vessel, and the Archangel Michael (in the body of Sam's half-brother Adam [Jake Abel]) is about to begin. Although it seems all hope is lost, Dean is determined not to let Sam die alone so he gets into the Impala and drives to the chosen battlefield—Stull Cemetery outside of Lawrence, Kansas. As close-up shots show Lucifer and Michael facing off, they hear the rumbling of an engine; they pause and look off screen. The shot cuts to an extreme close-up of Dean's hand putting a cassette tape into the Impala's outdated tape deck and turning it up. As Def Leppard's 1983 hit "Rock of Ages" begins to play, the shot cuts to a close-up of a determined and angry Dean behind the wheel of the Impala—the perfect image of bravado, of violent white masculinity. However, he is not there for a fight, but to talk to his brother. When Dean is unable to reach Sam, Lucifer is intent on killing him. As Lucifer is about to land his final blows, a

beam of light reflecting off the Impala's chrome trim triggers Sam's memories of the brothers' life together.

The montage images used earlier as Chuck told the Impala's story (the army man in the ashtray, Dean with the Legos, Dean and Sam carving their initials inside of the rear door panel) begin a series of accelerating subjective flashbacks covering the show's first five seasons. Accompanied only by the sound of the wind, the shots show the good times and the bad, the pranks and the serious moments, most of which take place in the Impala, ending with a close-up shot of Dean hugging Sam. These memories of the only home they have known, the Impala, and the only parent Sam has ever had, Dean, allow Sam to take control long enough for him to force Michael and himself into the cage from where he unwittingly released Lucifer in the season four finale. This car is more than "a signifier of masculinity and automobility" and an "instrument of *power*" and Dean is more than a one-dimensional representation of hard, violent white masculinity resurrected from the 1970s and 1980s (Passon 52).

However, our stories about masculinity are tenacious and difficult to rewrite as made evident by Dean's character development. Dean's narrative trajectory is not a straight line (and this is no homage to the "white man's burden"). For instance, although he spares Lenore and her nest in season two, in season seven's "The Girl Next Door" he kills Sam's childhood crush Amy (Jewel Staite), who is also a Kitsune monster, even though he has promised Sam he will not. He is a good parent to Ben, but his treatment of Kevin Tran (Osric Chau), high school senior and prophet of the Lord, in season six until his death in season nine is usually dismissive and sometimes abusive. Still, the stories about Dean's masculinity that are not in "opposition to fimininity" (Katz 351), but incorporate characteristics traditionally categorized as feminine in the male-dominated *Supernatural* universe are significant if small steps toward reconceptualizing the U.S. myth of masculinity.

Media, as Richard Slotkin observes, provides a "pervasive means for canvassing the world of events and the spectrum of public concerns...and for translating them into the various story-genres that constitute a public mythology" (8). This mediated mythology, for better or for worse, is a significant part of how people "forge their identities" (Kellner 1). Therefore, *Supernatural*'s fictional narratives are a beginning, because of the way they disrupt hegemonic stories about violent masculinity and change the meaning of powerful cultural symbols. If "a signifier of masculinity" like the Impala can become a

site of familial love (Passon 50), if we can open a frank public conversation about the connection between violence and the construction of masculinity, then perhaps we can thwart this latest crisis of masculinity by constructing a version that values kindness, compassion, empathy, and caregiving rather than one narrowly predicated on power and violence that denies the emotional life of "real men."

Note

1. It should be noted that the Impala spends most of Dean's year with Lisa and Ben covered by a tarp in the garage.

Works Cited

Ausiello, Michael. Exclusive: "'*Supernatural*' to 'End with a Bang' in 2010 (but There's C catch)." n. pag. *Entertainment Weekly*. CNN. 30 Aug 2009. Web. 14 Jan 2014.

"Bloodlust." *Supernatural: Complete Second Season*. Writ. Sera Gamble. Dir. Robert Singer. Warner Brothers, 2006. DVD.

Borsellino, Mary. "Buffy the Vampire Slayer, Jo the Monster Killer." *In the Hunt: Unauthorized Essay on Supernatural*. Eds. Supernatural.tv with Leah Wilson. Dallas: BenBella Books, 2009. 107–18. Print.

Brown, Simon. "Renegades and Wayward Sons: *Supernatural* and the '70s." *TV Goes to Hell: An Unofficial Road Map of* Supernatural. Eds. Stacey Abbott and David Lavery. Toronto: ECW Press, 2011. 60–74. Print.

Bruce, Melissa N. "The Impala as Negotiator of Melodrama and Masculinity in *Supernatural*." *Transformative Works and Cultures*, 4 (2010). n. pag. Web. 12 Nov. 2013.

Clifton, Jacob. "Spreading Disaster: Gender in the *Supernatural* Universe." *In the Hunt: Unauthorized Essay on Supernatural*. Eds. Supernatural.tv with Leah Wilson. Dallas: BenBella Books, 2009. 119–42. Print.

"Dream a Little Dream of Me." *Supernatural: The Complete Third Season*. Writ. Cathryn Humphris. Dir. Steve Boyum. Warner Brothers, 2007. DVD.

"Everybody Loves a Clown." *Supernatural: The Complete Second Season*. Writ. John Shiban. Dir. Phil Sgriccia. Warner Brothers, 2006. DVD.

Gilbert, James. *Men in the Middle: Searching for Masculinity in the 1950s*. Chicago: U of Chicago P, 2005. Print.

"In My Time of Dying." *Supernatural: The Complete Second Season*. Writ. Eric Kripke. Dir. Kim Manners. Warner Brothers, 2006. DVD.

"In the Beginning." *Supernatural: The Complete Fourth Season*. Writ. Jeremy Carver. Dir. Steve Boyum. Warner Brothers, 2008. DVD.

Katz, Jackson. "Advertising and the Construction of Violent White Masculinity." *Gender, Race and Class in Media: A Text-Reader*. Eds. Gail Dines and Jean M. Humez. Thousand Oaks: Sage Publications, 1995. 133–41. Print.

Kellner, Douglas. *Media Culture: Cultural Studies, Identity, and Politics Between the Modern and Post-modern*. New York: Routledge, 1995. Print.

"Meet the New Boss" *Supernatural: The Complete Seventh Season*. Writ. Sera Gamble. Dir. Phil Sgriccia. Warner Brothers, 2012. DVD.

Osteen, Mark. "Noir's Cars: Automobility and Amoral Space In American Film Noir." *Journal of Popular Film & Television* 35.4 (2008): 183–192. *Academic Search Complete*. Web. 21 March 2014.

Passon, Jerry W. *The Corvette in Literature and Culture: Symbolic Dimensions of America's Sports Car*. Jefferson: McFarland, 2011. Print.

"Pilot" Commentary. *Supernatural: The Complete First Season*. Writ. Eric Kripke. Dir. David Nutter. Warner Brothers, 2005. DVD.

Ryan, Maureen. "'It's the fun Apocalypse': Creator Eric Kripke Talks *Supernatural*." *chicagotribune.com*. *Chicago Tribune*. 26 Aug. 2009. Web. 1 Oct. 2013.

Slotkin, Richard. *Gunfighter Nation: The Myth of the Frontier in Twentieth-Century America*. New York: Harper Perennial, 1992. Print.

"Swan Song." *Supernatural: The Complete Fifth Season*. Writ. Eric Kripke. Dir. Steve Boyum. Warner Brothers, 2009. DVD.

Wilkinson, Jules. "Back in Black." *In the Hunt: Unauthorized Essays on Supernatural*. Eds. Supernatural.tv and Leah Wilson. Dallas: Benbella Books, 2009. 197–207. Print.

Wood, Robin. *Hollywood from Vietnam to Reagan…and Beyond*. Exp. and Rev. ed. New York: Columbia UP, 2003. Print.

Wright, Julia M. "Latchkey Hero: Masculinity, Class and the Gothic in Eric Kripke's *Supernatural*." *Genders*. 47 (2008). n. pag. Web. 6 Jan. 2014.

"How Is That Not Rape-y?": Dean as Anti-Bella and Feminism without Women in *Supernatural*

Rhonda Nicol

In "Buffy the Vampire Slayer, Jo the Monster Killer: *Supernatural*'s Excluded Heroines," Mary Borsellino argues that *Supernatural* is less a philosophical heir to *Buffy* and more of a reaction to and refutation of *Buffy*'s challenge to gender paradigms, arguing that "Buffy gave the world a story in which the traditional roles of masculine hero figures were questioned, and *Supernatural* responded ... by attempting to restore those pre-Buffy tropes" (112). Borsellino reads *Supernatural* as a response to and a "refutation/backlash" of the feminist reclamation of traditionally masculine hero tropes that *Buffy* represents and suggests that *Supernatural* privileges a "traditional form of American masculinity" (110), one that she implies is inevitably tinged with misogyny. Borsellino ultimately positions the show as a text wherein women are effectively silenced.

However, does a show that utilizes tropes of "traditional American masculinity" necessarily have to be antifeminist and regressive? Although not a direct refutation of Borsellino's argument, Jacob Clifton's examination of the series certainly complicates Borsellino's characterization of the show as actively antifeminist. In "Spreading Disaster: Gender in the *Supernatural* Universe," Clifton makes a similar argument, focusing upon questions of masculinity in the show, specifically by examining the show's narrative viewpoint. Clifton argues that although *Supernatural*'s entire narrative plays out against the backdrop of a "feminine emotional landscape," the show "is self-consciously meticulous about defining the

gender of its perspective," which is, he claims, rigidly masculine (123, 124). Clifton implicitly ties the show's tendency toward a masculine viewpoint to its reliance on and perpetuation of male privilege; the male gaze, he notes, is characterized by its habitual practice of "leveling desire and objectification at bodies" (123). Clifton's suggestion that *Supernatural*'s perspective is presented as a kind of invisible norm is valid, but I argue that this privileged position does not go entirely unchallenged. There are moments throughout the series during which the narrative viewpoint is disrupted and the normalization of the show's perspective is made manifest. These moments are arguably all the more powerful precisely because they are sites of disruption wherein the primacy of patriarchal authority is compromised. When the perspective shifts and events are brought into focus and presented through a nonnormative perspective, we notice, and the specific attention that we give to these moments imbues them with a heightened narrative authority. These moments are essentially points of argument that steer us toward a reading of the show as actively interrogating its own deployment of masculine privilege.

In the world of *Supernatural*, masculinity is always provisional, and it is clear that one's masculinity must be authenticated over and over. Clifton notes that Dean (Jensen Ackles), who has been positioned as Sam's (Jared Padalecki) only remaining parental figure, sees it as his duty "to train Sam in masculinity" (138). Clifton further notes that "the manhood game is as much about exclusion of non-masculine qualities as it is about absorbing or performing masculine qualities and acts" (138). In other words, *Supernatural*'s implicit argument about gender and gendering advances a theory of gender as performance[1] wherein one achieves "authentic" masculinity not only by upholding certain masculine values but also by refusing or rejecting other values and behaviors. This practice of encoding and reencoding masculinity is implicitly acknowledged in a ritualized exchange that transpires in the show's very first episode and reoccurs throughout the series: Sam calls Dean a "jerk" and Dean calls Sam a "bitch." This routine serves a few important functions.

First, it underscores the extent to which Dean and Sam are, on the surface, sketched in a kind of cultural shorthand for viewers. Dean, the elder, appears to be the stereotypical beer-swilling, muscle-car-driving ladies' man with a thick skull and limited social graces. Sam, the baby brother, is the intellectual (yet physically powerful), sensitive man who consistently encourages his brother to be more emotive and whose claim to legitimate masculinity is repeatedly questioned by Dean. Second, and

perhaps more importantly, this shorthand exchange can also be read as a kind of self-conscious mutual norming process by which the brothers warn one another about the dangers of falling into excess. If Dean worries that Sam will fail to perform his gender adequately, then Sam worries that Dean will perform his too well. There are also occasions wherein Dean must confront his own values and beliefs about what it means to be "a real man" in order to bring his own impulses to heel. Finally, I suggest that the ritualized repetition of a seemingly lighthearted and playful bout of mutual insult between brothers also provides evidence that *Supernatural*'s writers and producers are well aware of the tropes of masculinity that they routinely employ and that they do not do so unconsciously and/or uncritically; in fact, they frequently invite critique of these conventions. Masculinity in *Supernatural* is always in the process of being interrogated and therefore cannot be read as fixed—the show often deconstructs masculine tropes even as it deploys them.

Ironically, Dean, the ostensibly more "authentically" masculine of the two Winchester brothers and the one whose behavior most often serves to police and reinforce gender boundaries, is often the character who serves as the vehicle through which the show disrupts the male gaze. Dean not only confronts his own conceptions of masculinity throughout the series, but also periodically serves as a kind of surrogate female from a narrative perspective. Although part of Dean's role as the elder brother is to uphold their father's values and raise Sam to be a hunter/man (and the two are inextricably intertwined for Winchester men) in the model of John (Jeffrey Dean Morgan), their father, Dean himself is, and has been from the very beginning of the series, doubly coded. On one level, he is the good son who stands in opposition to his prodigal baby brother; he follows the codes of masculine behavior and upholds the values of patriarchal authority set forth by their father. However, Dean bears the burden of dual responsibility; he is both father *and* mother to Sam. In "Dean Winchester: Bad Ass...or Soccer Mom?," Tanya Michaels states that Dean effectively serves as the mother figure in the Winchester family dynamic, calling Dean "the de facto mother-hen in the testosterone-fueled Winchester family" who spent his own formative years not only nurturing Sam, but also providing emotional support for their father (82). She notes that in the prologue scene of the pilot episode, it is Dean who is tasked by their father with taking Sam to safety as their home burns, thus effectively establishing his role as Sam's primary caretaker. She also points out the many episodes wherein Dean tries to give Sam a normal childhood (80–81).

Michaels argues persuasively for reading Dean as a mother figure, but the figure of the self-sacrificing, boundlessly nurturing mother is an essentially sexless one, and Dean is also seen as an object of sexual desire. Several episodes of the show make reference to the show's predominantly female fan base, and the directors frequently position the three most conventionally attractive male characters (Sam, Dean, and, to a lesser extent, the angel Castiel) as objects of the camera's covetous gaze, a subject position that is submissive and therefore feminized. Dean is generally the character whose objectification is overtly and explicitly interrogated, thus calling viewers' attention to the practicing of objectifying *Supernatural*'s handsome male leads.

In "Red Sky at Morning" (3.6), Dean is explicitly portrayed as the object of desire, the one who is being looked upon. As Bronwen Calvert notes, in the scene when a tuxedo-clad Dean appears to escort Bela, a thief with whom Sam and Dean occasionally work, to a black-tie event, Dean "is shot as a femme fatale, descending a staircase: his feet and legs and then his torso and sultry glance are the focus of the camera's look, intercut with images of Bela sighing in appreciation" (100). Dean is quite literally revealed in pieces, thus explicitly underscoring the viewers' pleasure in Dean as an objectified body. Once Bela recovers herself, she tells Dean, "You know, when this is over, we should really have angry sex." After a significant pause, an obviously flustered Dean responds, "Don't objectify me." The scene is clearly meant to be read as humorous, but however tongue-in-cheek and playful the gender reversal is, it *is* present and calls attention to the show's normally masculinized point of view by self-consciously reversing it.

"Red Sky at Morning" explicitly introduces, however light-heartedly, the possibility of reading Dean as a sexually objectified character, as prey rather than predator. However, we are not actually encouraged to read Bela as a legitimate sexual threat. As Julia Serano argues, the standard cultural configuration is one of males as sexual predators and females as prey. This configuration, Serano notes, gives rise to a male binary that parallels the female Madonna/whore binary. Men, Serano claims, are divided along the lines of what she calls a "nice guy/asshole" configuration; she states that the latter are "men who fulfill the men-as-sexual-aggressors stereotype" and the former "are the ones who refuse or eschew it" (232). Moreover, Serano notes that men who "fulfill the sexual aggressor stereotype" are habitually rewarded for it with female attention, because it is the "asshole" and not the "nice guy" who has been established as the

erotic ideal (233). Dean may tease Sam for being a "bitch," but in the *Supernatural* world, it is clear that both are meant to be sexually attractive within the heterosexual matrix; therefore, the possibility that they might legitimately be victims rather than perpetrators of sexual violence is effectively limited within a framework of the kind of "traditional masculinity" that Borsellino identifies.

However limited such possibilities might be, the episode "Live Free or Twihard" (6.5) takes up the mantle of complicating and feminizing Dean's character, extending the implicit subversion of the show's narrative viewpoint that "Red Sky at Morning" introduces. It is perhaps the most explicit manifestation to date of Dean as doubly coded, as intermittent avatar for a feminized perspective that disrupts the series' normal masculine viewpoint. The "Live Free or Twihard" episode provides an avenue for Dean to interrogate his own masculine privilege and authority from the perspective of the abject body.

Season six executive producer Sera Gamble claims that the "Live Free or Twihard" episode "poked good-natured fun at the genre [of vampire-centric texts such as *Twilight* and *True Blood*] as a whole," but admits that "*Twilight* was definitely a larger target, because it's wildly popular and ripe for parody" (Knight 34). Gamble's statement implies that the "Live Free or Twihard" episode is meant to be read as parody, which raises two key questions: Which elements of the *Twilight* phenomenon are being parodied and why? How are we to understand "parody" in the context of this particular episode?

Although Gamble is clearly using the term "parody" in its popular usage as a synonym for "poking good-natured fun," the episode features enough moments of grim confrontation with male sexual violence that we might be better served by thinking of the "parody" the episode enacts as closer to Linda Hutcheon's use of the term: "a value-problematizing, de-naturalizing form of acknowledging the history (and through irony, the politics) of representations" (94). Hutcheon notes that "parody is doubly coded in political terms: it both legitimizes and subverts that which it parodies" (101), and while "Live Free or Twihard" certainly does the work of maintaining and preserving the male-as-sexual-predator configuration, it also calls for us to look outside of this configuration and critique it, and it does so via Dean's transformation over the course of the episode.

Although it would not be productive to enter the ongoing conversation about whether or not the *Twilight* series is "depressingly retrograde, deeply anti-feminist, [and] borderline misogynistic" (Mangan), in the context of this analysis, what matters is not whether or not

Twilight really *is* misogynistic but that the "Live Free or Twihard" episode positions it as such; *Twilight* is defined as an oppositional text, one anti-*Supernatural* in its values and concerns. As Clifton points out, the establishment of masculinity in the series is as much a process of rejection as of identification (138), and the establishment of the series' masculine ethos in "Live Free or Twihard" is as much about the devaluing of certain attitudes, acts, and even texts as it is about promoting others. The episode's critique of the more misogynistic elements of the *Twilight* series therefore places *Supernatural* firmly on the side of a particular post-Buffy feminist narrative of female authority and empowerment; it implicitly rejects *Twilight* and all it signifies culturally.

The episode critiques not only some of the assumptions underlying *Twilight*'s narrative but also hard-core *Twilight* fans themselves.[2] The title of the episode itself invites this assumption; it references not only the fourth entry in the wildly popular, hypermasculine *Die Hard* film series, but also specifically invokes the image of *Twilight* superfans, popularly known as "Twihards." Additionally, *Supernatural*'s creative team's choice to mock, however good-naturedly, hard-core fans of the *Twilight* saga provides the mechanism for implicitly critiquing the dangers of an uncritical fandom generally, although we may not necessarily read this practice as a critique of *Supernatural* fans themselves. If anything, the episode's critique of what it constructs as *Twilight* fans' passive consumption of misogynist narratives might be read as a commendation of *Supernatural*'s fan base. *Supernatural* fans, the episode implies, are not the naïve and credulous dupes easily swayed by facile declarations of love eternal, that *Twilight* fans are. Of these young *Dream of the Vampires* fans who serve as Twihard stand-ins, Sam says, "Talk about easy prey...I mean, these chicks are just throwing themselves at you. All you've gotta do is, I don't know, write bad poetry."

In the episode, the romance narrative that so enthralls *Twilight*'s fans is repeatedly and relentlessly mocked. At the end of the episode, when Dean arrives at the vampires' nest to confront Boris, a burly, hirsute man who looks more like a tough biker than a suave Ann Rice Lestat-type figure, at the end of the episode, he finds Boris, the leader of the local vampire group, dictating to Kristen as she lures in yet another unsuspecting young women via online chat: "'My skin is the black velvet of the night.' Nice. That stupid bitch'll eat that up." Dean's initial amusement at the thought of young women falling for eyeliner-sporting pseudo-vamps wrapped in ruffles is reflected and

refracted in Boris's casual denigrating of his teenage female victims. When Kristen, now a fledgling vampire thoroughly under Boris's control, finishes taking his dictation, Boris dismisses her by saying, "Go get yourself some blood, sweetheart. Then march that little ass right back here, okay?" Dean's own propensity for calling women "sweetheart" and deploying casual misogyny is reflected back at him writ large via Boris's behavior. Boris serves as a reminder of what Dean could easily become.

Boris's behavior serves as a warning to *Supernatural*'s female fan base not to be fooled by narratives that romanticize male power and authority. "Live Free or Twihard" decidedly calls into question the tradition, one much older than *Twilight*, of valorizing and eroticizing the bad boy, one that *Supernatural* also makes use of in its construction of Dean. The Byronic hero, this episode suggests, is not all he is cracked up to be; a misogynist by any other name is just as dangerous, and in this episode we see Dean's self-interrogation of his own impulses and desires with regard to sex and sexuality. Boris demonstrates the extreme version of Dean's own performance of heterosexuality. Dean, of course, has a history of seeing women (Cassie and Lisa aside) as casual conquests to be bedded, enjoyed, and quickly discarded, and even his commitment to Lisa does not nullify his tendency to objectify women. Moments after speaking to Lisa, Dean looks at the pictures of the missing girls he and Sam have come to search for and pronounces them "cute." He defends his roving eye to Sam, saying, "Hey, ice cream comes in lots of flavors, Sam." Dean may be less overtly manipulative than Boris, but he, like Boris, habitually engages in a mode of sexual behavior that Brad Perry refers to as the "get-some game" wherein male sexuality is understood to be "characterized by action, control, and achievement" (200). In the "get-some game," more sex with more partners equals greater success, and whatever you need to do in order to "win," even if that means deliberately misrepresenting yourself and your intentions, is acceptable as long as the desired outcome is achieved. Early in the episode, when Dean pursues and captures a potential vampire, Dean notes his appearance and asks him, "Are you wearing *glitter*?" The young wanna-be vamp assures Dean, "I only do it to get laid, man." Dean, seemingly incredulous and also a little intrigued, asks, "Does that work?" The wanna-be assents, and Dean declares, "I'll be damned" with an air of speculation, as if he is contemplating how to perhaps incorporate this tip into his own arsenal of "tricks" for beguiling and seducing women.

The episode calls attention to the naturalized association of male sexuality with predatory behavior, and the joke is that these pseudo-*Twilight* fans cannot see that the gentle, desexualized narrative of chaste romance is simply the hook to lure in naïve young females and not a promise of a legitimately counterhegemonic narrative of heterosexual coupling. Boris tells Dean, "These are the best days in the last six hundred years to be a vampire...These stupid little brats are so horny they've reinvented us as Prince Charming with a Volvo. They want a promise ring with fangs, so I give it to 'em." Boris's boasting of passing himself off as "Prince Charming with a Volvo" in order to lure unsuspecting young women is in keeping with a larger cultural construction. The act of "getting" women to have sex with you is equated with winning at masculinity, and Dean is as much a player in the game as Boris. However, Dean recognizes that there is a line, however ill-defined, between behavior that falls within the spectrum of predatory-but-still-acceptable and behavior that does not. When Sam searches the missing girl's computer for clues, Dean idly picks up a book in the pseudo-*Twilight* series, *My Summer of Blood*, and glances at the cover. He tells Sam, "Look at this. He's watching her sleep. How is that not rape-y?" Later in the episode when Dean is assaulted by Boris and starting to turn into a vampire, part of the horror is the horror of the slippery slope. As Dean's transformation progresses, he becomes less and less able to keep control of his impulses and is forced to recognize that his own casually predatory behaviors in the context of the game of heterosexual conquest exist not in opposition to Boris's own behaviors but on a continuum that includes both. In this episode, Dean's acknowledgment of the potential for monstrousness within himself is implicitly tied to his status as a successful heterosexual male in terms of his ability to rack up sexual conquests.

However, before Dean's confrontation with Boris at the end of the episode that forces this recognition, Dean is first feminized during his initial encounter with Boris. The scene takes place in a dark alley. When Boris emerges from the shadows and approaches Dean, he says to him, "You're pretty." Dean tries to dismiss him, saying, "I don't play for your team."[3] Although Dean's assertion also invokes the specter of homosexual rape, the episode's reliance on the male-as-sexual-predator and female-as-prey script facilitates a reading of the scene as a moment during which Dean's body is mapped with the feminine subject position, a reading that is underscored by the way the scene is blocked and shot.

Figure 12.1 Boris prepares to give Dean his blood.

When Boris first approaches Dean, the two seem to be roughly the same height and build, but as the scene progresses, Dean's menacing physical presence is mitigated. Dean attempts to walk away from Boris, who responds by lifting Dean and throwing him down the alley. As Dean struggles to regain his footing, the scene shifts to Dean's point of view; Dean, unable to fully focus, watches Boris approaching as he struggles to stand. The a low-angle shot from Dean's prone (and initially out-of-focus) point of view makes Boris literally loom large. The interaction culminates in a medium close-up of Boris holding Dean tight and controlling his body, keeping just enough of a grip on Dean to keep him more or less vertical, thus establishing Boris's physical superiority. At the end of the scene, when a badly beaten Dean is nearly unconscious and clearly incapable of resisting, Boris forces Dean to drink his blood, which, in *Supernatural*'s storyworld, is how one becomes a vampire. In the scene between Boris and Dean, Dean is not bitten; Boris uses his fangs to rip open his own wrists and rubs his wrist across an unresponsive Dean's face in order to force blood into his mouth, leaving Dean looking like he is covered in smeared red lipstick, thus completing Dean's transition into a feminized victim of sexualized violence perpetrated by a literal predatory male.

In this scene, Dean is once again objectified, but unlike the staircase scene in "Red Sky at Morning," we take no pleasure in watching his body. Also, the scene incorporates shots of the Boris–Dean interaction from Sam's point of view, and we know something that Dean does not; his humiliation is heightened *because* it is observed.

Sam sees Dean being assaulted and, although he clearly contemplates stopping the attack, ultimately he chooses to watch rather than act, making no move to intervene until he sees Dean swallow some of Boris's blood, thus ensuring that Boris's invasion of Dean's body is complete.[4] As soon as Sam arrives on the scene, we are presented with a series of close-up shots that cut from Dean's face to Boris's and then to Sam's. We not only watch Dean's assault but also watch Sam *watching* Dean's assault. As we are compelled to watch Sam's pleasure in Dean's humiliation, the metavoyeuristic moment—we watch Sam watching Dean—highlights the inherent power differential between the watcher and the observed. We bear witness to Dean as the object of the male gaze in that moment and the scene as shot emphasizes that Dean's violation is twofold; both Boris's assault and Sam's observation of the assault are acts of violation, and both Boris and Sam take pleasure in their acts.

Once Dean's transformation begins and the pendulum swings back from feminizing Dean to aligning him with a masculine, even hyper-masculine subjectivity (the vampire, after all, is often read as a figure of penetrating male sexuality), his experience as the victim of a sexu-alized assault makes him more aware of the predatory nature of male sexuality. This is demonstrated when Dean returns to Lisa; rather than announcing himself, he sneaks into her bedroom and, in a paral-lel to the actions of the pseudo-Edward character in the *Dream of the Vampires* series that he mocks so mercilessly, he stands and watches Lisa sleep. When Lisa awakens and the two have a sexually charged moment, Dean clearly feels a conflation of sexual desire and desire to satisfy his own urge to feed. When Lisa reaches for him, he grabs her and slams her against the wall. Dean, overwhelmed with the sound of her steadily increasing heartbeat, leans in to kiss her, but turns away at the last moment. With Dean in the foreground of the shot, we see what she does not—his needle-like vampire teeth begin to descend marking his physical shift into monstrosity. He cannot control his own impulses, so he pushes her away and even hurls Ben, Lisa's son, against a wall in an effort to effect his escape.

"Live Free or Twihard" makes the case for the show's feminist sym-pathies by taking Dean on a journey that moves him from a unprob-lematized masculine authority to a vulnerable feminized position of abjection and back again. Dean's transition into a vampire is coded as a kind of dual subjectivity wherein he is both adhering to hyper-masculine scripts and watching and critiquing himself adhering to those scripts, which effectively serves as a kind of gender critique that

invites a reading of the show as a whole as perpetuating gender-as-performance. This viewpoint also suggests that there is not a line between "nice guy" and "asshole" but a whole spectrum of possible positions. Clifton argues that "whenever the less typically male lead (Sam) goes too far into alien (feminine) territory, the more strongly delineated male lead (Dean) is there to mock him back into place" (123), but it is Dean far more than Sam who repeatedly questions his own understanding of how "masculinity" could and should be defined and what "masculine" acts actually signify.

Sam and Dean are complex, multifaceted characters who change and evolve over the course of the series, and that evolution is rooted in vigorous self-investigation; both Winchester brothers are constantly questioning themselves, their acts, and their places in the world. For Dean especially, much of his character's growth has been the result of touring the margins and discovering empathy for the Other, sometimes by experiencing Otherness himself. In "Live Free or Twihard," Dean is the site of working out and working through gender as category via his own shifting subjectivity. The episode invites us to perceive gender categories as provisional rather than fixed and inviolate. Dean's constant reinvention and reaffirmation of his own understanding of manhood is facilitated by his embodiment of a feminized subject position. Therein lies the answer to Clifton's question, "Where is the place for the female or queer viewer in such a strongly defined masculine story?" (123). Despite the show's generally masculine worldview, the show invites feminist and/or queer readings through episodes such as "Live Free or Twihard" that foreground *Supernatural*'s persistent grappling with issues of masculine authority and gender performativity.

Notes

1. As Judith Butler explains, "Gender cannot be understood as a *role* which either expresses or disguises an interior 'self'...As performance which is performative, gender is an 'act,' broadly construed, which constructs the social fiction of its own psychological interiority" (279).
2. Admittedly, there is probably a great deal of crossover between the two fandoms. It is fairly easy to see how both texts could appeal to the same audience; after all, "brooding male protagonist with a dark secret" could apply as well to Sam and Dean as it does to Edward. However, the "Live Free or Twihard" episode presumes a shared joke, hailing the viewers of the episode as co-conspirators in the *Twilight* parody, which effectively manufactures a division between the two fan groups.

3. Given the extent to which *Supernatural* perpetuates "the association of a submissive femininity with gay men within a dominant culture that expects heterosexuality of its subjects" (Elliott-Smith 106), Dean's response can be read both as an attempt to deflect Boris's attempt to feminize him and as a tacit devaluing of the homosexual male subject as authentically masculine.

4. Sam is still soulless at this point and has been exhibiting sadistic and sociopathic behaviors. During the attack, it is clear that Sam hesitates to intervene at least in part because he sees the potential usefulness: Once turned, Dean can serve as a homing beacon for the vampires' nest. Samuel later accuses Sam of failing to help Dean for precisely that reason, which Sam (rather unconvincingly) denies.

Works Cited

"Bloodlust." *Supernatural*. Writ. Sera Gamble. Dir. Robert Singer. CW, 16 Oct. 2006. *Netflix*. Web. 4 Sept. 2012.

Borsellino, Mary. "Buffy the Vampire Slayer, Jo the Monster Killer: *Supernatural*'s Excluded Heroines." *In the Hunt: Unauthorized Essays on* Supernatural. Eds. Supernatural.tv and Leah Wilson. Dallas: BenBella/Smart Pop, 2009. 107–18. Kindle e-book.

Butler, Judith. "Performative Acts and Gender Constitution: An Essay in Phenomenology and Feminist Theory." *Performing Feminisms: Feminist Critical Theory and Theatre*. Ed. Sue-Ellen Case. Baltimore: Johns Hopkins UP, 1990. 270–82. Print.

Calvert, Bronwen. "Angels, Demons, and Damsels in Distress: The Representation of Women in *Supernatural*." *TV Goes to Hell: An Unofficial Road Map of* Supernatural. Eds. Stacey Abbott and David Lavery. Toronto: ECW Press, 2011. 90–104. Print.

Clifton, Jacob. "Spreading Disaster: Gender in the *Supernatural* Universe." *In the Hunt: Unauthorized Essays on* Supernatural. Eds. Supernatural.tv and Leah Wilson. Dallas: BenBella/Smart Pop, 2009. 119–41. Kindle e-book.

Elliott-Smith, Darren. "'Go be gay for that poor, dead intern': Conversion Fantasies and Gay Anxieties in *Supernatural*." *TV Goes to Hell: An Unofficial Road Map of* Supernatural. Eds. Stacey Abbott and David Lavery. Toronto: ECW Press, 2011. 105–15. Print.

Hutcheon, Linda. *The Politics of Postmodernism*. New York: Routledge, 1989. Print.

Knight, Nicholas. *Supernatural: The Official Companion Season 6*. London: Titan Books, 2011. Print.

"Live Free or Twihard" *Supernatural*. Writ. Brett Matthews. Dir. Rod Hardy. CW, 22 Oct. 2010. *Netflix*. Web. 6 Aug. 2012.

Mangan, Lucy. "Dangerous Liaisons." Rev. of *Twilight*. dir. Catherine Hardwicke. *The Guardian* Guardian News and Media Ltd. n. pag. 4 Dec. 2008. Web. 2 Aug. 2012.

Michaels, Tanya. "Dean Winchester: Bad Ass…or Soccer Mom?" *In the Hunt: Unauthorized Essays on* Supernatural. Eds. Supernatural.tv and Leah Wilson. Dallas: BenBella/Smart Pop, 2009. 77–86. Kindle e-book.

Perry, Brad. "Hooking Up with Healthy Sexuality: The Lessons Boys Learn (and Don't Learn) about Sexuality, and Why a Sex-Positive Rape-Prevention Paradigm Can Benefit Everyone Involved." *Yes Means Yes: Visions of Female Sexual Power and a World Without Rape*. Eds. Jaclyn Friedman and Jessica Valenti. Berkeley: Seal Press, 2008. 193–208. Print.

"Red Sky at Morning." *Supernatural*. Writ. Laurence Andries. Dir. Cliff Bole. CW, 8 Nov. 2007. *Netflix*. Web. 4 Sept. 2012.

Serano, Julia. "Why Nice Guys Finish Last." *Yes Means Yes: Visions of Female Sexual Power and a World Without Rape*. Eds. Jaclyn Friedman and Jessica Valenti. Berkeley: Seal Press, 2008. 227–40. Print.

God, the Devil, and John Winchester: Failures of Patriarchy in *Supernatural*

Charlotte E. Howell

By the finale of *Supernatural*'s fifth season, God is gone, Lucifer briefly escapes Hell and is revealed to be the instigator of the series' narrative arc, and two brothers fight to save the world and their small family by repeatedly defying powerful patriarchs' plans. In its ninth season at the time of this writing, *Supernatural* continues to push at the powerful and interlocked metanarratives[1] of Christianity and patriarchy, but it is in its first five seasons and their concomitant apocalyptic narrative that the show's structure, story lines, and characters represent its most trenchant challenge to the patriarchal concept of God-the-Father. It does so by presenting various iterations of literal fathers—and, notably, bloodline-begetting fathers, leaving out fathers of choice like Bobby Singer (Jim Beaver)—at terrestrial, infernal, and celestial levels and then deconstructing the figures' claims to power. The human father dies and is usurped by a demon, Azazel (Fredric Lehne), who is acting for *his* father, Lucifer (Mark Pellegrino), to end the world. Throughout the seasons, humanistic fraternity is upheld as father figures come and go and the Devil is revealed to be the best example of the God-the-Father power structure. *Supernatural* challenges the power of patriarchy by presenting the Devil as the epitome of it. As religious scholar Ursula King argues, "Patriarchy is inextricably tied up with deep religious roots and ramifications, not only because of the widely perceived (rightly or wrongly) absolutist rule of a divine father—which must be rejected—but also because of the

inherent patriarchal structure of all historical religions" (23). I argue that the show not only presents a more egalitarian fraternal approach to power but also directly challenges and provides evidence for subverting the metanarrative of Christian-based patriarchy that has shaped Western culture.

Supernatural centers on Sam (Jared Padalecki) and Dean Winchester (Jensen Ackles), brothers taught to hunt monsters by their obsessed father, John (Jeffrey Dean Morgan). John's wife, Mary (Samantha Smith), is killed by Azazel when both boys were young, and that initiating trauma sets the Winchesters on the hunt. Among the many genres *Supernatural* hybridizes, the family melodrama is key—if underemphasized in favor of horror—and frames how the show represents patriarchy. By focusing on the Winchester family and its symbolism within Christian social and dogmatic structures as a reflection of the heavenly family, the show establishes the connection between earthly fathers and otherworldly fathers in a way that invites mutual commentary. In his essay on family melodrama, Thomas Elsaesser argues that "the element of interiorization and personalization of what are primarily ideological conflicts" is key to the genre's genealogy and character (369). As the Winchester family melodrama invites deeper symbolic meanings in relationships and the sense that "there is always more to tell than can be said," it creates space to critique the social structures—namely patriarchy—that force such sublimation (Elsaesser 377). The underlying Christian patriarchal claim to power shapes the Winchester family dynamics at the symbolic level; these dynamics are then reiterated and are themselves recursive iterations of the Christian-inflected family structure: God as father to angels, and the fallen angel, Lucifer, as father to demons.

The lack of mother figures within these family structures is significant, as it represents the patriarchal construction of power as primarily operating for and through men (Kimmel 54). The show signals the alignment of God and John Winchester as fathers by having a woman named Mary bear their sons. For much of the series, Mary's defining characteristic is that she is the dead mother of Sam and Dean. In the first moments of the pilot, she goes to check on baby Sam and is immolated above the crib by Azazel for her protective urge. For three full seasons, the most we know about Mary is that she died trying to protect Sam. It is the originating trauma for the Winchester family. In her book, *Unclaimed Experience: Trauma Narratives and History*, Cathy Caruth explains that "Trauma is not locatable in the simple violent or original event in an

individual's past, but rather in the way that its very unassimilated nature...returns to haunt the survivor later on" (4). She further notes that, "The story of trauma, then, as the narrative of a belated experience, far from telling of an escape...from a death, or from its referential force—rather attests to its endless impact on a life" (7). The image of Mary bursting into flames on the ceiling recurs in the pilot episode as the now-grown Sam's college girlfriend is killed in the same way. The image also reoccurs as Sam dreams of the event throughout the first season and in the establishing "previously on" segments of the first season and beyond. Mary's death is visually reduced to a trigger. A one-dimensional, dead mother remembered as good and pure whose subjectivity is subsumed in her role as traumatic object for her family.

However, in the season four episode, "In the Beginning," Dean and the audience learn that Mary was a part of a hunting family and knew the demon who killed her. In that episode, Azazel's presence in Sam's bedroom on the night Mary died is revealed to be the price of a deal she made to save John from death; the only stipulation was that she would not interfere. She does and is killed for it. A later season four episode, "Lucifer Rising," reveals the deal as part of Lucifer's plan to escape Hell, incorporating Mary's actions into the plan to serve the father of demons. "In the Beginning" rewrites the originating trauma of the Winchester family. It shifts the onus of her death from purely the demon's fault—and thus a righteous cause for John's crusade—to partly her fault for making the demonic deal. The episode moves Mary from pure mother and martyr to a more complicated representation of a mother who colluded with Azazel in his patriarchal operations. Despite the altered image of Mary in seasons four and five, she continues to lack operative agency. Revelations of her character do little to alter her role as trauma object and pawn in a larger patriarchal plan. Mary, the mother, is subsumed into the story of fathers.

Although the dearth of female characters on *Supernatural* can be disheartening to feminist media scholars, it allows for a clear focus on patriarchal relations among men within the show. The feminized generic elements of family melodrama—expressing that which cannot be said and relating the domestic familiar to wider social institutions in a heavily masculine-skewed diegesis—create a sense of patriarchy and family operating on the same level and thus mutually influential. *Supernatural* allows for the connotations of the Devil from one metanarrative, Christianity, to taint another: patriarchy.

Even Eric Kripke, creator, head writer, and showrunner for the first five seasons, articulates a link between family units and the larger narrative structure, although he focuses on the tension between family and the religious narrative but not the reiteration of one in the other. In an interview with critic Maureen Ryan, Kripke says:

> For me, the story is about, "Can the strength of family overcome destiny and fate, and can family save the world?" If I had a worldview, and I don't know if I do, but if I did, it's one that's intensely humanistic. [That worldview] is that the only thing that matters is family and personal connection, and that's the only thing that gives life meaning.

In Kripke's conception of cosmology reduced to familial relations, we find the machine that drives the destabilization of patriarchy. Instead of families modeled on religious figures (usually God in the Western tradition), we see an entire universe of Christian beings modeled on a particularly traumatized and fractured family, the Winchesters.

This formulation of the relationship between religion and family upends the hierarchy of power. Religion in *Supernatural* is a fact of the narrative, no longer reliant on faith without proof. Heaven exists. Angels interact with humans. All three Winchesters have spent time in Hell, and the gods of other world religions—Baldur, Kali, Ganesh, and others—even appear as characters in the season five episode "Hammer of the Gods." Yet, as Kripke indicates, religion is only as important as it shapes the experiences of the human brothers, Sam and Dean. The conclusion of the apocalyptic arc emphasizes this as the end of the world is halted by the love and shared connection between the brothers.

As I have argued elsewhere, the season five finale "Swan Song" (5.22) implies that "God, the Devil, [and] the apocalypse do not matter as long as the brothers are together" and it is their fraternal love that overpowers Lucifer and saves the world (Howell). The climactic scene begins as a showdown between Sam, who is possessed by Lucifer, and his previously dead half-brother Adam (Jake Abel), who is possessed by Michael. The brother versus brother face-off is part of the prophesized Apocalypse. Yet, that battle is interrupted by Dean, fully human, who allows Lucifer to beat him badly while telling his brother, "It's okay, Sammy. I'm here, and I'm not going to leave you." The reassertion of brotherly love and togetherness (both literally and figuratively through a reflection off the Impala) triggers a montage of brotherly moments from the series that reflect Sam accessing his

memories and feelings that allow him to overpower Lucifer and save the world. This is the culmination of five seasons of bringing the brothers onto equal narrative footing and agency. David Simmons articulates this equal positioning. He notes that "While a sense that the lives of the two brothers have been predetermined by larger forces permeates the Apocalypse story line, much of the narrative of seasons four and five suggests that Sam and Dean are engaged in an active and conscious struggle to fight against their pre-ordained destiny" (141). Simmons implies that the brothers working equally in such a way undermines the hierarchical structure of patriarchy. "Swan Song" reasserts the ultimate centrality of two brothers, men of equal standing, as an alternative to and in defiance of the various fathers and their machinations throughout the first five seasons, both in terms of the religious arc and the familial story.

The religion of family is a central concept in *Supernatural*'s worldbuilding, but one that deeply troubles assumptions of Christianity held in Western culture. As scholar Erin Giannini writes, the last words of "Swan Song," said by the prophet Chuck Shurley (Rob Benedict), "sum up the 'religion' of *Supernatural* succinctly: 'They chose family. And well, isn't that kind of the point?'" (175). According to Kripke's avowed worldview, yes, but that choice arises from five seasons of undermining Christian religion by presenting an absent, uncaring God, a successful Lucifer who manages to fulfill his plan to open the portal to Hell, demons operating as pragmatic allies to humanity, and angels as villains bent on the total annihilation of humanity. Choosing family, it is implied, is the only option. The real decision is between choosing fathers (God, Lucifer, John Winchester, who are all either absent or evil) or brothers (Sam, Dean, angel Castiel [Misha Collins], who build their relationships based on love, parity, and respect). The decision, underlined in "Swan Song" is an easy one: fraternity and parity over patriarchy and power.

Although *Supernatural* focuses primarily on a masculine world and relations among men, this drive to destabilize hierarchical, patriarchal power aligns with long-standing discourses of feminist religious studies. Feminist scholars of religion King and Mary Daly have criticized the God-the-Father model and the inherent patriarchal power structures in Western religion, criticisms that do well to support *Supernatural*'s approach to the same by supplanting patriarchal power with fraternal equality. King articulates the dominance of the God-the-Father figuration of patriarchy, writing, "Whilst God as all-encompassing Ultimate Reality transcends the differences of sex, this

Reality has in many religions been predominantly, and one might say to the point of idolatry, presented as 'father' rather than 'mother'" (23). Daly expands on this argument by criticizing the naturalization of the divinely ordained father. She prescribes an end to this model's dominance in *Beyond God the Father*:

> The method of liberation, then, involves a *castrating* of language and images that reflect and perpetuate the structures of a sexist world. It castrates precisely in the sense of cutting away the phallocentric value system imposed by patriarchy, in its subtle as well as in its more manifest expressions. (9)

Although castration may be too strong a characterization of what *Supernatural* does to the God-the-Father model, the difference is of degree rather than kind. *Supernatural*'s apocalyptic narrative arc undermines the power of sanctioned fathers at almost every opportunity. Bobby Singer is an exception, but his construction as the Winchester brothers' father figure also operates outside the God-the-Father model as there is no "natural" reason for him to occupy the father role. He is a father of choice, not of religious or patriarchal destiny.

Supernatural's father figures create a spectrum of patriarchs: John represents the human father through whom Dean and Sam (and the viewer) conceptualize a patriarch, God stands as the supreme Father—explicitly of the angels, implicitly of humans—on whom patriarchs are modeled, Azazel as usurping father to Sam, and Lucifer is the father of Azazel and the only patriarch who successfully gives orders that are fulfilled. God's absence, revealed by the angel Joshua (Roger Aaron Brown) to the Winchesters when they visit Heaven in "Dark Side of the Moon" (5.16) and confirmed by their angel ally Castiel, allows for the failures of the other patriarchs' fatherhood to shift into the primary patriarchal space previously held by God. This destabilizes the patriarchy at its religious core by placing Lucifer as the new primary patriarch. The parallel metanarratives of patriarchy and Christianity allow for one to implicate the other.

The first patriarch presented on the show is John, Sam and Dean's biological father. Hints of the Winchesters' difficult childhood appear throughout the series, but flashbacks in episodes "Something Wicked" (1.18), "A Very Supernatural Christmas" (3.8), and "After School Special" (4.13) portray John as absent if not neglectful. The overarching plot of season one is the search for their absent father, a plot that reiterates in season five as Castiel, allied with the Winchesters to stop

Lucifer, is searching for his absent father, God. The linkage between the two absent fathers is emphasized as Castiel must use Dean's amulet to find God, an amulet Sam gave Dean when he was eight and their father was absent for Christmas. The connection between the two absent fathers is made explicit in the text as Dean remarks on Castiel's quest: "There were times I was looking for my Dad when all logic said that he was dead. But I knew in my heart that he was still alive" ("Free to Be You and Me" 5.3). This connection further implicates John as a failed patriarch when the Winchesters and Castiel find out that God is willfully absent from both their apocalyptic conflict and Heaven itself. Arising from the idea discussed earlier that the heavenly Father reflects the earthly father (instead of God-the-Father serving as a solely top-down model), God's absence can be read as a reflection of John's initial absence. Because of the order of their narrative appearance and Dean's formulation that places John in the primary rhetorical position, God becomes a shadow of John. John's absence is the symbolic touchstone and primary iteration.

In "Dark Side of the Moon," the Winchester brothers visit Heaven to look for God in the "garden" but instead only find Joshua who says, "He has a message for you: Back off....He knows everything you want to tell him...He just doesn't think it's his problem." Dean replies by characterizing God as "just another deadbeat dad with a bunch of excuses." God operates as an absent interventionist, allowing for miraculous change but refusing to act or offer any proof of His existence. God's absence, strongly portrayed despite the presence of proxies, is often seen as rejection by those who call God "Father." John operates similarly, but without responsibility to the whole of the cosmos as an excuse. When John reunites with his sons in the season one episode "Shadow" (1.16), Dean places his safety as paramount, doing his filial duty, saying that demons will use Sam and Dean against John. Although Sam objects, John takes Dean's suggestion as his own, saying, "This fight is just starting. And we are all gonna have a part to play. For now you gotta trust me, son. Okay? You gotta let me go." John makes accepting his absence the duty of his sons, not allowing them parity in the fight. Then, when John reappears in "Devil's Trap" (1.22), he is possessed by the demon and orders Sam to kill him, an order that is not carried out but remains psychologically scarring for his sons. The parallel between God the Father and John the father reflects the mutual implication of a failed patriarch(y).

After John's death at the beginning of season two, the patriarchal onus shifts to Azazel, who tells Sam he spared him in his crib the

night his mother was killed. Azazel's patriarchal importance is further emphasized when John makes a deal with him to spare Dean's life, locating him in a life-giving space for both Winchester brothers by "saving" both Sam and Dean despite being the cause of their potential deaths. The overarching plot of season two is the brothers' attempt to find and kill Azazel, a quest that is tied to their increasing encounters with Sam's psychic peers to whom the demon refers as his own "special children" ("In My Time of Dying" 2.1). Azazel accompanies Sam in a psychic flashback of Mary's death, revealing that at six months old, Sam imbibed a few drops of the demon's blood, making him part of Azazel's bloodline and granting him his precognitive powers. Significant in that scene, however, is the paternal tone Azazel takes, crowing that his blood is "better than mother's milk," calling Sam his favorite, and even removing him from the flashback right before Mary's death saying, "I don't think you want to see the rest of this" ("All Hell Breaks Loose, Part 1" 2.21). These brief bits of Azazel's dialogue and his performance suggest some sense of perverted protectiveness over Sam, a protective paternalism that John does not exhibit.

Moreover, by calling Sam his favorite, Azazel harkens back to when he possessed John in season one's "Devil's Trap"—a moment in which he literally was Sam's father—saying, "Sam, he's clearly John's favorite." In doing so, he cements himself into the patriarchal position John left open by his death, perhaps even attempting to present himself a better, more protective father to Sam than John was. Azazel holds the patriarchal position until John's spirit returns to help Dean kill Azazel, destroying the patriarchal usurper before vanishing forever into the afterlife. Though this still leaves the patriarchal place of power unstable, John succeeds in removing his primary rival for patriarchal power only to again create a vacuum in his absence. By closing the loop of life-giving fathers of the Winchesters with the death of Azazel and John, the patriarchs of blood give way to patriarchs of symbol, God and Lucifer. The bloodline fathers who represent patriarchal Christianity and the begetting of power through them have proven inadequate. The symbolic patriarch, God, is implicated in this inadequacy through God's linkage with John. Their absences echo each other, and thus their plans remain unrealized. Lucifer, however, lurks as a potentially powerful model of Christian patriarchy.

Season four brings God into the position of patriarchal authority by the presence and assertion of angels who refer to God as "Father" ("It's the Great Pumpkin, Sam Winchester"). However, the end of season four reveals that God is absent and that the Father who speaks

Figure 13.1 Azazel as priest receiving revelation from Lucifer.

instead is Lucifer, whom the demons call "Father" ("Lucifer Rising"). In "Lucifer Rising," during a flashback to 1973, Azazel speaks of both God and Lucifer as fathers, placing them on equal patriarchal ground. Azazel, possessing a priest, addresses a convent of nuns: "But sometimes it seems as if it's difficult to know the Creator. Sometimes I feel, in a very literal sense, that I have been wandering the desert for years. Looking for our Father. Well, not our Father, my Father. See, he's in jail. Your dad put him there." In a later scene of the same flashback, Lucifer, speaking through a dead nun, calls Azazel "my son" and gives Azazel a directive: "You must find me a child. A very special child." This scene is important to both the myth-arc of the show and to the metanarrative of patriarchy, for the voice of Lucifer speaks in a desecrated Church to Azazel who possesses a Catholic priest. Lucifer is implicated as a perversion of God by this setting, giving revelation to his son, Azazel, in the accoutrements of the Catholic Church, an institutionalizing force of patriarchy in Western culture and history.

However, Lucifer is also the only father who clearly communicates with his "son," telling Azazel exactly what he must do to free him, a plan that includes Azazel's machinations toward Sam, co-opting whatever successes he has. The flashback scene ends with Azazel asking, "What child?" followed by a cut to Sam Winchester. This moment rewrites Sam's relationship with Azazel thus far, using Azazel's patriarchal posturing from season two to implicate Sam as Lucifer's chosen

child. Sam, the brother who felt the most distant from his earthly father, is now presented as possessing two *patresfamilias* who have guided him on his path thus far. They are the shapers of his destiny. All of Azazel's plotting and his success in shaping Sam as a powerful psychic with enough fortitude and demon blood to open Lucifer's cage becomes Lucifer's success as a patriarch. He is the only father in the narrative whose plans come to fruition, if only briefly. He is the only patriarch with a "son," Azazel, who follows his orders to completion and without questioning his path or duty. Lucifer is the only iteration of these father figures who fulfills his role as a strong, knowledgeable, guiding, and purposeful father who can exert his power over men.

To further differentiate the success of Lucifer-the-father from the other patriarchs, Lucifer's commands are the clearest and most thoroughly followed. Both Azazel and John send messages to Sam and Dean, respectively, in the first two seasons, but they are cryptic messages coded as visions and coordinates. Codes that must be broken before the messages are legible, and even then they are vague and unclear, not orders as much as suggestions. Lucifer, however, fulfills the idealized role of the patriarch as the one who gives orders (to other men), following Michael Kimmel's formulation of the men in patriarchy who represent hegemonic masculinity. Kimmel argues that power differences among men create patriarchy by forcing men to assert their place within power hierarchies by oppressing femininity and nonhegemonic masculinities. In "Masculinity as Homophobia," he writes, "In contrast to women's lives, men's lives are structured around relationships of power and men's differential access to power, as well as the differential access to that power of men as a group" (70). He contends that those few who fit the very narrow definition of hegemonic masculinity—who wield patriarchal power—are those who can and do give orders (Kimmel 71). By Kimmel's analysis of power differentials, Lucifer is the only successful patriarch on *Supernatural*, the arbiter of powerful orders.

This idea is borne out in season five when Lucifer escapes his cage and ultimately succeeds in his plan to possess Sam. Sam is his chosen earthly vessel. Azazel and Lucifer's machinations prepare Sam's body to house Lucifer by encouraging him to drink demon blood. Their plan also prepares him mentally by drawing parallels between Sam's resentment of John and Lucifer's resentment of God. Lucifer feels abandoned by God because he was not the idealized vision of a son; he dared to step out of the bounds created by God for his angel-sons, so Lucifer attempts to be a better father than his own. Similarly,

Sam is initially characterized as the outsider in the Winchester family, feeling emotionally abandoned by John because of his inability to fit into John's idea of a good soldier-son. Though these parallels between Lucifer and Sam in relation to their fathers are important in Lucifer's attempts to convince Sam to let him inhabit his body, Lucifer is ultimately a patriarch, to both Sam and the demons. Each goal Lucifer sets he meets because of his ability to impose his patriarchal power. That, I contend is the point of these iterations of patriarchs. In connecting Lucifer—a character so connoted as evil in Western culture that no mater how sympathetically or seductively he is portrayed he will always be associated with evil—with this image of a successful patriarch, *Supernatural* inexorably taints the very notion of a successful patriarch within the structure of patriarchy. When it is the Devil who is successful, the system is called into question.

Although "Swan Song" presents Lucifer as a triumphant patriarch, with his goals realized, he is finally bested by the bonds of brotherhood. The final moments of the apocalyptic story arc that drove seasons one through five show Sam wresting control of his body from Lucifer. The moment Sam regains control is articulated through a montage recalling Sam and Dean's lives together and their brotherly love. This highlights the relationship between the brothers Winchester as more balanced than their relationships with any of the patriarchs they have encountered. It is also a moment that engages the theme of sacrifice that began with Mary, but unlike that originating trauma and almost every re-articulation of it, there is little selfishness in Sam's sacrifice. He jumps into the pit of Hell to save the world, not to escape it. Perhaps this is a moment when the haunting trauma of Mary's death finally becomes assimilated and articulated through displacement. With the five-year apocalyptic narrative arc closed, season six and beyond have seen the trauma of Mary's death only operating at the periphery of the narrative, no longer with the same privileged place of origin. Therefore, the iterations of the originating Winchester trauma, particularly in the figures of failed patriarchs, no longer hold centrality in the narrative. The iterative fathers are laid to rest. Just as the narratives of patriarchal power are concluded in favor of fraternity, the Winchester brothers assert the insignificance of religion in their world, particularly Christianity, when they stop the Apocalypse and overcome their Christian inflected destinies. Both metanarratives remain linked even in their concluding marginalization.

With all the fathers ultimately undermined, the "mother of all," Eve, hastily dismissed in season six, and the angels generally

indifferent, does the rule of brothers become the persistent power dynamic? Can fraternity replace patriarchy? Perhaps, but the narrative terrain after the Apocalypse storyline is too muddied to see the path. The Winchesters continue to be shaped by their battle with their supposed dominant fathers, with Sam literally existing with Lucifer (or at least a mental construction of him) in his head in season seven. Despite the narrative closure offered by "Swan Song" and the apparent end to the traumatic reiteration of patriarchs, *Supernatural*'s story line and characters have not found a way out of patriarchy nor a viable alternative.

The Winchesters' world is still dominated by male characters: demons, hunters, angels, leviathans, men of letters, and a prophet (still a male, Kevin Tran). They may no longer search for their fathers, but they still operate in a world built around God, the Devil, and John Winchester as the paragons of paternal power, those to whom all others must be compared, even when the comparison is favorable, as it is regarding a father-of-choice, Bobby Singer. The issues *Supernatural* continues to have with its portrayal of female characters persist as well. Despite the failure of fathers, mothers in the narrative seem only to be pivot points, whether making the deal that leads the Winchesters on their destined path (Mary) or birthing the monsters they encounter (Eve). *Supernatural* can destabilize only so much of the metanarrative. Although the idea of patriarchy operating among men may be a reason for the masculine world of *Supernatural*, the show often challenges the rule of fathers while reifying the rule of men.

Note

1. I draw on feminist scholar Angela McRobbie, who argues that "postmodernity…mark[s] a convergence of a number of discourses each of which opens up new possibilities for positioning the self" in such a way that can work to destabilize the myths of power that have shaped Western culture since the Enlightenment (522). I use McRobbie's formulation of the term "metanarrative" because despite the program's restricted cast and setting (the regular cast has not exceeded five and there was no permanent set until season three) the show's scope addresses larger Western power structures, particularly patriarchy and Christianity, that face postmodern destabilization.

Works Cited

"A Very Supernatural Christmas." *Supernatural: The Complete Third Season.* Writ. Jeremy Carver. Dir. J. Miller Tobin. Warner Brothers, 2007. DVD.

"After School Special." *Supernatural: The Complete Fourth Season*. Writ. Andrew Nabb and Daniel Loflin. Dir. Adam Kane. Warner Brothers, 2008. DVD.

"All Hell Breaks Loose Part 1." *Supernatural: The Complete Second Season*. Writ. Sera Gamble. Dir. Robert Singer. Warner Brothers, 2006. DVD.

"And Then There Were None." *Supernatural: The Complete Sixth Season*. Writ. Brett Matthews. Dir. Mike Rohl. Warner Brothers, 2010. DVD.

Caruth, Cathy. *Unclaimed Experience: Trauma, Narrative, and History*. Baltimore: Johns Hopkins UP, 1996. Print.

Daly, Mary. *Beyond God the Father: Toward a Philosophy of Women's Liberation*. Boston: Beacon Press, 1973. Print.

"Dark Side of the Moon." *Supernatural: The Complete Fifth Season*. Writ. Andrew Dabb and Daniel Loflin. Dir. Jeff Woolnough. Warner Brothers, 2009. DVD.

"Devil's Trap." *Supernatural: The Complete First Season*. Writ. Eric Kripke. Dir. Kim Manners. Warner Brothers, 2005. DVD.

Elsaesser, Thomas. "Tales of Sound and Fury: Observations on the Family Melodrama." *Film Genre Reader III*. Ed. Barry Keith Grant. Austin: U of Texas P, 2003. 366–95. Print.

"Free To Be You and Me." *Supernatural: The Complete Fifth Season*. Writ. Jeremy Carver. Dir. J. Miller Tobin. Warner Brothers, 2009. DVD.

Giannini, Erin. "'There's Nothing More Dangerous Than Some a-Hole Who Thinks He Is on a Holy Mission': Using and (Dis)-Abusing Religious and Economic Authority on *Supernatural*." *TV Goes to Hell: An Unofficial Road Map of Supernatural*. Eds. Stacey Abbott and David Lavery. Toronto: ECW Press, 2011. 163–75. Print.

"Hammer of the Gods." *Supernatural: The Complete Fifth Season*. Writ. Andrew Nabb and Daniel Loflin. Dir. Rick Bota.Warner Brothers, 2009. DVD.

Howell, Charlotte. "The Gospel of the Winchesters (And Their Fans): Neoreligious Fan Practices and Narrative in *Supernatural*." *Kinephanos*. 4:1 (Sept 2013). n. pag. Web. 17 Dec. 2013.

"In My Time of Dying." *Supernatural: The Complete Second Season*. Writ. Eric Kripke. Dir. Kim Manners. Warner Brothers, 2006. DVD.

"In the Beginning." *Supernatural: The Complete Fourth Season*. Writ. Jeremy Carver. Dir. Steve Boyum. Warner Brothers, 2008. DVD.

"It's the Great Pumpkin, Sam Winchester." *Supernatural: The Complete Fourth Season*. Writ. Julie Siege. Dir. Charles Beeson. Warner Brothers, 2008. DVD.

Kimmel, Michael. "Masculinity as Homophobia." *Privilege: A Reader*. Eds. Michael Kimmel and Abby Ferber. Cambridge: Westview, 2003. 51–74. Print.

King, Ursula. *Women and Spirituality: Voices of Protest and Promise*. Houndmills: Macmillan, 1993. Print.

"Lucifer Rising." *Supernatural: The Complete Fourth Season*. Writ. and Dir. Eric Kripke. Warner Brothers, 2008. DVD.

McRobbie, Angela. "Feminism, Postmodernism, and the 'Real Me.'" *Media and Cultural Studies: Key Works*. Eds. Meenakshi Gigi Durham and Douglas M. Kellner, Rev. Ed. Malden: Blackwell, 2006. 520–32. Print.

"Pilot." *Supernatural: The Complete First Season*. Writ. Eric Kripke. Dir. David Nutter. Warner Brothers, 2005. DVD.

Ryan, Maureen. "'It's the Fun Apocalypse': Creator Eric Kripke Talks 'Supernatural'—The Watcher." *chicagotribune.com.*. Chicago Tribune 26 Aug. 2009. n. pag. Web. 14 Sept. 2012.

"Shadow." *Supernatural: The Complete First Season*. Writ. Eric Kripke. Dir. Kim Manners. Warner Brothers, 2005. DVD.

Simmons, David. "'There's a Ton of Lore on Unicorns Too': Postmodernist Micro-Narratives and *Supernatural*." *TV Goes to Hell: An Unofficial Road Map of Supernatural*. Eds. Stacey Abbott and David Lavery. Toronto: ECW Press, 2011. 132–45. Print.

"Something Wicked." *Supernatural: The Complete First Season*. Writ. Daniel Knauf. Dir. Whitney Ransick. Warner Brothers, 2005. DVD.

"Swan Song." *Supernatural: The Complete Fifth Season*. Writ. Eric Kripke. Dir. Steve Boyum. Warner Brothers, 2009. DVD.

Who's Your Daddy?: Father Trumps Fate in *Supernatural*

Lugene Rosen

From the beginning, *Supernatural* has clearly been rooted in family, specifically in a male-only family. In the series pilot, the brief glimpse viewers have of the Winchesters as an intact household is quickly replaced by that of a family ravaged by the death of a beloved mother and wife. Following Mary's (Samantha Smith) death, the family becomes less like kin and more like an elite fighting squad with John (Jeffrey Dean Morgan) as the stern general. John's shift from loving, nurturing father to disciplinarian will have far-reaching effects on Dean and Sam and the men that they will ultimately become. Yet their experiences with John as father are vastly different from one another. In Freud's *The Interpretation of Dreams*, the father or father figure is beloved and hated, admired and feared. This duality can be confusing for children, especially those whose fathers are frequently absent and cannot offset the negative emotions that this delicate balance needs. This chapter examines the characters using several psychological indicators of present/absent fathers: the father hunger scale designed by Paul. B. Perrin et al. and the schemas developed by several other father-focused theorists. These indicators will help explain the motivations that drive Dean (Jensen Ackles), Sam (Jared Padalecki), and to a lesser extent the Winchester's family friend Bobby Singer (Jim Beaver). Based upon this exposure to fatherhood and father roles, Dean and Sam seem to be fulfilling a destiny that was decided, not by fate, but by their relationships with their father.

The word father conjures up many images. For some, it evokes safety and warmth; for others, stern discipline and coldness, and for others still, father embodies the ambivalence between love and hate. This makes the concept of father confusing. According to Kavita Datta, there is a sharp distinction between "fathers, fathering, and fatherhood" (98). While fathers and fathering have a reproductive association, the social construct of fatherhood goes beyond genetic material (biology) and is focused more on parenting functions (socialization). Fatherhood, from this viewpoint, becomes a crucial factor in the development of masculinities and identity. In *Supernatural*, the role of fatherhood is focused less on biology than who fulfills the parenting role.

In the first scene of the pilot, John Winchester is depicted as what David Blankenhorn characterizes as a "Good Family Man, that is to say as a morally correct, unselfish model of masculinity who is married and co-resides with the children" (qtd. in Nobus). John jokes with his son Dean, talks about tossing around a football, and takes an active role in putting his other son, Sam, to bed. In this first episode, John is the ideal father; however, with the death Mary, John shifts from "Good Family Man" into Michael Gurian's "outlaw father," a move with lasting repercussions (35). The outlaw father lives beyond the confines of society, often leaving home for long stretches of time while pursuing goals that do not coincide with the social norms. This definition applies to John, whose life is dedicated to the destruction of the yellow-eyed demon, Azazel, that killed his wife, often at the expense of his children's well-being. Dean and Sam have different childhood experiences with their father, based upon their respective ages at the time of Mary's death. In Dean's case, masculinity and identity are formed by having an absent father, a void that he will attempt to fill throughout his life.

From the pilot on, John's absence is treated as the norm, not the exception, as both Dean and Sam acknowledge their father's frequent absences. The boys react differently to John's absence based upon whether he is on a bender or on a hunting trip. When Dean breaks into Sam's apartment at Stanford and confronts him about their missing father, John on a bender elicits no sense of worry. Sam responds to Dean, "So he's working overtime on a Miller-time shift" ("Pilot"). Dean's reply that John is on a hunting trip ratchets up the sense of urgency in a way that John on a bender does not. Only the possibility that John has been harmed while hunting brings about anxiety. This

exchange provides a glimpse into the family dynamic that forms both Winchester boys.

As an "outlaw father," John Winchester is more than just a father figure. He is an authoritarian figure, a drill sergeant instead of a caregiver. According to Gurian, the outlaw father has little time for nurturing. His focus is on strict obedience and instruction in survival skills (35–36). In at least one episode per season, Sam' comments that "We were raised like warriors" ("Pilot") has a deeper resonance when looking at the family dynamic from this perspective and shows the effects on Dean having an outlaw, absent father.

As the eldest, Dean bears the brunt of John's outlaw fatherhood. In "Something Wicked," (1.18), he is a child left in charge of his younger brother. Yet he assumes an adult's responsibility. Given a list of strict rules to follow, he is in charge of Sam's physical and emotional well-being in John's absence. When Dean plays video games, leaving Sam alone in the motel room, he is not exhibiting an adult sensibility of primary caregiver but a child's desire to have fun. In terms of his psychological development, John's absence and expectation for Dean to fill the void are events that will shape Dean's self-worth. According to Perrin et al., a father's absence creates father hunger and has a direct effect upon boys in the development of their masculinity. Fatherless sons are often less secure and harbor self-doubt. They feel that there must be a reason for their father's absence, frequently placing the blame on themselves: If I were a better son, my father would not leave me. Dean embodies this self-doubt and sense of guilt. Left in charge while John hunts for a shtriga, a monster that feeds on the life-force of children, Dean is given careful instructions; should either of the boys be threatened, he is to shoot first and ask questions later. Walking in on the shtriga attacking Sam, Dean reacts like any frightened child: he hesitates. That brief hesitation is unacceptable to John, who chastises him for not doing his duty, and Dean's guilt at not obeying his outlaw father is apparent:

> DEAN: He looked at me different, you know. Which was worse. Not that I blame him. He gave me an order, and I didn't listen. I almost got you killed.
> SAM: You were just a kid. ("Something Wicked")

In this world, Dean can never truly be a child. He has been protector over Sam from the moment of Mary's death, and every mistake

he makes, no matter how small, adds another layer of guilt and self-loathing. John wants the perfect little soldier who follows every command with mindless obedience. Dean cannot live up to John's impossible standards, a fact which only underscores his desire to please his absent father.

Dean's lowered self-esteem is not the only effect of John's absence. Academically, Perrin et al. assert that male children with absent fathers are twice as likely to drop out of school as their counterparts with present fathers (314–5). In early episodes of the show, much is made of the fact that Dean is not the brothers' go-to resource for supernatural lore. As Dean eloquently states, he is "a [high school] drop-out with six bucks to his name" ("The Song Remains the Same" 5.13) and the proud owner of a "GED and a give-em-hell attitude" ("Sympathy for the Devil" 5.1). Dean's lack of academic achievement appears to support the fallout commonly associated with father absence; however, Dean is not without resources. Although he eschewed school, he has proven himself to be an autodidact and keen strategist, often dropping in references to literature. In "The Monster at the End of This Book" (4.18), Chuck Shurley (Rob Benedict), writer and prophet, mentions that the latest installment of *Supernatural* is very Vonnegut. Dean asks if he means *Slaughterhouse Five* Vonnegut or *Cat's Cradle* Vonnegut, a distinction that surprises Sam, who is usually the repository of learning. Again, the lack of academic achievement is a component of father hunger, not the lack of intelligence. Dean does not finish high school because of his desire to please his father and join him on the road full-time, but that academic sacrifice does not make John more present.

Similarly, on Perrin et al.'s father hunger scale, men possessing father hunger may experience low self-esteem, anger management problems, trust issues, and engage in sexually promiscuous and violent behaviors. Dean clearly fits this template. His anger and hypermasculinity are manifested throughout the series. During the first five seasons, Dean is depicted as the one who acts aggressively without thinking. One scene that best illustrates this tendency toward violence takes place in "Bloodlust" (2.3). Dean joins the hunter Gordon Walker's (Sterling K. Brown) fight, no questions asked, and beheads a downed vampire with a band-saw. This results in Dean getting splattered with blood. Dean exhibits a certain glee in his carnage. Dean clearly considers himself the brawn and Sam the brains. Instead of the tact exhibited by Sam (with a soul), Dean often uses violence to get what he needs, in the manner of many sons who rank high on the father hunger scale.

Dean may not always win the fight, but he certainly has no qualms about joining into the fray. This trait is portrayed as a coping mechanism for Dean to cover up his deep-seated insecurities at not being good enough, which fits Lyn Carlsmith's observations that boys without fathers often "attempt to compensate by demonstrating extreme masculinity" (4). Dean is so angry he threatens God with destruction, taunts Lucifer into beating him nearly senseless, and shares a couple of meals with Death, all while exhibiting hypermasculine bravado. Dean even has the temerity to summon Death and ask a favor, an act that clearly shows his brash male façade ("Two Minutes to Midnight" 5.21). While this audacity produces a positive end result, this masculine front does not come from a place of confidence.

Dean's problems with trust also follow the father hunger scale. Perrin et al. posit that the lack of a stable father figure in childhood has far-reaching effects on the levels of trust an adult will exhibit. In Dean's case, he is slow to trust, but steadfast once he does. As a child, he trusted his father to protect him, to return when promised and to provide a home however temporary. Instead, Dean was left alone with his brother in a series of seedy motels while John roamed the world seeking out evil. As Gurian's "outlaw father," John is cavalier about his sons. He could die on any hunt. Yet he leaves them alone with only vague instructions to call Preacher Jim, Bobby, or a string of other hunters in the event he does not return. Holidays pass, birthdays pass, and promises are broken. Dean's misplaced trust in his father, who repeatedly fails him and Sam, affects his ability to trust others. For example, at the end of season four, when Sam chooses to follow the demon Ruby (Genevieve Cortese) instead Dean, the loss of trust is devastating. The image of Dean on the floor of Sam's hotel room shows a broken man ("When the Levee Breaks," 4.21). Not only has Dean been physically beaten by Sam, but he has been emotionally crushed. No betrayal could have been as shattering as that of his brother. The breaking and rebuilding of trust is a central theme in Dean's life. Once burned, Dean is hesitant to trust again.

Although slow to trust, Dean is quick to hop into bed, which also hits the mark on the father hunger scale regarding sexual promiscuity since sons with absent fathers often grow into men who seek validation and self-worth through their sexual ability (Perrin et al. 316). Throughout the series, Dean is depicted as the promiscuous brother. Although the soulless Sam of season six is also promiscuous, he cannot be considered in the same light. Sam is interested in relationships; Dean is interested in one-night stands. From a series of truck stop

waitresses to the Hollywood starlet to the Doublemint twins to a fallen angel, Dean seems to have little willpower when it comes to sexual opportunity. At times, it seems as if sex is his only goal in life. Although sexually active, Dean is both unwilling and unable to form lasting attachments with his conquests with two notable exceptions, Cassie and Lisa. Of the two, only Lisa is indicative of his ability to put his lack of paternal attachment behind him and form a stable relationship.

As a man formed by an absent father, Dean frequently finds himself in the role of present father. He is able to function as Blankenhorn's "Good Family Man" during his time with Ben and Lisa in season six. Dean's predilection toward fatherhood is a natural culmination of a life spent fathering his younger brother. His relationship with Lucas in "Dead in the Water"(1.3) is a precursor to his preference for stepping into a protective role with children. Although the relationship begins as a means to Lucas's mother, Dean soon finds that his attachment is to the son. As the series progresses, he falls easily into the role of fatherhood with Michael in "Something Wicked" (1.18), Ben in "The Kids are Alright" (3.2) and throughout season six, Cole in "Death Takes a Holiday" (4.15), and Jesse in "I Believe the Children Are Our Future" (5.6). In each of these relationships, Dean embodies the father that he never had: kind, supportive, loving, and attentive. As a result of taking on the fatherly persona at a young age, Dean does not emulate the drill sergeant mentality that shaped his own views on masculinity. Although he states that he is "a killer, not a father" ("You Can't Handle the Truth," 6.6), it should be noted that this statement is only the truth as Dean sees it, based upon his own insecurities. Dean has been Blankenhorn's "good, family man" since the day of his mother's death.

Just as with Dean, Sam's childhood is revealed through flashback and dialogue, and important divergences emerge. These disparities create their masculinities and outlooks on life. From the moment John hands Sam to Dean and tells him to save his brother and get out of the house, Sam is effectively Dean's responsibility. He is Sam's de facto father. In many ways, Dean grew up less as a son and more as a father and caregiver. He provides for Sam in every sense. He feeds him, protects him, teaches him, and loves him. He even passes on his knowledge as a mechanic to Sam, a tradition he mirrors with Ben. Dean is a constant. This is the defining difference between the masculinity formed by Sam and that of Dean. According to Datta, having a male family member, especially a brother, step in and assume responsibility

for a child produces the same results as having a present father (106). For Sam, Dean's willingness to assume the role of fatherhood allows him to develop into a markedly different man than his brother in several important ways.

According to Perrin et al., "the active involvement of a father in a child's life has been associated with healthier development patterns" (315). Specifically, greater father involvement has been linked to more advanced cognitive and academic achievement. From the "Pilot" on, Sam has thrived under Dean's care. Unlike his GED-holding brother, Sam has excelled in academics and much is made of his 174 score on the LSAT ("Pilot"). He attends Stanford University and has a shot at a full scholarship to law school. Sam has a greater sense of his worth and can clearly envision a future that involves a stable relationship, a regular job, a permanent home, and the standard complement of children.

Another characteristic of children with present fathers is the development of social competence. Marshall L. Hamilton states that children with involved fathers show a greater ability to understand and fit into social situations (qtd. in Perrin et al. 315). Sam is often depicted as the brother who can flash his "puppy-dog" eyes and get people to listen, no matter how crazy he might sound. He has an innate ability to read people and situations and to act and react accordingly. Children of present fathers also show evidence of possessing higher self-esteem, a more positive self-image, and the ability to set and reach goals. Each one of these positive results can be seen in Sam, sometimes in excess. The fact that Sam is able to establish a life for himself in California, create a strong bond with Jessica, exhibit the self-esteem to believe in himself and his abilities, form friendships, and set goals is a direct reflection on Dean's parenting skills. John's absence has less of an effect on Sam's development than Dean's presence. In fact, according to Stanley Greenspan in his essay "The Second Other," having a second caregiver in children's lives helps them with the process of individuation, of understanding that they are a person separate from all others (123–28). This leads to a more confident child who can develop a more balanced emotional life.

In "Dark Side of the Moon" (5.16), we can see Sam's conflict with having two fathers. While in Heaven, each brother is given the opportunity to relive scenes from his life. For Dean, his whole world is wrapped in family, so it is particularly hurtful that Sam's memories are rooted outside of kin. The Thanksgiving dinner spent with a childhood crush's family and reconnecting with Bones, the dog that

Sam adopted when he ran away from home might indicate that Sam was unhappy with his home life. This, however, does not mean that he was unhappy with Dean. Instead, it is John who is the unwanted family member. Because John's unsolicited insertion into the life Sam shares with Dean is accompanied by John's more traditional, authoritarian rule, Sam cannot be blamed for his refusal to bend to John's will. It could be speculated that if John did not make his irregular returns, Sam would have been satisfied with his life as Dean's ersatz son. In this world, there would have been no need for Sam to ignore his family.

While it can be argued that Dean is simply being a big brother, Sam himself is the one who confers fatherhood on him. In "A Very Supernatural Christmas" (3.8), Sam makes the conscious choice to give Dean the gift that was specifically chosen for his father. During this episode, Dean is again Sam's primary caregiver, the one who truthfully answers his questions and delivers on the promises that John breaks. Throughout the episode, Dean reiterates that John will be there for Christmas, and they will all celebrate as a family. After John fails to appear, Dean fulfills John's broken promises. To do this, he steals gifts from a nearby house so that Sam can celebrate a traditional Christmas. Dean steals nothing for himself. Instead, the gifts are all for Sam's benefit, including a mangy tree and some haphazard decorations. Even though the stolen gifts are meant for a little girl, Sam realizes that Dean is the only constant in his life. Sam could have put John's gift away until he returned, but chooses not to. When he gives Dean the amulet, he is gifting him with more than a tangible token. He is giving Dean the power over his love and safety. Dean is officially the father he has acted as since Sam was six months old. This conferral of fatherhood supports Datta's assertion that fathers need not be biological. Instead, fathers need only be men who are willing to provide masculine support in the lives of father-absent children.

Sam, of course, comes with his own set of problems. After he ingests demon blood as a baby, outside forces try their hardest to push Sam into accepting his role as Lucifer's vessel, but having Dean by his side, as his brother and his father, allows Sam to toss destiny aside in favor of family. In "Swan Song" (5.22), Sam's visions of Dean's presence throughout his life provide the catalyst for Sam to force the devil back into the box. In light of Datta's assertion that brothers can step into father roles and provide the necessary emotional stability to nurture fatherless sons, Dean's role in Sam's life is essential. Dean has

Figure 14.1 Sam gives Dean the gift meant for their father.

always given him strength, but to give him the strength to control the devil shows just how powerful their bond is.

As men, Dean and Sam differ in their need for constructing a paternal figure after John's death. Seeking a father figure is not just for children but for men of any age. According to Gurian, males naturally look to other males to try to understand how to be responsible men. For Sam, his titular father is still alive, so he does not feel the same loss as Dean when John dies. Little has changed for Sam. Dean, on the other hand, feels the void deeply. Children with absent fathers often find it necessary to impress them and receive any attention possible, even negative attention posits Gurian (16–20). In the case of complete absence or death, they seek surrogates. Dean is no different. After John's death, Dean briefly transfers his need for a father figure to Gordon, in the episode "Bloodlust." Gordon, however, is not quite what Dean is looking for. In fact, the encounter with Gordon leads Dean to doubt himself even more. Oddly enough, it is Sam who reminds Dean that to replace John with someone like Gordon is an insult.

It is not until season two, with the introduction of Bobby Singer as a recurring character, that Dean begins to feel that the void left by an absent father is filled. Bobby has all of the attributes that were missing in John: patience, caring, trustworthiness, and a physical home. The viewer gets a glimpse of Bobby's importance after Dean digs himself out of the grave in the season four episode "Lazarus Rising" (4.1). His first stop is Bobby's house, and his words are revealing: "Your name

is Robert Steven Singer. You became a hunter after your wife got possessed. You're just about the closest thing I have to a father." Bobby is not just close to being a father. For all intents, he is Dean's father. Since Sam does not feel this same need, Bobby does not hold the same fascination for him. In fact, even Bobby can sense the difference. He often refers to Dean as *son* while Sam only rates the appellation *boy*, and in the episode "You Can't Handle the Truth" (6.6), he admits that Dean is his favorite.

Episode by episode, Bobby becomes the father figure for the boys. When Sam needs familial blood to cast the spell to avoid having his damaged soul returned to his body, he is told that "you need the blood of your father, but your father need not be blood" ("Appointment in Samarra" 6.11). Bobby finds himself in the uncomfortable position of father figure and has to lock Sam in the basement after Sam turns on him. Since John is dead, and Dean is acting as Death for the day, Bobby is next in line. Although Sam is clearly intent on killing Bobby, Bobby is careful to avoid damaging Sam's body even though he is willing to return Sam's ravaged soul to its vessel not knowing what physical or mental damage it may cause.

Bobby, however, has his own set of absent father issues. As revealed in the episode "Death's Door" (7.10), Bobby killed his father and buried him out behind the shed of the home where Bobby still lives. His father was abusive in a more active fashion than John Winchester, but some of the same issues can be seen in the Singer household as in the Winchesters'. For one thing, Bobby's father is an authoritarian just like John. His every command is to be followed with no debate. To question his authority is to invite his wrath. In his book *When a Child Kills*, Paul Mones describes how continued abuse, whether verbal, physical, or sexual, can cause a child to commit parricide (12–15). In Bobby's case, the abuse is verbal and physical; however, it is evident from the killing scene in the episode that the abuse has been long-standing.

When Bobby decides to kill his father, it is because he feels that there is no other solution. The scene unfolds with a young Bobby knocking over his milk at the dinner table. His mother tries to draw attention away from Bobby, thereby taking on the physical punishment that Bobby's father would focus on his son. In "Death's Door," the adult Bobby addresses his vision of his father, "You drunken bully. Punching women and kids...Is that what they call fatherhood in your day?" The child Bobby appears with a rifle, which prompts Bobby's father to state, "I will deal with you later." It is evident from

this exchange that Bobby has been "dealt with" often, so even though the catalyst is his mother's beating, Bobby knows that his turn is coming.

In this seminal episode, Bobby's motivations to become a father figure are exposed. According to Mones, the majority of children who commit parricide are males who kill their fathers (13). After seeing Bobby's childhood, it is easy to understand why he creates such an anchor for the Winchester boys. He has a permanent home. He has great knowledge to impart. He is even willing to go up against John himself, in order to give Dean a day of just being a child and tossing around a baseball. The boys were never really boys, but they came closest when they were with Bobby. Sam and Dean were men in search of a father just as he was a man in search of his sons. Finding each other was a miracle.

What the show does not address is the enormity of the odds against Bobby ever stepping into this father role. More often than not, abused children go on to become abusers. This fear of becoming his father is the force that drives a wedge between Bobby and his wife, Karen. As seen in "Death's Door," one of Bobby's greatest regrets is that the last real conversation he had with her was an argument about not wanting to become a father. Bobby overcomes his fear of following his father into spousal abuse, but having children is still at issue. This supports Mones's assertion that it requires work on the part of victim of abuse to overcome the fear of repeating the cycle (80–81). At this stage in his life, Bobby has not fully processed his abuse or his reactions to it.

In addition, Mones argues that as adults, children who commit parricide have diminished capacities for empathy and sympathy (319–21). He states that it requires enormous insight, support and help from others, and a healthy dose of luck for abused children to go forward and lead productive lives (39). Throughout the series, Bobby is portrayed as an introspective man who embodies empathy and sympathy. Although the audience is not privy to the secrets he has kept, it is apparent that something more than his wife's death has formed him. This makes his final scene as a living character all the more poignant, for his last memory is that of Dean and Sam, not Karen. It is only at his life's end that he fully reconciles his fears and claims the boys as his own. He is a father.

As the series has progressed, the images of fatherhood have evolved. Whether absent or present, fathers have played a central role in this fictive realm just as they do for men in real life. The characters are emblems of hope in a world where more and more boys grow up either

without fathers or with abusive ones. *Supernatural*'s characterizations of Dean, Sam, and Bobby show that men can transcend the reality of their broken families and create new ones based on bonds of love rather than blood. The characters demonstrate that, even without a biological father present, boys can mature into men who are willing to provide love, shelter, knowledge, and a model of what fatherhood should be. Having faith in another human being to provide an emotional safety net is central to these created paternal bonds. In *Supernatural*, as in life, father truly does trump fate.

Works Cited

"Appointment in Samarra." *Supernatural: The Complete Sixth Season.* Writ. Sera Gamble and Robert Singer. Dir. Mike Rohl. Warner Brothers, 2010. DVD.

"Bloodlust." *Supernatural: The Complete Second Season.* Writ. Sera Gamble. Dir. Robert Singer. Warner Brothers, 2006. DVD.

Carlsmith, Lyn. "Effect of Early Father Absence on Scholastic Aptitude" *Harvard Educational Review,* 34.1: 3–21. *America: History & Life.* Web. 28 Sep. 2013.

"Dark Side of the Moon." *Supernatural: The Complete Fifth Season.* Writ. Andrew Dabb and Daniel Loflin. Dir. Jeff Woolnough. Warner Brothers, 2009. DVD.

Datta, Kavitta. "'In the Eyes of a Child, a Father Is Everything': Changing Constructions of Fatherhood in Urban Botswana." *Women's Studies International Forum,* 30.2: 97–113. *ScienceDirect.* Web. 28 Sep. 2013.

"Dead in the Water." *Supernatural: Complete First Season.* Writ. Sera Gamble and Raelle Tucker. Dir. Kim Manners. Warner Brothers, 2005. DVD.

"Death's Door." *Supernatural: The Complete Seventh Season.* Writ. Sera Gamble. Dir Robert Singer. Warner Brothers, 2011. DVD.

Freud, Sigmund. *The Interpretation of Dreams.* Trans. A. A. Brill. New York: The Modern Library, 1994. Print.

Greenspan, Stanley I. "'The Second Other': The Role of the Father in Early Personality Formation and the Dyadic-Phallic Phase of Development." *Father and Child: Developmental and Clinical Perspectives.* Ed. Stanley H. Cath. Boston: Little, Brown and Company, 1982. 123–28. Print.

Gurian, Michael. *The Prince and the King.* New York: G. P. Putnam's Sons, 1992. Print.

"Lazarus Rising." *Supernatural: The Complete Fourth Season.* Writ. Eric Kripke. Dir. Kim Manners. Warner Brothers, 2008. DVD.

Mones, Paul A. *When a Child Kills: Abused Children Who Kill Their Parents.* New York: Pocket Books, 1991. Print.

"The Monster at the End of This Book." *Supernatural: The Complete Fourth Season.* Writ. Julie Siege. Dir. Mike Rohl. Warner Brothers, 2008. DVD.

Nobus, Dany. "Spectres of Fatherlessness: Social and Clinical Implications of a Modern Scourge." *The Discourse of Sociological Practice*. Spring 2003. n. pag. Web. 16 Dec. 2013.

Perrin, Paul B., et al. "Development, Validation, and Confirmatory Factor Analysis of the Father Hunger Scale." *Psychology of Men & Masculinity*, 10.4: 314–27. *PsycARTICLES*. Web. 28 Sept. 2013.

"Pilot." *Supernatural: The Complete First Season*. Writ. Eric Kripke. Dir. David Nutter. Warner Brothers, 2005. DVD.

"Something Wicked." *Supernatural: The Complete First Season*. Writ. Daniel Knauf. Dir. Whitney Ransick. Warner Brothers, 2005. DVD.

"The Song Remains the Same." *Supernatural: The Complete Fifth Season*. Writ. Sera Gamble and Nancy Weiner. Dir. Steve Boyum. Warner Home Video, 2009. DVD.

"Swan Song." *Supernatural: The Complete Fifth Season*. Writ. Eric Kripke. Dir. Steve Boyum. Warner Brothers, 2009. DVD.

"Sympathy for the Devil." *Supernatural: The Complete Fifth Season*. Writ. Eric Kripke. Dir. Robert Singer. Warner Home Video, 2009. DVD.

"Two Minutes to Midnight." *Supernatural: Complete Fifth Season*. Writ. Sera Gamble. Dir, Phil Sgriccia. Warner Brothers, 2009. DVD.

"A Very Supernatural Christmas." *Supernatural: The Complete Third Season*. Writ. Jeremy Carver. Dir. J. Miller Tobin. Warner Brothers, 2007. DVD.

"When the Levee Breaks." *Supernatural: The Complete Fourth Season*. Writ. Sera Gamble. Dir. Robert Singer. Warner Brothers, 2008. DVD.

"You Can't Handle the Truth." *Supernatural: The Complete Sixth Season*. Writ. David Reed and Eric Charmelo. Dir. Jan Eliasberg. Warner Brothers, 2010. DVD.

Metal and Rust: Postindustrial White Masculinity and *Supernatural*'s Classic Rock Canon

Gregory J. Robinson

Since *Supernatural*'s first season, the use of well-known music from the classic rock and heavy metal soundworlds has been central in the show's diegetic and nondiegetic contexts.[1] Music frequently takes center stage as characters listen to songs from the late 1960s through the 1980s, share stories and anecdotes about these works and the bands that created them, and argue over different notions of musical aesthetics and authenticity. In addition, selections from this repertoire punctuate moments of intense emotion, character growth, and narrative development. By using a familiar catalog of preexisting popular music, *Supernatural* draws on a wide range of emotional, historical, and cultural associations that have accrued to this repertoire over the past several decades. These discourses become key resources in the show, as producers mobilize the deep cultural resonances of these songs in order to bring texture and depth to key moments.

Since the early years of academic research on hard rock and heavy metal, scholars have highlighted the fact that discourses surrounding these genres have centered on notions of power, excess, transcendence, and masculinity. Simon Frith and Angela McRobbie's influential 1979 essay, "Rock and Sexuality" coins the term, "cock rock" to emphasize the ways in which certain styles of rock evoke male sexual performance stating:

> Mikes and guitars are phallic symbols; the music is loud, rhythmically insistent, built round techniques of arousal and climax; the lyrics are assertive and arrogant, though the exact words are less significant than the vocal styles involved, the shouting and screaming (319).

Robert Walser traces many of the same discursive undercurrents within heavy metal in his 1993 book, *Running with the Devil*:

> Musically, heavy metal articulates a dialectic of controlling power and transcendent freedom. Metal songs usually include impressive technical and rhetorical feats on the electric guitar, counterposed with an experience of power and control that is built up through vocal extremes, guitar power chords, distortion, and sheer volume of bass and drums. Visually, metal musicians typically appear as swaggering males...punctuating their performances with phallic thrusts of guitars and microphone stands (108–9).

More recent scholarship refines and nuances the concepts laid out in these works. Glenn Pillsbury's research on Metallica, for example, highlights the different kinds of masculinity at play in performances by specific metal bands, while Susan Fast's writings locate female subjectivity within hard rock performance and reception. All of these works, however, recognize the extent to which themes of masculine power, excess, and transcendence have dominated representations of these genres.[2]

Supernatural's use of preexisting music creates a discourse of musical canon in which the program identifies a corpus of "great works" that articulates a specific set of values. In this particular case, the core values elaborated by the canonic discourse are precisely the notions of masculine power, excess, and transcendence that scholars have pointed out as persistent themes in hard rock and heavy metal. However, rather than claiming totalizing authority for this canon or uncritically embracing the values it reflects, the show maintains an ambivalent rhetorical relationship toward this discourse, at times inviting viewers to participate in feelings of power and triumph through the use of classic rock as a nondiegetic device, and at other moments, situating both the music and the values it evokes as the specific province of particular characters. Unlike critics and journalists, then, who according to Matthew Bannister seek to establish a musical canon for use as "a tool of education and a means of distributing cultural capital" ("Loaded" 82), *Supernatural* moves between evocations of this canon as a technique of education and a narrative device.[3]

This ambivalent treatment of the classic rock canon enables *Supernatural* to create a nuanced, contemporary critique of this music, for within the discrepancy between diegetic and nondiegetic deployments lies an equally ambivalent assessment of the canon itself (alternately

a site of transcendence and an antiquated expression of out-of-touch sensibilities). Drawing on classic rock's status as both "alternative canon" and "remote canon,"[4] *Supernatural* portrays this music as an index of both power and the outsider status of the Winchesters, and in particular, for older brother, Dean (Jensen Ackles). The show creates a dual narrative approach within which (even as classic rock comments on the drama) the characters' use of this music reflects the producers' vision of the repertoire's social position in an early twenty-first century context. In this chapter, I take on the first side of this representational paradigm in order to address the second, considering what this music can tell us about *Supernatural* primarily in the service of my ultimate objective, to understand what *Supernatural* says about this music. This particular example of early twenty-first–century discourse on the classic rock canon provides insight into some of the ways in which this repertoire has been reconfigured in the contemporary context.

Classic Rock in *Supernatural*

Over the first few seasons of *Supernatural*, as the show moves from a "monster of the week" format to a longer narrative arc, the character development of and relationship between the two Winchester brothers becomes a central element of the drama, and the use of preexisting music, particularly classic rock, is a crucial driver of this development. More often than not, classic rock is specifically associated with Dean. If the diegetic musical world of *Supernatural* conforms to Jason Toynbee's definition of a canonical culture, then Dean plays the role of disc jockey, "who acts both as reportorial archaeologist and performer" (125). As film and television scholar, Simon Brown states, "This is Dean's world. The car, the music, and the clothes are an established part of Dean when he arrives to collect Sam [Jared Padalecki] in the pilot" (67). From the very first episode, *Supernatural* lays out several clear parameters for how viewers are meant to interpret this music and about its role in the soundworld of the show. First and most importantly, *Supernatural* draws on the kinds of discourses highlighted in the scholarly literature to depict classic rock as bound up with notions of power, excess, transcendence, and masculinity. Time after time, anthemic choruses and instrumental solos from classic rock standards accompany dramatic moments of triumph, heroism, bravery, loyalty, brotherly love, and recklessness.

Examples are myriad and include, for instance, the glorious return of the Impala early in season two. Several episodes after the Impala's apparent destruction, "Bloodlust" (2.3), begins with lingering long shots of the Impala, restored to "her" former glory and hurtling down a two-lane highway, cross cut with close-ups of various parts of the car. Deep, rumbling "American muscle" car engine noises drift in and out of the sequence over AC/DC's "Back in Black," which sets the emotional tenor for the scene. In a recurring example, each season finale begins with a montage recapping recent plot highlights along with the Winchesters' more cinematic feats of bravery, over the sound of Kansas's "Carry On My Wayward Son." Additionally, the producers chose classic rock to punctuate one of the most climactic moments in the entire series. In the season five finale, "Swan Song" (5.22), all hope seems lost for the brothers, who have accidentally started, and then failed to stop the Apocalypse prophesied in the Book of Revelation. As Lucifer and the Archangel Michael meet in Stull Cemetery that is to serve as the field of battle, possessing the bodies of Sam and the Winchesters' half-brother Adam (Jake Abel), it seems as if the world's fate is sealed. However, in a moment of desperation and steely resolve, which ultimately leads to triumph for the Winchesters and for humanity, Dean pops a tape into the Impala's tape deck and slowly drives onto the scene to break up the fight as Def Leppard's "Rock of Ages" blares from the car stereo. In each of these examples, classic rock provides the soundtrack to the Winchesters' greatest moments of triumph and bravery, cementing this repertoire's connections to notions of power and transcendence.

The pairing of classic rock anthems with these moments of heightened action and emotion represents the show's most direct use of pre-existing music, but it is not the only way in which this repertoire creeps into the show. Sam and Dean's use of famous musicians' names on their various fake IDs from the beginning of the series until early in season seven, and the frequent discussions among characters about musical tastes also serve to solidify music's role in the series' narrative framework. These references to music outside the soundtrack gradually reveal a distinction among various forms of classic rock in which music specifically linked to Dean skews slightly harder than the repertoire used in more general settings.

Viewers are invited into a classic rock soundscape that emphasizes the likes of AC/DC and Ozzy Osbourne, but also includes artists ranging from the Allman Brothers to Bob Dylan, Creedence, and more contemporary acts like Alice in Chains. However, music

identified with Dean, either through direct diegetic association, textual reference, or nondiegetic settings within scenes that focus specifically on him, remain within the more uniformly metal-oriented realm of Warrant, Metallica, and, his professed favorite group of all time, Led Zeppelin.[5] The importance of this discrepancy cannot be overstated, for the difference between the soundtrack the audience hears and the one that seems to exist in Dean's head provides the space within which *Supernatural* establishes its ambivalent stance on classic rock. This discrepancy invites viewers to participate in certain moments of hard rock transcendence while simultaneously and reflexively drawing attention to this music's outdated aesthetic and marginal or outsider status within contemporary popular culture. In this way, the show clearly marks the boundaries of normative musical taste and shows Dean transgressing these boundaries in moments of private reverie.

Even while the show embraces this repertoire, it continually draws attention to the fact that Dean's music is out of fashion, portraying him as defiantly out of touch with contemporary style, and at some points even going so far as to suggest that he has bad taste. This perspective is voiced primarily through Sam's running commentary. In the pilot, Sam, recently reunited with his estranged older brother, sits in the passenger seat of the Impala rifling through Dean's music collection and says in exasperation, "Seriously, man, you have to update your cassette tape collection...One, they're cassette tapes, and two, Black Sabbath? Motörhead? Metallica? It's the greatest hits of mullet rock." Dean shrugs off his brother's disapproval, replying, "House rules, Sammy. Driver picks the music, shotgun shuts his cake hole."

Several scenes throughout the series use Dean's musical choices as a source of humor. In season two's "Simon Said" (2.5), Dean passes sarcastic judgment on another character for selecting REO Speedwagon's "Can't Fight This Feeling" on a jukebox. Several scenes later, he absentmindedly sings the song to himself as he and Sam drive to their next destination. As in the pilot, Sam shames Dean for his musical choices, this time with a furrowed brow and a simple, "You're kidding, right?" The joke is repeated in "Slash Fiction" (7.6) as Sam catches Dean singing along to Air Supply's overwrought power ballad, "All Out of Love." In each of these examples, Sam's disapproval of Dean's musical choices serves to place ironic distance between the audience and Dean's taste, highlighting the boundary that separates the permissible excesses of nondiegetic rock from the emotional overindulgence of Dean's selections. In the case of the power ballads by

REO Speedwagon and Air Supply, Dean's visible embarrassment at his own enjoyment of what he has already defined as "bad music" further underscores his transgression of the boundaries of normative musical sensibilities.

Another sequence that casts Dean's musical taste as out-of-touch occurs in "Mystery Spot" (3.11). In this episode, Sam wakes up in a motel room to find Dean lacing up his boots and cheerily rocking out to Asia's "Heat of the Moment." When Dean greets Sam with an uncharacteristically chipper, "Rise and Shine, Sammy!" Sam's only response is, "Dude, Asia?" Dean once again brushes off his brother's passive-aggressive criticism, offering a perfunctory, "C'mon, you love this song and you know it." After Sam retorts, "Yeah, and if I ever hear it again I'm gonna kill myself," Dean, undeterred, cranks up the volume and apologizes to Sam for not being able to hear him as he begins energetically lip syncing. The episode turns out to be a Groundhog Day format. Sam is stuck in a loop in which he lives this same Tuesday over and over, and every iteration ends with Dean dying in increasingly preposterous ways. In this context, the chorus from "Heat of the Moment" serves as a narrative cue that Sam's Tuesday is beginning again, and, marked as antiquated and unfashionable music from the beginning, the song becomes more and more humorously irritating with each hearing. Concomitantly, Dean's exaggerated enjoyment of the work becomes more and more ridiculous, further emphasizing his outsider status.

An additional example that situates Dean's music as out-of-date, and even reactionary, occurs in "Lazarus Rising" (4.1). When Dean returns from a four-month stint in Hell, Sam, who has adopted the Impala as his own, returns the keys to his older brother. Upon entering the car, Dean finds that Sam has mounted an iPod jack in front of the tape deck and exclaims, "You were supposed to take care of her, not douche her up!" Insult compounds injury when he starts the ignition and finds contemporary folk/rocker Jason Manns issuing from the speakers, at which point he rips the iPod out of the jack and hurls it into the back seat. This moment offers viewers a deeper insight into Dean's outmoded musical preferences. The outrage with which he responds to the modification of the Impala's sound system reflects an uneasy relationship with both contemporary musical tastes and modern technological means of musical consumption.

It is through the matching of classic rock with these uncertainties and anxieties within the character of Dean Winchester that *Supernatural*'s interpretation of this repertoire's cultural position in

Figure 15.1 Jensen Ackles, in an unscripted outtake, lip syncs to Survivor's "Eye of the Tiger," while playing leg guitar atop the Impala.

the early twenty-first century context becomes most clearly audible and visible. While Stan Beeler argues convincingly in "Two Greasers and a Muscle Car" that Dean's enthusiasm for classic rock serves to emphasize his devotion to his father, I believe that this music ultimately achieves something else within the broader narrative of the show and of Dean's character development. *Supernatural*'s ambivalent treatment of this repertoire—on the one hand, celebrating its connotations of excess, transcendence, and masculinity, and on the other, poking fun at its stubborn resistance to twenty-first century sensibilities— positions the music as an outdated but surprisingly effective resource in Dean's various confrontations with adversity. The most obvious of these conflicts are against the ghosts and demons that make up the show's cast of antagonists, but Dean also uses classic rock to negotiate his own marginal social status.

Supernatural and the Postindustrial Context

Dean's resistance to fashionable musical tastes points up his broader rejection of postmodern sensibilities and reflects his lack of access to the kind of middle-class "apple-pie life" that the characters regard as an American middle-class norm. His cultural, economic, and musical marginality outlines the show's evocation of a broader postindustrial context, or the overarching cultural and economic processes of deindustrialization. The notion of the postindustrial musical context was developed primarily by hip-hop scholars such as Tricia Rose, Robin

Kelley, and Mark Anthony Neal, to discuss specific conditions that affected minorities in urban areas in the 1970s and 1980s, but it is not too much of a stretch to think about *Supernatural* and classic rock in these terms. Tricia Rose sets the broad framework for the postindustrial context in her book, *Black Noise*:

> In the 1970s, cities across the country were gradually losing federal funding for social services, information service corporations were beginning to replace industrial factories, and corporate developers were buying up real estate to be converted into luxury housing, leaving working-class residents with limited affordable housing, a shrinking job market, and diminishing social services. (27)

Supernatural's America is a place of decay, full of tortured ghosts and restless spirits, and deindustrialization provides a good part of this context. From the rusted out factories and warehouses that often serve as the Winchesters' hunting grounds, to the dilapidated, kitschy, love-shack-style motels that function as their makeshift headquarters, to the endless sea of dead cars in Bobby's scrap yard, the characters wander through a world filled with the broken promises of postwar prosperity.

Creator Eric Kripke seems to be keenly aware of the way he is building these connotations into the show. During an interview at the William S. Paley Television Festival, he explains:

> I'm from a small town in Ohio and this is the music I listen to. I was a huge Zeppelin fan…I think it's like a real signature to the show, and plus it's Midwestern, it's like two guys from Kansas and a muscle car and this is the music they listen to (Kripke).

In this context, Kripke's references to Midwestern themes and the blue-collar cultural symbol of the muscle car seem to suggest that he envisions the show's setting as a place deeply affected by the same postindustrial economic processes described by Rose.

Within this blue-collar, Midwestern America, Sam and Dean Winchester represent two separate versions of twenty-first century masculinity, placed in very different situations by economic deindustrialization. Dean occupies a marginalized position, ensured not only by his sense of obligation to protect his brother and the rest of humanity, but also by a neglected education (as represented in "After School Special" 4.13), an adversarial relationship with law enforcement (exemplified by his erroneous implication in a homicide in "Skin"

[1.6] and his subsequent status as a wanted criminal), and a mountain of debt accumulated over a lifetime of credit card fraud referenced in the pilot.[6] By contrast, Sam often seems like less of an outsider in a service-based, twenty-first century economic context, with his more extensive education, research skills, and technological savvy that he draws upon each time he does background research either on his laptop computer or at a local library.

The Winchester brothers' forms of cultural expression, and music in particular, serve to reinforce their respective positions within the postindustrial economy. Brown draws attention to the Winchesters' outsider position and points out music's role in communicating this alienation to audiences. He observes, "The use of '70s rock in association with the drab-colored clothes and the gas-guzzling, lead-spewing Impala clearly separates Sam and Dean from the contemporary world" (66). While Brown argues that these devices work to identify the Winchesters with the 1970s, Aaron Burnell sees these same tropes locating the brothers as working-class cultural outsiders, inhabiting the complex representational space of "white trash" (47). Once again, the specific association between Dean and classic rock cements his position further outside the contemporary cultural mainstream than his brother. An exploration of postindustrial musical cultures beyond *Supernatural* confirms this point.

In "'Behind the Mask': Eminem and Post-industrial Minstrelsy" cultural studies scholar Russell White provides insight into some of the possible relationships between postindustrialism and the listening habits of white men:

> Eminem speaks to an emergent class of grey-collar male workers—both black and white—who are unsure of and dissatisfied with their roles within post-industrial, postmodern American society, a society dominated by political correctness and in which women and ethnic minorities have or are perceived to have more power and influence than ever before. (77)

Not only does Dean find himself in an economic position similar to the one described by White, he also harbors the same mistrust of postmodern values referenced here. Dean's stubborn rejection of contemporary musical taste reflects a more all-encompassing set of values and positions and fits within the broader patterns of juxtaposition by which *Supernatural* develops both of the Winchester brothers. Whereas Sam approaches moral and ethical dilemmas in

a manner more consistent with postmodern values, considering various perspectives and searching for good in the show's antagonists, Dean tends to be more confident in his own moral authority and to see these creatures as uncomplicatedly evil. This pattern emerges in episodes such as "Metamorphosis" (4.4) and "The Girl Next Door" (7.3), in which Dean advocates killing the monsters while Sam prefers to rehabilitate them, and in the brothers' respective relationships to the demon, Ruby (Katie Cassidy/Genevieve Cortese).

In addition, while Sam chooses healthy living options like eating fruits and vegetables, Dean seems to live on a steady diet of cheeseburgers, pie, and alcohol. The Winchesters' eating habits are juxtaposed starkly in episodes such as "Swap Meat" (5.12) and "There Will Be Blood" (7.22), each of which features one brother scrutinizing the other's preferences. Moreover, in contrast to Sam, who attended Stanford University and was set to interview for law school before being pulled back into the family business, Dean boasts "a G.E.D. and a give-em-hell attitude" ("Sympathy of the Devil" 5.1). While Sam tends to treat women as equals, Dean relishes opportunities to attend strip clubs and pick-up bars, as demonstrated in episodes such as "Heart" (2.17), "Sex and Violence" (4.14), and "Season Seven, Time for a Wedding!" (7.8), as well as Dean's dream sequence from "The Song Remains the Same" (5.13), which features two strippers, dressed in angel and demon costumes, dancing seductively to Warrant's "Cherry Pie." And finally, while the audience has very little indication regarding the kind of music Sam listens to, regular viewers know Dean's favorites well. His taste in music, then, reflects not only his marginal social and economic position, but also his broader rejection of an emerging cultural and gender sensitive, nutritionally prudent, early twenty-first century American ethos.

Susan A. George's contribution to this volume demonstrates the ways in which the show undermines the overarching dichotomy I am tracing here even as it constructs it. The program accomplishes this primarily by placing Dean in positions where he has to make increasingly complicated and emotionally fraught decisions, revealing in the process the more human, sensitive, and nurturing aspects of his character. Despite this gradual progression by which Dean's character becomes more three-dimensional, his engagement with hard rock and heavy metal continues to serve as an outlet for and expression of his notions of his own power, masculinity, and outsider status. In this way, classic rock becomes a kind of leitmotif used to stand in for Dean's particular brand of backward-looking masculinity.

Conclusion

Within the symbolic world of *Supernatural*, Dean's embrace of classic rock says as much about the music as it does about him, and to the extent that the series' representations of this repertoire resonate within a cultural context, analysis of these representations puts us in some kind of position to discern broader trends in the resignification of classic rock in the early twenty-first century. Matched to Dean Winchester, classic rock becomes the music of an archetypal figure of masculinity, disenfranchised by the postindustrial economic turn and with deep misgivings about modern technology and the postmodern, twenty-first century sensibilities, concerns, and perspectives as articulated by Sam. If this function is only implicit in *Supernatural*, Kripke makes it explicit in another portion of the interview cited previously:

> When it came time to write the pilot and produce it, it was so important to me that it have that music and not have, you know, all due respect to my beloved network, not have the music that's usually on that network. And it was so important to me, I was so rabid about it that in the original draft of the pilot, I even wrote in the script, "Cue music. And you can take your anemic alternative pop and shove it up your ass." (Kripke)

Kripke's statement and Dean's use of classic rock position this repertoire as a strategy for recuperating a kind of masculine power that has become increasingly difficult for individuals represented by the character of Dean Winchester to sustain within the economic context of deindustrialization and the political climate of postmodernism.

Through its ambivalent treatment of the classic rock canon, then, the show enlists this music as part of Dean's symbolic critique of twenty-first century sensibilities and then invites viewers to participate in this critique by sharing in the emotions of triumph and empowerment that the repertoire comes to represent. Although, as George demonstrates, this critique is ultimately unsatisfactory for the emotional demands of the post-9/11 world, the show seems to hit on something important when it represents classic rock as a rejection of a softer, more introspective postmodern vision of masculinity and as an attempt to recuperate a sense of masculine power in the postindustrial context. The discourses of excess and power that have historically accrued to this genre, when recontextualized as an explicit rejection of contemporary culture, become a strategy for a retrograde and nostalgic masculine identity formation. In this way, classic rock's ambivalent status

as a transcendent and antiquated discourse translates into a social positioning that is simultaneously countercultural and reactionary.

Notes

1. Different writers use the term "classic rock" in different ways. Music critics often use the term to identify "the greatest albums of all time," ranging from Chuck Berry to contemporary groups (see discussions of this discourse in von Appen, Regev and Shepherd Doehring). By contrast, in the realm of radio, Katz Media Group defines classic rock as a format "based in 60s, 70s and 80s rock music," which is distinguished from "Classic Hits" by the fact that "the Classic Rock format will play deeper, harder cuts from Classic albums." *Supernatural*'s classic rock canon overlaps more extensively with this radio-based definition of the genre, and this is the sense in which I use the term here.
2. Fast's groundbreaking book on Led Zeppelin shows that, to the exclusion of other perspectives, masculine and heterosexual interpretations "have become *the* way in which Zeppelin is discussed by journalists and academics in terms of gender and sexuality" (168). One of her main interventions is to critique these discourses and create a space for other perspectives. My objective here is not to argue for the hegemony of masculine and heterosexual interpretations of hard rock, but rather to demonstrate that it is precisely these discourses that *Supernatural*'s producers draw on when they use this music in the series.
3. For further analysis of canonic discourses in pop-rock music, see for example Regev, Bannister, von Appen and Doehring, or Shepherd.
4. Kärjä, adapting Bohlman's notion of "small group canon," defines an alternative canon as a discourse of value based on "a confrontation between the mainstream...and the alternative to it" (14), while Toynbee uses the term "remote canon" to refer to "a code imposed on a variety of texts which had never been asked to carry such a burden of coherence at the moment of production" (127).
5. Though Led Zeppelin apparently disdained description of their music as "heavy metal," they are credited with creating many of the performance practices, playing techniques, and artistic postures that became standards of the genre (Walser 6).
6. Dean's attempt to leave the hunting profession and enter a middle-class lifestyle in seasons five and six ends abruptly when he simultaneously discovers, in "Exile on Main Street" (6.1), that Sam is back on Earth and that several djinn have sought him out to exact vengeance for the killing of their father several seasons earlier ("What Is and What Should Never Be" [2.20]).

Works Cited

"After School Special." *Supernatural*. Writ. Andrew Dabb and Daniel Loflin. Dir. Adam Kane. CW. *Netflix*. Web. 18 Jan. 2014.

Bannister, Matthew. "'Loaded': Indie Guitar Rock, Canonism, White Masculinities." *Popular Music* 25.1 (2006): 77–95. Print.

Beeler, Stan. "Two Greasers and a Muscle Car: Music and Character Development in *Supernatural*." *TV Goes to Hell: An Unofficial Road Map of Supernatural*, Eds. Stacey Abbott and David Lavery. Toronto: ECW Press, 2011. 18–32. Print.

"Bloodlust." *Supernatural*. Writ. Sera Gamble. Dir. Robert Singer. CW. *Netflix*. Web. 18 Jan. 2014.

Bohlman, Philip V. *The Study of Folk Music in the Modern World*. Bloomington: Indiana UP, 1988. Print.

Brown, Simon. "Renegades and Wayward Sons: *Supernatural* and the '70s." *TV Goes to Hell: An Unofficial Road Map of Supernatural*. Eds. Stacey Abbott and David Lavery. Toronto: ECW Press, 2011. 60–76. Print.

Burnell, Aaron C. "Rebels, Rogues, and Sworn Brothers: *Supernatural* and the Shift in White Trash from Monster to Hero." *TV Goes to Hell: An Unofficial Road Map of Supernatural*. Eds. Stacey Abbott and David Lavery. Toronto: ECW Press, 2011. 47–59. Print.

"Exile on Main Street." *Supernatural*. Writ. Sera Gamble. Dir. Phil Sgriccia. CW. *Netflix*. Web. 18 Jan. 2014.

Fast, Susan. *In the Houses of the Holy: Led Zeppelin and the Power of Rock Music*. New York: Oxford UP, 2001. Print.

Frith, Simon and Angela McRobbie. "Rock and Sexuality." *Screen Education* 29 (1979): 1–19. Rpt. in *On the Record: Rock, Pop, and the Written Word*. Ed. Simon Frith and Andrew Goodwin. New York: Routledge, 1990. 317–32. Print.

"Formats: Classic Rock." *Katz Media Group Radio Resource Center*. Katz Media Group, n.d. n. pag. Web. 29 Oct. 2013.

"The Girl Next Door." *Supernatural*. Writ. Andrew Dabb and Daniel Loflin. Dir. Jensen Ackles. CW. *Netflix*. Web. 18 Jan. 2014.

"Heart." *Supernatural*. Writ. Sera Gamble. Dir. Kim Manners. CW. *Netflix*. Web. 18 Jan. 2014.

Kelley, Robin. "Kickin' Reality, Kickin' Ballistics: Gangsta Rap and Postindustrial Los Angeles." *Droppin' Science: Critical Essays on Rap Music and Hip Hop Culture*. Ed. William Eric Perkins. Philadelphia: Temple UP, 1996. 117–58. Print.

Kripke, Eric. "The Paley Center: Supernatural: Creator Eric Kripke on the Music." *Hulu*. Web. 2 Dec. 2013.

"Lazarus Rising." *Supernatural*. Writ. Eric Kripke. Dir. Kim Manners. CW. *Netflix*. Web. 18 Jan. 2014.

"Metamorphosis." *Supernatural*. Writ. Chathryn Humphris. Dir. Kim Manners, CW. *Netflix*. Web. 18 Jan. 2014.

"Mystery Spot." *Supernatural*. Writ. Jeremy Carver. Dir. Kim Manners. CW. *Netflix*. Web. 18 Jan. 2014.

Neal, Mark Anthony. *What the Music Said: Black Popular Music and Black Public Culture*. New York: Routledge, 1999. Print.

Pillsbury, Glenn. *Damage Incorporated: Metallica and the Production of Musical Identity*. New York: Routledge, 2006. Print.

"Pilot." *Supernatural*. Writ. Eric Kripke. Dir. David Nutter. CW. *Netflix*. Web. 18 Jan. 2014.

Regev, Motti. "Producing Artistic Value: The Case of Rock Music." *The Sociological Quarterly* 35.1 (1994): 85–102. Print.

Rose, Tricia. *Black Noise: Rap Music and Black Culture in Contemporary America*. Middletown: Wesleyan UP, 1994. Print.

"Season Seven, Time for a Wedding!" *Supernatural*. Writ. Andrew Dabb and Daniel Loflin. Dir. Tim Andrew. CW. *Netflix*. Web. 18 Jan. 2014.

"Sex and Violence." *Supernatural*. Writ. Cathryn Humphris. Dir. Charles Beeson. CW. *Netflix*. Web. 18 Jan. 2014.

Shepherd, Becky. "Rock Critics as 'Mouldy Modernists.'" *Portal Journal of Multidisciplinary International Studies* 8.1 (2011): n. pag. Web. 29 Oct. 2013.

"Simon Said." *Supernatural*. Writ. Ben Edlund. Dir. Tim Iacofano. CW. *Netflix*. Web. 18 Jan. 2014.

"Skin." *Supernatural*. Writ. John Shiban. Dir. Robert Duncan McNeill. CW. *Netflix*. Web. 18 Jan. 2014.

"Slash Fiction." *Supernatural*. Writ. Robbie Thompson. Dir. John F. Showalter. CW. *Netflix*. Web. 18 Jan. 2014.

"The Song Remains the Same." *Supernatural*. Writ. Sera Gamble and Nancy Weiner. Dir. Steve Boyum. CW. *Netflix*. Web. 18 Jan. 2014.

"Sympathy for the Devil." *Supernatural*. Writ. Eric Kripke. Dir. Robert Singer. CW. *Netflix*. Web. 18 Jan. 2014.

"Swan Song." *Supernatural*. Writ. Eric Kripke. Dir. Steve Boyum. CW. *Netflix*. Web. 18 Jan. 2014.

"Swap Meat." *Supernatural*. Writ. Julie Siege. Dir. Robert Singer. CW. *Netflix*. Web. 18 Jan. 2014.

"There Will Be Blood." *Supernatural*. Writ. Andrew Dabb and Daniel Loflin. Dir. Guy Bee. CW. *Netflix*. Web. 18 Jan. 2014.

Toynbee, Jason. *Making Popular Music: Musicians, Creativity, and Institutions*. London: Arnold, 2000. Print.

von Appen, Ralf and André Doehring. "Nevermind the Beatles, Here's Exile 61 and Nico: 'The Top 100 Records of All Time': A Canon of Pop and Rock Albums from a Sociological and Aesthetic Perspective." *Popular Music* 25.1 (2006): 21–39. Print.

Walser, Robert. *Running with the Devil: Power, Gender, and Madness in Heavy Metal Music*. Hanover: UP of New England, 1993. Print.

White, Russell. "'Behind the Mask': Eminem and Post-Industrial Minstrelsy." *European Journal of American Culture* 25.1 (2006): 65–79. Print.

"What Is and What Should Never Be." *Supernatural*. Writ. Raelle Tucker. Dir. Eric Kripke. CW. *Netflix*. Web. 18 Jan. 2014.

Contributors

Ralph Beliveau is an associate professor in the Gaylord College of Journalism and Mass Communication, and affiliate faculty in Film & Media Studies and Women & Gender Studies, University of Oklahoma. His scholarship has concerned horror media, *The Wire*, African American biographical documentaries, Alex Cox, documentary, rhetoric, and critical media literacy. His doctoral work at the University of Iowa covered media pedagogy and the Rhetoric of Inquiry, and he studied film at Northwestern University.

Candace Benefiel is an associate professor and humanities reference librarian at Texas A&M University, and a Ph.D. student there as well, focusing on the vampire in literature. She has published in the *Journal of Popular Culture*, *Wilson Library Bulletin*, *College and Research Libraries*, and other journals. Her poetry has appeared, among other places, in *Borderlands*, *The Concho River Review*, and *Classical Outlook*. Her book, *Reading Laurell K. Hamilton*, was recently published by ABC-CLIO.

Laura Bolf-Beliveau is an associate professor in the English department at the University of Central Oklahoma. She coordinates the English education program and works with preservice teachers and student teachers. Her research interests include feminist poststructural theory, young adult literature, and social justice pedagogy.

Cait Coker is an associate editor for *Foundation: The International Review of Science Fiction*. Her research focuses on the depictions of women and sexuality in science fiction and fantasy.

Rebecca-Anne C. Do Rozario is a lecturer at Monash University. She is interested in fairy tales, fantasy, children's literature, and musical theater. She has published work in journals including *Children's Literature*, *Musicology Australia*, *Marvels & Tales* and *Women's*

Studies in Communication, and in collections including *The Gothic in Children's Literature: Haunting the Borders.*

Susan A. George, Ph.D., teaches at the University of California, Merced. Focusing on the construction of gender and technology in fantastic film and television, her work has appeared in *The Journal of Popular Film and Television, Post Script, Reconstruction: Studies in Contemporary Culture,* and in several anthologies, including *The Essential Science Fiction Television Reader* (2008) and the award winning *Why We Fought: America's Wars in Film and History* (2008). Her book, *Gendering Science Fiction Films: Invaders from Suburbs,* was published in 2013. She serves on the editorial board of *Science Fiction Film and Television,* was division head of Film and Media for the International Conference for the Fantastic in the Arts, and has been a member of the Executive Committee of the Science Fiction Research Association.

Erin Giannini, Ph.D., is an independent scholar in television studies whose research focuses on new technology, product placement, and its effect on narrative. She has published and presented work on religion, socioeconomics, technology, and corporate culture in works such as *Supernatural, Dollhouse, Heroes, The Cabin in the Woods,* and *Mystery Science Theater 3000.*

Patricia L. Grosse is a graduate student at Villanova University's doctoral program in Philosophy. Her dissertation focuses on themes of embodiment and materiality in the works of St. Augustine. She lives in West Philadelphia with two cats, a cello, and a large quantity of rock salt just in case.

Regina M. Hansen, Ph.D., teaches at Boston University and is the author/editor of *Roman Catholicism in Fantastic Film* (2011) and coeditor of the reader *Cultural Conversations: The Presence of the Past* (2001). Her recent scholarship has appeared in *Science Fiction Film and Television* and the anthologies *Neo-Victorian Families* (2011) and *Fathers in Victorian Fiction* (2011). She is also a contributor to *The Ashgate Encyclopedia of Literary and Filmic Monsters* (2014), has reviewed for *The Journal of the Fantastic in the Arts* and writes regular articles for the nationally circulated children's magazines *Calliope* and *Dig.* She is the recipient of grants from the Massachusetts Cultural Council and the William Morris Society in America and was a PEN New England Children's Book Caucus "discovered" author.

Charlotte E. Howell is a Ph.D. student in the department of Radio-Television-Film at the University of Texas at Austin. Her work has been published in *Networking Knowledge* and *Kinephanos*. Her research interests include television studies, television genres, production studies, and the discourse of religion as they circulate through media.

Sharon D. King, Ph.D. in Comparative Literature from UCLA, is an associate at UCLA's Center for Medieval and Renaissance Studies and a film and TV actor. Her publications include an essay in the critical anthology *Of Bread, Blood and The Hunger Games* (2012) and the fantasy story "Read Shift" forthcoming in *Kaleidotrope* (Spring 2014). Her theatrical troupe Les Enfans Sans Abri has performed short fifteenth to seventeeth-century European comedies in translation in the United States and Europe since 1989.

Rhonda Nicol is an instructional assistant professor of English at Illinois State University. Her research focuses on issues of gender, power, and identity in contemporary fantasy. She has published essays on works such as *Harry Potter, Twilight, Supernatural*, and *Buffy the Vampire Slayer*. She has always been a fan of things that go bump in the night.

Gregory J. Robinson is an assistant professor of music at George Mason University. He holds a Ph.D. in anthropology of music from the University of Pennsylvania and specializes in Latin and North American traditional and popular repertoires. His forthcoming book centers on traditional music and transnationalism in Chilean Patagonia, and his articles and reviews appear in *Ethnomusicology, Yearbook for Traditional Music*, the *Encyclopedia of Popular Music of the World*, and several edited collections.

Lugene Rosen is a reference librarian at Chapman University and instructor of English at Coastline Community College. She received her MA in literature and MFA in creative writing from Chapman University and her MLIS from San Jose State University. She is a regular presenter at the annual Southwest Popular Culture Conference held in Albuquerque. Her papers focus on horror films as well as the television show *Supernatural*. She has followed the show since the "Pilot."

KT Torrey is a Ph.D. candidate in Rhetoric and Writing at Virginia Tech. As a scholar, she wrestles with porn studies, sophistic rhetoric,

and popular romance. Her current research combines these approaches to explore evangelical rhetorics about female sexuality created by and for Christian women. She also writes extensively (sometimes even academically) about metatextuality, fan fiction, and *Supernatural*.

Elisabeth G. Wolfe is a freelance translator and editor from Llano, Texas. She holds a Ph.D. in English from Baylor University. Her academic specialties include medieval literature and theology, J. R. R. Tolkien, and C. S. Lewis. Wolfe is also an independent novelist who writes steampunk and historical fantasy set in various periods of Texas history.

Index

Printed and bound in the United States of America